༄༅།།རབ་བྱུང་ ༢༣ པའི་རྒྱུ་ཡོས་བོར་ཞབས་དུང་གྲགས་སྐྱལ་ ༣ པ་དང་འབྲུག་སྟེ་ སྤྱིད་ ༢༢ པའི་སྐབས་སུ་ཕྱི་སྐྱིད་པ་རམས་ཀྱུ་འེལ་དུའི་ཕེསུ་ཅེས་པས་འབྲུག་ཡུལ་དུ་ལྭ་སྦོར་ལ་ཕྱིན་དེ་ཁོ་པས་བསམ་འཆར་ཡེ་གེར་བཀོད་པ་དང་ས་ཆ་རྫོང་སྒྲ་ཁང་སོགས་རི་མོ་བྲིས་པ་འདི་ཚོ་སྤྱན་དབྱིན་དགེ་མའི་ཁྲིལ་ཡེ་རིས་འདས། ཀྱུན་ཆོས་འཕེལ་དུ་འབོར་པས་འབྲུག་པའི་སྲོལ་བཟང་རྙིང་པ་མི་ཉམས་གོང་དུ་འཕེལ་བའི་ཆེད་དུ་སྐྲིག་སྟུན་བགྱིས།།

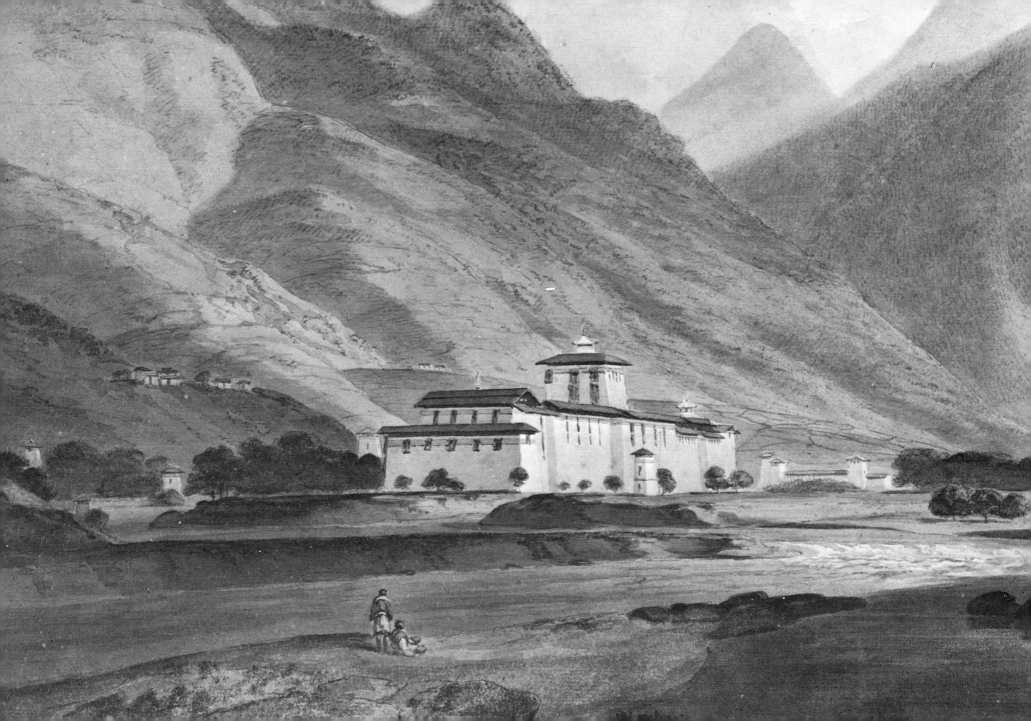

Views of Medieval Bhutan

The Diary and Drawings of
Samuel Davis
1783

MICHAEL ARIS

SERINDIA PUBLICATIONS / SMITHSONIAN INSTITUTION PRESS

London Washington, D.C.

British Library Cataloguing in Publication Data

 Davis, Samuel
 Views of medieval Bhutan.
 1. Bhutan—Pictorial works
 I. Title II. Aris, Michael
 954.9′8 DS485.B503

 ISBN 0-906026-10-5 (Serindia)
 ISBN 0-87474-210-2 (Smithsonian)

 Library of Congress Catalog Card No: 81–85435

Frontispiece: "The Palace of Punukka", watercolour by Samuel Davis, 1783. By courtesy of the India Office Library and Records (WD 3271).

Copublished in 1982 by SMITHSONIAN INSTITUTION PRESS, Washington, D.C., and SERINDIA PUBLICATIONS, 10 Parkfields, London SW15 6NH.

Printed in Great Britain by
Biddles Ltd, Guildford, and John Swain & Son Ltd., London.
Bound by Hunter & Foulis Ltd., Edinburgh.

Contents

For our sons
Alexander and Kim

Acknowledgements

Among the friends and colleagues who have helped me with points of facts and interpretation, I would particularly like to thank Mildred Archer, Samten Karmay, Braham Norwick and Hugh Richardson. I am also indebted to William Fowle, direct descendant of Samuel Davis, and his family for their kindness in answering several queries. My brother Anthony Aris, the publisher of this book, gave me continuous encouragement and practical assistance. In preparing it for publication my wife Suu has as usual been my most discerning critic.

I am very grateful to the staff of the following institutions for their prompt and accurate response to my enquiries and requests for assistance: The Royal Society, the Royal Geographical Society, the Royal Asiatic Society, the Indian Institute Library and the Bodleian Library, Oxford, the India Office Library, the Department of Prints and Drawings at the British Museum, the Yale Center for British Art, and the Victoria Memorial, Calcutta.

For permission to reproduce the drawings of Samuel Davis and related material in their collections, I express my gratitude to Her Majesty the Queen, the Yale Center for British Art, the Victoria Memorial, Calcutta, the India Office Library, the British Museum, the Victoria and Albert Museum, the School of Oriental and African Studies, the President and Fellows of Corpus Christi College, Oxford, the Master and Fellows of University College, Oxford, Dr Maurice Shellim, Giles Eyre and Christer von der Burg.

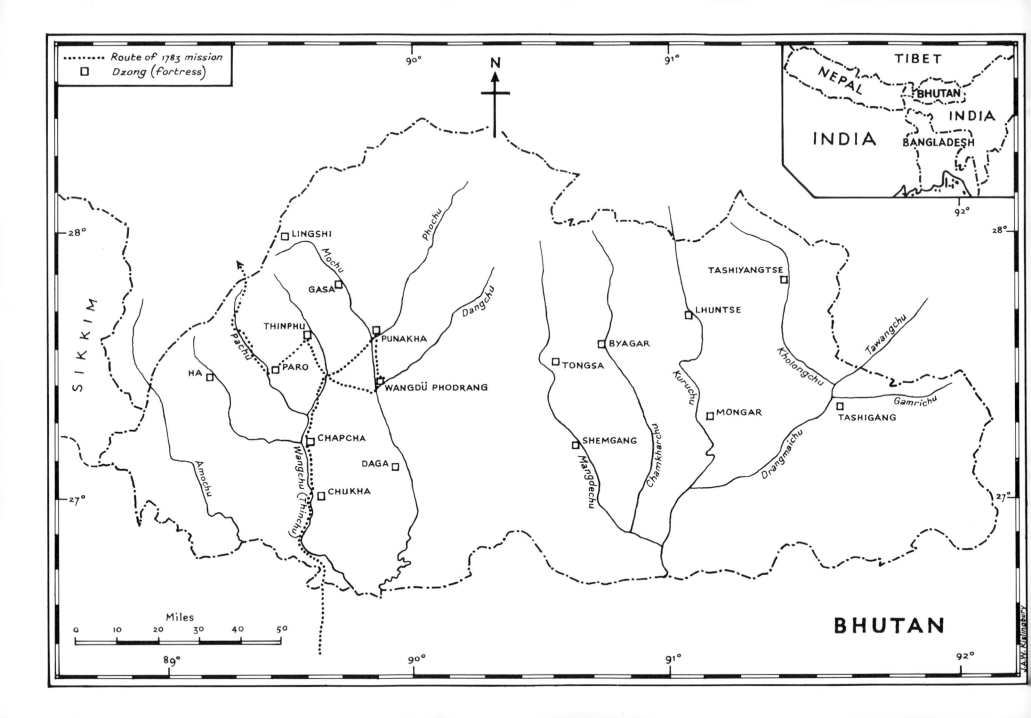

Route of 1783 mission
Dzong (fortress)

TIBET
NEPAL
BHUTAN
INDIA
INDIA
BANGLADESH

90°
91°
92°

N

S I K K I M

28°
28°

LINGSHI

Mochu
GASA

Phochu

THINPHU
Pachu
PARO

Dangchu

PUNAKHA

HA

WANGDÜ PHODRANG

BYAGAR

TASHIYANGTSE

LHUNTSE

Kholongchu
Tawangchu

TONGSA

CHAPCHA

Wangchu (Thinchu)

DAGA

Kuruchu

MONGAR

Gamrichu

TASHIGANG

CHUKHA

Amochu

SHEMGANG

Mangdechu

Chamkharchu

Drangmaichu

27°
27°

Miles
0 10 20 30 40 50

BHUTAN

89°
90°
91°
92°

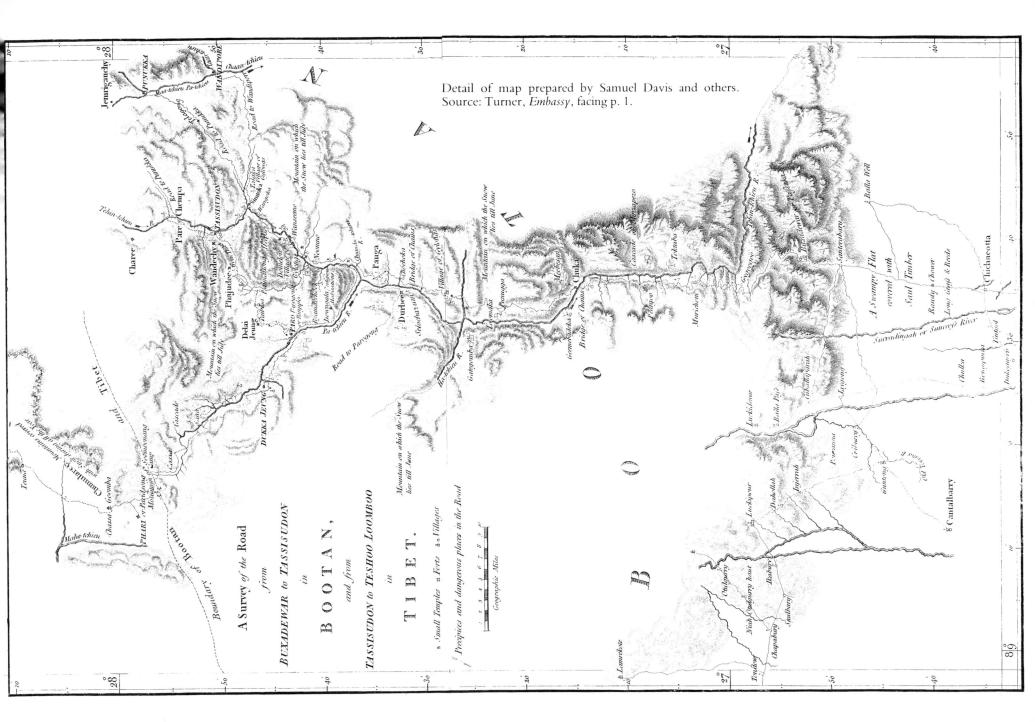

Detail of map prepared by Samuel Davis and others.
Source: Turner, *Embassy*, facing p. 1.

A Survey of the Road
from
BUXADEWAR to TASSISUDON
in
BOOTAN,
and from
TASSISUDON to TESHOO LOOMBOO
in
TIBET.

☙ *Small Temples* ⚐ *Forts* ☖ *Villages*
⫶ *Precipices and dangerous places in the Road*

Geographic Miles

Introduction

In 1783 Samuel Davis, a young lieutenant in the Bengal Army, was appointed by Warren Hastings to join Samuel Turner's mission to Bhutan and Tibet as draftsman and surveyor. The drawings that Davis made in Bhutan and the journal he kept there form the subject of this book. It is now recognized that Hastings's motives for opening diplomatic contact with the countries of the north were of a complex nature. According to the particular documents of the period one chooses to emphasize, the missions organized by Hastings can be interpreted either as commercial reconnaissances or as cultural embassies aimed at exploration and exchange. To appreciate the work of Davis it is necessary to see it not only in the context of these extraordinary missions but also against the political and cultural backcloth of Bhutan itself in this period, and in the setting of the scholarly and artistic world of the English in the east in the late eighteenth century. Clearly this is not the place for a detailed discussion of all these diverse issues as they relate to the achievements of Davis and no more than a sketch is given here. An outline of Davis's life, which remains very elusive, is also attempted and an account given of the subsequent fate of his Bhutanese drawings, their reception in Europe and present dispersal.

The traversing of so many cultural let alone geographic and political boundaries stems more from the cosmopolitanism of the age of Enlightenment as personified in Davis than from the colonial involvement of the British in Asia (though the two are here closely interwoven). True, Davis did enter Bhutan as the representative of an imperial power trying to extend its commercial interests into high Asia but this role is completely muted in all that he left behind. The warm sympathy with which he accurately recorded the local scene was certainly inspired by the realization that here was a society *almost* as good as his own, enjoying a high state of civilization and surpassing natural beauty, inhabited by people to whom he could truly relate. It appears that he set down these qualities, along with certain credible defects, entirely for his private satisfaction (he never sought to publicize them himself) and so we can take it that his was a genuinely personal response and not the product of official policies and attitudes. Even so it is not difficult to detect in his journal a certain mild condescension, a natural ethnocentrism, yet one very far removed from the grossly racist response shown by so many British in the east in the next two centuries. His value judgements one feels are close to those he might have expressed had he found himself

transported back into our own medieval past. Most of the popular connotations of the word "medieval" seem inevitably to be evoked when the westerner visits Bhutan, then as now. Although the word is of course absent from Davis's vocabulary – it was only invented in the nineteenth century – I have not hesitated to use it in the title of this book.

Davis's legacy played no part in the development of those imaginary utopias which the west continues to locate in the trans-Himalayan region. Even if his work had been more readily available to succeeding generations, the tone of his writing is secular and his art possesses a clear naturalism, neither of which are conducive to false dreams. If sublime and romantic qualities are sometimes found expressed in his art this is surely because Davis, like most of us, was constitutionally incapable of reacting otherwise to certain combinations of mountains, light, fortresses and forests. The coldest eye could hardly have done otherwise. Although these qualities played their part in satisfying the European taste for the picturesque and the exotic, even behind the reworkings aimed at the nineteenth-century public one senses the sobre, open eye of Davis. The traditional scene in Bhutan changed little between the time of the Turner mission and the advent of large-scale development and package tours in the 1970s. Even now the remoter parts of the country remain untouched by the intervening centuries and for those who knew Bhutan before the opening of the motor roads, Davis's drawings are highly evocative. One might almost be there but for the fiery taste of chillies, the smell of woodsmoke, and the sound of chanting monks.

<p style="text-align:center">★ ★ ★</p>

Beneath the apparently frozen surface of Bhutanese society lies three and a half centuries of turbulent change. The country found its first unity in the seventeenth century under a Buddhist theocracy somewhat akin to that of Tibet. By the second half of the nineteenth century the greatest authority lay in the hands of a number of quasi-independent, non-hereditary baronies. In the early years of the twentieth century these, and the theocracy which legitimized them, were in turn replaced with a modicum of British help by the present monarchy (the Wangchuk Dynasty). So much is clear and well documented. The history of the country before the unification can also be partly reconstructed from various sources including historical legend and hagiography to provide a picture of fragmented principalities based either on monastic power or on the rights of "royal" clans. Both forms of rule were thought to depend on divine authority transmitted along authentic pedigrees and the progression to full theocracy under the great *Shabdrung* Ngawang

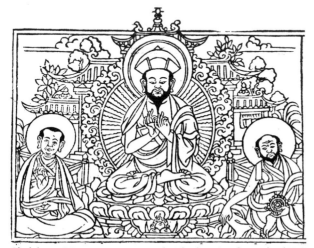

Shabdrung Ngawang Namgyel. Block-print from the *lHo'i chos-'byung* (1759), fo. 2a. By courtesy of Hugh Richardson.

Namgyel (1594–?1651), even though achieved in the face of much internal and external opposition, can be seen as a natural process which accorded well with local aspirations. Once the movement towards nationhood had been properly established all the heterogeneous local communities seem to have quickly abandoned their ancient, separate identities to become part of the prestigious new state. "Triumphant in All Directions" was the epithet adopted by the ruling Drukpa school of Lamaism to which the founder had belonged and which now imposed a uniform set of institutions on every region. The Drukpa school had taken its name from its first monastery, Druk ("Thunder Dragon"), and the Bhutanese refer to their own country as Drukyul ("Land of the Thunder Dragon"). "Bhutan" is really an Indian term. Despite the barriers of race and language (there are three principal languages, all mutually unintelligible, belonging to the Tibeto–Burman group) and the obvious difficulties of the terrain, Bhutan has probably enjoyed a greater degree of cultural, if not political, unity than any other region in the Himalayas, Nepal included.

For a state supposedly founded on the compassionate principles of Buddhism as introduced from Tibet in the eighth century onwards, the history of Bhutan's theocracy as well as its later monarchy with its tangle of plot and counter-plot makes strange reading. The founding *Shabdrung* left no suitable successor though he had deliberately abstained from final ordination till he had produced an heir. In order to maintain the cohesion and legitimacy of the new state the *Shabdrung*'s death in *c*. 1651 was kept secret by an inner coterie for the extraordinary (and surely unparalleled) period of more than half a century: it was declared he was in retreat. After the disclosure of the secret in *c*. 1705 the way was open for the discovery of his true heir in the form of a recognized reincarnation. (The Dalai Lamas who provided the closest model for this had gained authority over Tibet in 1642.) Even this solution was fraught with difficulties as contending parties advanced rival claimants. Ultimately the notion of multiple reincarnation permitted different embodiments to represent the physical, verbal and mental principles of the founding *Shabdrung* – a complex device which gave theoretical primacy to the "mental" incarnation. These were known to the British in India as the Dharma Rajas ("Kings of Religion"). Although they seldom wielded effective power they were indispensable symbols of national identity. In theory the Dharma Rajas delegated civil authority to their nominees, the Deb Rajas. In practice however the right to the office of Deb Raja (of whom there were fifty-five between 1651 and 1905) depended on many other factors of which one certainly was the sheer resource and cunning of the individual concerned. Many of the Deb Rajas and the often equally or more powerful provincial governors ("pönlop" and "dzongpön") were entirely self-made men who had risen through the

ranks of court servitors to high office. If not already ordained, such officers would be required to give up their wives, to adopt monastic dress and to abide by at least some of the monastic vows.

If one were to compare Bhutanese society with that of Tibet under their respective theocracies, the most striking difference would surely be the absence of strong social stratification in Bhutan, which has never really had a powerful landed aristocracy such as Tibet had till the end of the 1950s. The vast majority of the Bhutanese population has always consisted of a peasantry devoted to agriculture and pastoralism for whom the ties of mutual obligation have usually been at least as important as the services due to regional lord or central government. Whatever the conditions existing before may have been, after the unification the monastic or quasi-monastic style of government militated against the formation of heritable wealth or power. Generally speaking those who had their sights set on worldly ambition and wealth had to win it for themselves since they were unlikely to have inherited much. Government in fact largely consisted in a recycling of transferable wealth to the greater glory of the "Teachings of the Glorious Drukpa" and not towards the amassing of great personal fortunes. However, it is right to offset this purely material perspective by emphasizing the very close identification of the laity with the main direction of monastic government which was considered as simply one part of the whole spectrum of monastic endeavour. Nearly all families had members in the monkhood. Admittedly many of them were placed in the state monasteries by way of obligatory "monk-tax" but perhaps an equal or greater number lived voluntarily as semi-ordained, religious practitioners outside the formal communities. Even if it were an imposed state, the life of a monk carried great prestige and was usually the only means to social advancement.

Each of the gigantic fortresses ("dzong") so well depicted by Davis, which loom over the central Bhutanese valleys, function both as state monasteries and as centres of local and central government. It was in the construction and upkeep of these palaces of the "Dual System" (of royal and religious law) that the government of Bhutan must have spent most of its revenue. In the local literature they are commonly described as the heavenly abodes of the tantric divinities to whom they are dedicated, while the inmates are presented more or less as the human retinue of those gods. The hierarchs who acted as heads of state or regents certainly did use them as their official residences but many seem to have had quite separate establishments built for them on the sides of the valleys. Others might take over an existing temple or monastery at some remove from the intrigues of the monastic fortresses and they would retire to these sanctuaries as often as possible. Many of these outlying temples and monasteries, all constructed with public funds and the conscripted labour-services of the local population, came directly into the hands of the

government on the decease of the personages for whom they were built. Taken as a whole these forts, temples and monasteries – with their inward-sloping walls tapering to the sky, their lavish use of open woodwork, and their careful control of decorative detail of Chinese and Indian origin received through Tibet – must surely rank among the highest achievements of the Bhutanese.

Another class of fort is found on the old trade routes south to India. Much smaller than the great dzongs of the central valleys but in their way no less impressive, they must have been built to control all movement along these routes and at the same time to oversee the local administration. Although the religious role of these buildings is diminished, the band of red paint below the eaves of their central citadels still mark them out as sacred places. The control of the country or a region depended on the ability to guard all lines of communication and the development of bridge construction must have contributed to this. The cantilever, chain-suspension and ropeway bridges of Bhutan are masterpieces of traditional engineering. As a pundit surveyor employed secretly in Bhutan during the nineteenth century observed, all travel and transport in the country during times of trouble could easily be brought to a halt by the simple expedient of dismantling the bridges.

After the first explosion of effort which drew its motivation and experience partly from the need to counter continuous Tibetan aggression in the period *c.* 1620–1730, the theocratic state settled into a broad pattern which continued into times well within living memory. The state exercised a virtual monopoly on scholarship, trade, the arts – indeed on almost every activity outside the village where agriculture and the crafts had their base. Domestic architecture certainly shows the strongest conservatism of all; the fine structures drawn and painted by Davis in 1783 are identical to those described by a Portuguese Jesuit in 1627 and still visible everywhere today. Indeed what we find in the humble world of the village is but an expression of a force felt throughout the whole of Bhutanese society; custom and tradition acted as restraints upon innovation and enterprise and men sought everywhere to justify and perpetuate the present in terms of the past. However, once the lay element grew stronger and gradually dominated the structure of the state, Bhutanese government underwent a transformation which culminated in the founding of the monarchy. But if the heavy weight of monastic tradition bore down on free enterprise, secular *and* spiritual, on the positive side it sometimes succeeded in curbing exploitation by rapacious officials and in healing the wounds of civil strife. Moreover it cannot be denied that even within the traditional constraints it was possible for some true renouncers to transcend the fetters of religious society and to attain a position at its peak, standing at the same time apart from the world.

The rulers of Bhutan, and a few adventurous individuals too, seem to have recognized quite early that the easiest and most acceptable opportunities for profit lay in the exploitation of favourable market forces rather than in the exploitation of their own compatriots. Rich pickings were to be made in the Indian borderlands either through formally conducted trade or, it must be admitted, through predatory raids aimed at the capture of slaves and movable goods. The southernmost groups in Bhutan had been doing this since time out of mind and in several places had won traditional rights over the adjoining Indian peoples. After the unification the state appears to have assumed these rights for itself, a movement which brought it into contact with the Ahom dynasty in Assam and the rulers of certain minor border states including Cooch Behar in what is now West Bengal. It was this growing interest in Indian profit which led not only to the construction of the small forts and border outposts noted above but also to direct contact with the British. The Indian connection in the end came to exceed in political importance the far older and more organic ties with Tibet but that did not happen until the end of the nineteenth century.

* * *

Zhidar (alias Sonam Lhundrub), the 16th Deb Raja of Bhutan (*regn.* 1768–73), is chiefly remembered for the cruelty with which he compelled his subjects to rebuild on a new site and in under a year the huge capital fortress of Tashichö Dzong in the Thinphu valley after it had been destroyed by fire in 1772. He renamed it Sonam Phodrang (the Palace of Sonam) but the name lasted for no longer than he occupied the throne. Soon after its completion certain portents were interpreted as pointing to war with India. Zhidar had already overrun Sikkim and the principality of Vijayapur. Now as predicted he turned his attention to Cooch Behar over which Bhutan had gained considerable authority by the mid–eighteenth century. The Deb Rajas seem to have claimed the right to appoint its rulers. A long and complicated struggle for the succession culminated in the Bhutanese enthroning the candidate of their choice, Bijendranarayan. The ousted raja Dharendranarayan, a minor, fled with his minister and part of his family to the protection of the British. Hastings was quick to grasp an opportunity for political expansion and promised to reinstate the raja if he agreed to cede the sovereignty of Cooch Behar to the East India Company and to bear the expense of driving off the Bhutanese. A treaty to this effect was signed in April 1773 and a small field force under the command of Captain John Jones was dispatched to the Bhutanese border. According to one version Zhidar at this point succeeded in obtaining a promise of military aid from the rulers of Nepal, Assam and even Sylhet. Whether or

Southern *View* of DELLAMCOTTA *FORT* in BOOTAN,

PLAN of DELLAMCOTTA FORT,
By Captain Claude Martin.

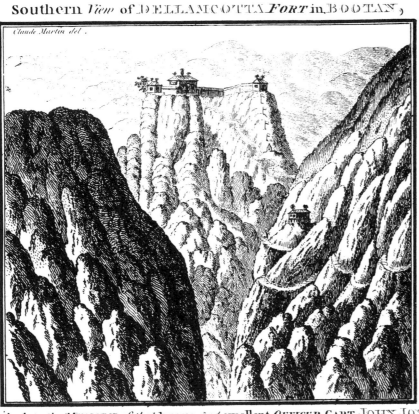

Inscribed *to the* MEMORY *of that* brave *and* excellent OFFICER CAPT. JOHN JONES;
Who *took it by* Afsault *in* April 1773. *and soon after fell a Sacrifice to the unwholesome*
Climate of Coos Beyhar.

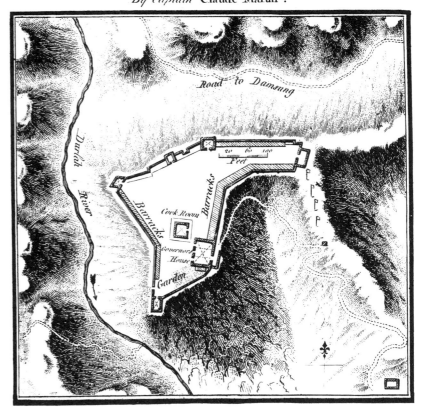

View and plan of Daling Dzong (Dellamcotta), engraving after Claude Martin, in James Rennell, *A Bengal Atlas* (London, 1780), plate 18 (insets). By courtesy of the President and Fellows of Corpus Christi College, Oxford.

not this is true, such aid never arrived and the Bhutanese were driven back to their mountains and three of their border forts were taken. Captain Jones however together with a great many of his troops died of malaria.

The view and plan shown here of Daling Dzong (Dellamcotta), one of the forts captured by Jones, is an engraving based on an untraced original by Claude Martin (1735–1800), the famous and much-loved French turncoat who ended up in the service of the nawab of Oudh (Awadh). This view must have been done early in his career while he was employed in the East India Company's survey of Bengal under the leadership of the brilliant geographer James Rennell. Rennell produced this engraving for his *Bengal Atlas* and gave a copy of the view to Thomas Pennant who reacted volubly:

> It is impossible for imagination to invent a ruder situation; the surrounding mountains are equally horrible, and approximate so near as to form only darksome chasms of immense depth. On the sides are narrow roads impending over the dreadful precipices. Along these paths Captain *John Jones,* on April 7th, 1773, led his detachment to attack this aerial fortress, and took it by storm . . . I trust that this hero was a *Welshman,* and may be added to the list of my illustrious countrymen . . .

Meanwhile the defeated Zhidar retreated to western Bhutan where he found his subjects in open revolt. Their patience had been exhausted by his foreign adventures, by the grim episode of the reconstruction of Tashichö Dzong and by his flaunting of a seal granted to him by the Chinese authorities, an unacceptable act of servility in what Bogle called "this state, naturally free and independent". Zhidar fled to the region of Lhasa and finally took refuge with the third Panchen Lama of Tibet, the great Lobzang Palden Yeshe (1737–80), who was residing at his seat of Tashilhunpo. At the request of Zhidar and the Nepalese authorities who had an interest in the matter the Panchen Lama now interceded with Hastings on behalf of the Bhutanese whom he claimed with exaggeration to be Tibetan subjects. The Panchen's emissary was an Indian devotee of his called Purangir Gosain, a key figure in all the negotiations which followed. Hastings reacted very quickly and positively to these overtures by appointing George Bogle (1748–81) as ambassador to Bhutan and Tibet and by relinquishing all Bhutanese land captured in the campaign of 1773. Hastings's desire to re-establish the trans-Himalayan trade disrupted by war with Nepal and the rise of the Gorkhas was probably strengthened by the need to offset the huge financial losses incurred as a result of the Bengal famine of 1770. The company had first sought to explore Bhutan for its commercial possibilities in 1771. Hastings now set himself to read all of the scanty

Warren Hastings by Tilly Kettle (*c.* 1775). By courtesy of the Asiatic Society of Bengal.

George Bogle, artist unknown. Source: Sir Francis Younghusband, *India and Tibet* (London, 1910), facing p. 8.

Opposite: The 3rd Panchen Lama receives George Bogle at Tashilhunpo. Oil painting by Tilly Kettle, *c.* 1775. By gracious permission of Her Majesty the Queen.

but intriguing literature on the region available to him in Calcutta, summarizing this in a fascinating "memorandum" for George Bogle. While Bogle's letter of appointment deals mainly with the need to open "a mutual and equal communication of trade" between India and Tibet, it is in his list of private commissions to Bogle that Hastings reveals a genuine intellectual curiosity. Bogle was to report on everything and to obtain for him yaks, shawl goats, Tibetan coins; and walnuts, rhubarb and ginseng for seed. The following selection makes clear how Hastings declined to separate the human and physical sciences, perceiving these as forming an indivisible whole in a manner typical of the eighteenth century:

> Any curiosities, whether natural productions, manufactures, paintings, or what else may be acceptable to persons of taste in England. Animals only that may be useful, unless any that may be remarkably curious . . . To keep a diary inserting whatever passes before your observation which shall be characteristic of the people, the country, the climate, or the road, their manners, customs, buildings, cookery &c. . . . Every nation excels others in some particular art or science. To find out this excellence of the Bhutanese . . . To inform yourself of the course and navigation of the Brahmaputra . . .

Hastings was particularly fortunate in his choice of Bogle, a young company servant who had risen high in his favour and who possessed a special charm and sensitivity which won him many friends in the lands to which he was sent. "I always like to do in Rome as they do at Rome", he was to declare – and so he did, eating and dressing like the peoples he moved among, learning passable Tibetan and entering gaily and naturally into the spirit of each occasion. In his journal, not published till late in the nineteenth century, he shows himself to be the true, plain-speaking yet courteous and patient Scotsman that he was. His adoption of local habits seems to have been remarkably free from the self-consciousness and self-important fancy-dressing which have lent derisory overtones to the term "going native". Rather, Bogle's easy appropriation of local costumes and practices was a matter of simple enjoyment and convenience, not unmixed with a certain self-deprecatory humour that could only have come from a basic confidence in the traditional values of his own background. Surely it is this attitude which finds expression in the fanciful re-creation of Bogle's reception by the Panchen Lama shown here, painted by the famous Tilly Kettle in Calcutta, presumably on Bogle's return in 1775. The picture was recently identified for what it is by Mildred Archer in the Royal Collection where it had previously been wrongly catalogued. It is assumed that Hastings presented the picture as a gift to King George III. Although many details in the picture are individually authentic, being recognizably Tibetan or Bhutanese, as a whole it is not a convincing representation of Bogle's actual reception by the

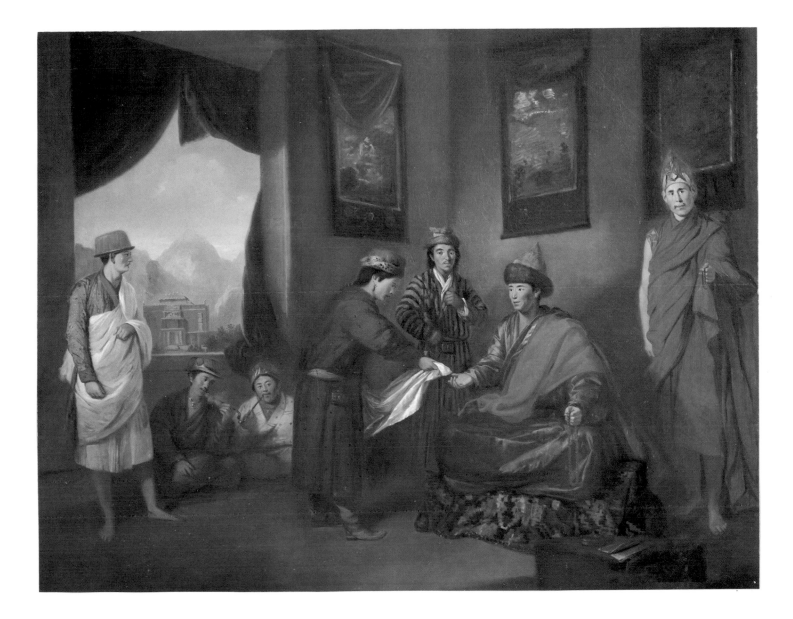

Panchen and does not tally with his own account of it. Bogle is shown standing on the left wearing what must have been the robe presented to him by the Deb Raja of Bhutan (Zhidar's successor) at their first meeting, a garment he described to his sister as "a water tabby gown, like what Aunt Katty used to wear, with well-plated haunches . . . Thus attired I walked home, like Mordecai, in great state to my lodgings". His legs as bare as those of any Bhutanese are matched by those of the figure who is probably the Panchen's monk-chamberlain. He stands to the left of the seated Panchen who is seen here receiving Bogle's ceremonial white scarf ("khatag") from the hands of another figure who may represent "Paima", the Panchen's own servant who accompanied Bogle in all his travels. To the Panchen's right stands another figure wearing a Bhutanese robe, while seated beneath the window are two gentlemen improbably smoking their pipes in the presence of the lama. There is the added incongruity of men failing to remove their hats within the chamber and the Panchen himself has been ornamented with the wrong headgear, a winter riding hat such as is never worn indoors. Through the window can be seen a distant monastery which may have been based in part on the "view of Teshu Lumbo" received by Bogle among the parting gifts of the lama. In fact the picture must represent an amalgam of Bogle's recollections of his many audiences in Bhutan and Tibet. For all its inaccuracies it has real charm and bears a peculiar testimony of its own.

Bogle accompanied by his surgeon Alexander Hamilton, the agent Purangir and others reached the Bhutanese capital from Cooch Behar in ten stages. The five months he spent in Bhutan from May to October 1774 were taken up with negotiations for the opening of trade and for his onward journey to Tibet. The new Deb Raja was Kunga Rinchen (*regn.* 1773–6). He had formerly been the monk in charge of the college of philosophical logic in the principal state community and had been raised to the throne by the regent Jigme Senge (1742–89) during the revolt against Zhidar (see the Appendix). An insurrection in support of the ousted Deb took place during Bogle's stay and even his fine patience was sorely tried by the protracted delay in bringing his negotiations to a conclusion: "Of a truth, an ounce of mother-wit is worth a pound of clergy", he confided to his journal. To Hastings he declared ". . . this place is very little favourable to my commercial inquiries. It is monkish to the greatest degree. The Rajah, his priests, and his servants, are all immured like state prisoners in an immense large palace . . .". That was in August but by October he could say with feeling:

> The more I see of the Bhutanese, the more I am pleased with them. The common people are good-humoured, downright, and, I think, thoroughly trusty. The statesmen have some of the art which belongs to their profession. They are the best-built race of men I ever saw;

many of them very handsome, with complexions as fair as the French. I have sometimes been tempted to wish I could substitute their portrait in the place of my friend Paima's [see above].

Ultimately Bogle succeeded in securing an agreement for the passage of British merchandise in and through Bhutan by means of non-European agents. His greatest achievement however was his fine account of life in Bhutan and Tibet and the warm friendship which developed between him and the Panchen Lama who seems to have possessed an intellectual curiosity at least equal to that of Hastings. These matters lie outside the scope of this introduction and there can be no substitute for reading Bogle's wonderful journal in its entirety. Hastings considered it the equal of the standard account of Captain Cook's travels and sent a copy to Samuel Johnson hoping he would encourage its publication. Johnson died in 1784 before Hastings returned to England and impeachment, and all that appeared until Markham's edition of 1875 was a short, second-hand version in the *Philosophical Transactions,* lxvii (1877). Four years after his return from Tibet Bogle himself was appointed to the Collectorship of Rangpur in order to stimulate the Bhutan trade. Writing to his sister he said ". . . although not in my Bhutan hills, I am within sight of them". In January 1780 he wrote to his brother saying he hoped to spend a month in the north, "but shall regret the absence of my friend the Teshu [Panchen] Lama, for whom I have a hearty liking, and should be happy again to have his fat hand on my head". The lama was visiting the emperor of China at Peking where he subsequently died. Bogle himself died in Calcutta on 3 April 1781 aged only thirty-four.

Bogle's journal was not the only solid legacy from his Himalayan adventures to resurface much later. In 1948 Nora Heathcote wrote to the *Sunday Times* claiming descent from Bogle through a Tibetan lady referred to in the family papers as "Tichan, sister of the Teshoo Lama" whom he is said to have married. My friend Hugh Richardson has carefully assembled in his unpublished paper "George Bogle and his Children" all the available evidence for this union. He establishes beyond reasonable doubt that Bogle indeed had several children by a Tibetan lady, Dechen by name, that she almost certainly was not a close relative of the Panchen Lama and that two girls (Martha and Mary) born to him by Dechen were sent back in 1785 to the care of Bogle's family at Daldowie near Glasgow. Although there are still a few unfilled gaps it seems certain that there are some Scottish veins with a small measure of Tibetan blood in them to this day.

Even before Bogle's death Hastings had deputed two more missions to Bhutan in 1776 and 1777. Both were of relatively minor importance and were led by Alexander Hamilton, the surgeon who had accompanied Bogle. The first of these missions was aimed at settling Bhutanese

claims to a border district in the south and the second was deputed to congratulate a new Deb Raja on his accession to the throne. This was Jigme Senge (*regn.* 1776–88), not to be confused with the regent of the same name referred to above. Unfortunately Hamilton left no account of his experiences and the next contact did not take place until 1783 when Turner's mission finally brought our Samuel Davis to Bhutan.

In February 1782 Purangir the Indian mendicant who continued to act as the official intermediary between Calcutta and Tashilhunpo arrived back in Calcutta with a detailed account of the Panchen Lama's journey to China and his subsequent death in Peking. (The unedited English manuscript version of his account has now strangely come into my own possession.) Soon afterwards word was received that the new incarnation of the Panchen Lama had been found and Hastings again took the opportunity of furthering his commercial and scientific interests by organizing another mission, this time led by his own kinsman Samuel Turner (1749–1802). The surgeon on this occasion was the gifted botanist Dr. Robert Saunders. Samuel Davis about whom almost nothing is known before this date (see below) was appointed "Draftsman and Surveyor" to the expedition. Purangir was also in attendance as usual.

In many ways the 1783 mission was identical to that led by Bogle in 1774: both were delayed for many months in Bhutan while waiting for permission to enter Tibet (an issue greatly complicated by fear of the Chinese reaction and other factors); both coincided with insurrections in support of Zhidar who continued to work mischief from across the border; and both gave members of the British missions the chance to explore western Bhutan, an experience they valued highly. The Deb Raja in 1783 seems to have been very favourably disposed towards the British and the activities of Davis clearly helped to establish a close rapport. As Turner said:

> . . . nor did he seem less pleased, that Mr. Davis had improved the opportunity of drawing various views in our route . . . We were in no respect abridged in the liberty of ranging where we chose; and the Raja appeared rather to encourage Mr. Davis, in taking views of his different palaces, and of the various scenery exhibited in this wild and picturesque country.

During their first audience with the Deb Raja, Turner relates how:

> I told the Raja in plainer terms, that drawings constituted in England a branch of education; and that as we made unequal progress in the art, I could boast but little skill in it, but that my friend Mr. Davis had attained a great degree of perfection. Mr. Davis happened to have with him, a view of Calcutta, which he had taken from Fort William, comprehending the line of buildings that skirt the esplanade, and the shipping on the river: it had sustained some damage from the carriage; but he promised, as soon as it could be repaired, to present it to the Raja.

The ruler's enthusiasm calls to mind how in 1627 the founder of his state, *Shabdrung* Ngawang Namgyel, had borrowed a painting of St. Raphael from the Jesuit Cacella to make a copy of it himself. Neither the *Shabdrung* nor the Deb Raja however could have reacted to Davis's drawings as Turner himself did, when speaking of:

> . . . these admirable scenes, on which Mr. Davis, the companion of our travels, was at the same time most successfully employing his pencil. His subjects indeed, in themselves, are not more remarkable for their grandeur and beauty, than for the judgement, fidelity, and taste, with which he has seized on and recorded their features. To such as find satisfaction in contemplating nature, in its most gigantic and rudest form, what an inexhaustible fund of delight is here displayed! Gratification waits on every step, and the mind is animated with the sublimest sentiments, while the beholder, fascinated with the ever-varying beauties, pauses to enjoy the rich repast, insensible of fatigue, and turns his eye with reluctance from so magnificent a prospect.

This is a typical example of what has been called the "elegant, rather elevated prose style" which Turner used in recollecting his experiences. It contrasts strongly with Bogle's spontaneous outpourings, no less literate even if somewhat less polished. Davis as will be seen is again different – there is less emotion than either Bogle or Turner and rather more emphasis on balanced judgement and accurate observation. This accorded well with his nature as revealed in his later interests which were those of an Amateur Gentleman of Science, as the contemporary phrase had it. In 1783 however he was in Bhutan in a professional capacity to survey the road and record the topography of the country. Hastings's appetite for the pictures of Davis must have been greatly stimulated by Bogle's earlier written reports and by the Tilly Kettle picture. The map of Turner's mission route illustrated here must have been the product of Davis's work with the waywiser (see Plate 53), completed for the Tibetan portion (not shown here) either by Turner himself or by Saunders the surgeon. It was Saunders who later wrote the first scientific account of Bhutan and Tibet from the point of view of their geology and botany, published in the *Philosophical Transactions,* lxxix (1789). His medical researches in Bhutan enjoyed the close co-operation of the Deb Raja who supplied him with more than seventy specimens of the local medicines. He concluded:

> I think the knowledge and observations of these people on the diseases of their country, with their medical practice, keep pace with a refinement and state of civilization, which struck me with wonder, and, no doubt, will give rise to much curious speculation, when known to be the manner of a people, holding so little intercourse, with what we term civilized nations.

Davis like so many others at different times was excluded from Tibet. After four months in Bhutan the representative of the Tibetan authorities finally agreed that the expedition could proceed but that it was to consist only of "the same number of persons, as upon a former occasion had visited the Teshoo Lama. He could, on no account, admit a third gentleman of the party; saying, that his life might answer for such a breach of trust". Turner seems to imply that it was really Tibetan suspicion of Davis's skills which caused them to refuse him entry. On 8 September 1783 they left him "with deep and sincere regret" and proceeded to Tashilhunpo. It is not known how much longer Davis stayed in Bhutan before returning to India. His subsequent career there is outlined below.

Turner's mission to Tibet culminated in his audiences with the infant 4th Panchen Lama (1781–1854):

> Teshoo Lama was at this time eighteen months old. Though he was unable to speak a word, he made the most expressive signs, and conducted himself with astonishing dignity and decorum . . . His features were good; he had small black eyes, and an animated expression of countenance; altogether, I thought him one of the handsomest children I had ever seen.

Turner's description is very nicely complemented by the following passage (in Luciano Petech's translation) from the biography of this Panchen Lama:

> The minister [Turner] with his suite were given a place in the ceremonial tea with great cheerfulness; they showed great rejoicing. Although they were not knowers of the niceties of religion, by merely gazing [at the infant Panchen Lama] an irrepressible faith was born in them, and they said: "In such a little body there are activities of body, speech and mind, so greatly marvellous and different from others!" Thus they said with great reverence.

"Not knowers of the niceties of religion" is an apt enough phrase to describe all the British travellers of the eighteenth century to Bhutan and Tibet; none had time to penetrate much beyond the furthest externals of religion but reading their accounts one must concur with the viewpoint implicit in the above passage from the Panchen's biography: basic human sympathy could achieve a closer rapport than a ton of theoretical knowledge. It was left to the next century for Tibetan studies to begin properly. The "abridged history of Tibet, from their own annals" which was composed for Turner at Tashilhunpo (now preserved at the Bodleian Library, Oxford) was certainly never read by him or by any of his contemporaries.

Without having Davis to record the scenes of Tashilhunpo, Turner himself produced at least two drawings. These were engraved by James Basire along with nine of Davis's drawings for the

Opposite: Wash-drawing by unknown artist after Samuel Turner, for James Basire's engraving "The Dwelling of Tessaling Lama, with the religious Edifice, stiled Kugopea", in Samuel Turner, *An Account of an Embassy to the Court of the Teshoo Lama in Tibet* (London, 1800), plate 12. By courtesy of the Trustees of the British Museum (1944-10-14- 195).

"The Mausoleum of Teshoo Lama", engraving by James Basire after Samuel Turner, in his *Account of an Embassy*, plate 11.

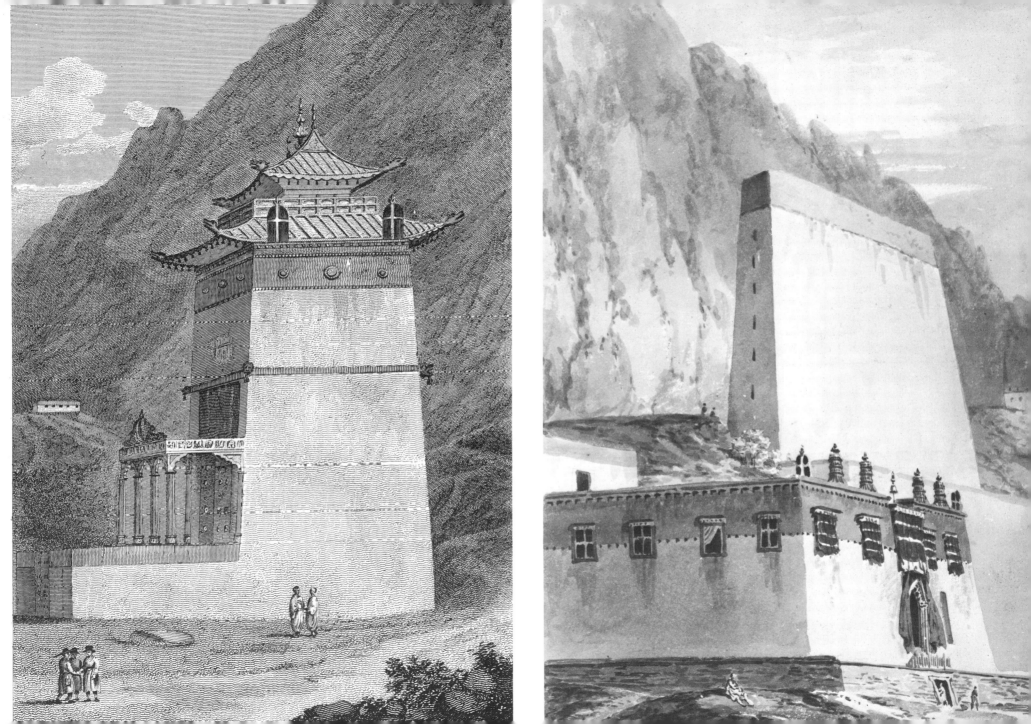

publication in 1800 of Turner's *An Account of an Embassy to the Court of the Teshoo Lama in Tibet*. There is still preserved a version of one of these views by Turner, copied from the original by an unknown artist prior to engraving it for publication; it is in a style and format identical to three wash–drawings based on the work of Davis in the same collection, which was formerly in the possession of the late Miss M. H. Turner (granddaughter of a cousin to J. M. W. Turner, but no connection with Samuel Turner). The building in the foreground is the residence of the unidentified "Tessaling Lama" and the tall construction to the rear is what Turner called the "Kugopea" (Tibetan: *Gos-sku-spe'u,* "Cloth-Image Tower"). Its purpose was to serve as a frame for displaying once a year a gigantic tapestry of Buddhist divinities worked in appliqué of a type still seen during certain festivals in Bhutan today. The other drawing by Turner has come down to us only in the form of Basire's engraving. It shows the tomb of Bogle's friend the 3rd Panchen Lama, which had been constructed before the Lama's departure for China and thus was ready to receive his corpse when it was brought back with lavish ceremony and all the funerary gifts of the Chinese emperor.

Two years after his return to England in 1798 Turner published his *Account of an Embassy* which gained him admission to the Royal Society. It soon went into German, Italian and French editions. A reviewer in the *Gentleman's Magazine,* lxx (Oct. 1800), expressed the common reaction, surprise at the juxtaposition of "dreadful" or "horrible" mountains and the civilization located in them: "The entrance to Tibet is distinguished by the dreariest objects in nature, by severity of cold, by mountains clothed in perpetual snow, and by feeble vegetation; yet the scenery is represented as altogether sublime. We trace among the Tibetians many conformities with the patriarchal times and manners". The work passed into European culture, valued particularly for its account of the young Panchen Lama. The passage quoted above in which Turner described the little incumbent of Tashilhunpo was the acknowledged source for a humorous travesty by the Irish poet Thomas Moore (1779–1852), author of the famous Kashmirian romance "Lalla Rookh". The poem in question, "The Little Grand Lama", appeared in his collection *Fables for the Holy Alliance* (1823) dedicated to the poet's friend Lord Byron. The following extracts are sufficient to convey its tone and flavour:

> In Thibet once there reign'd, we're told,
> A little Lama, one year old –
> Rais'd to the throne, that realm to bless,
> Just when his little Holiness
> Had cut – as near as can be reckon'd –
> Some say his *first* tooth, some his *second*.

Opposite:
3rd Panchen Lama, Lobzang Palden Yeshe. Detail of a block-print from Tashilhunpo. Private Collection.
4th Panchen Lama, Lobzang Tenpai Nyima. Detail of a block-print from Tashilhunpo. Private Collection.

Chronologers and nurses vary,
Which proves historians should be wary.
We only know the' important truth,
His Majesty *had* cut a tooth.

. .

But short this calm; – for, just when he
Had reach'd the' alarming age of three,
When royal natures, and, no doubt,
Those of *all* noble beasts break out –
The Lama, who till then was quiet,
Show'd symptoms of a taste for riot;
And, ripe for mischief, early, late,
Without regard for Church or State,
Made free with whoso'er came nigh;
Tweak'd the Lord Chancellor by the nose,
Turn'd all the Judges' wigs awry,
And trod on the old General's toes.

. .

The Parliament of Thibet met –
The little Lama, call'd before it,
Did, then and there, his whipping get,
And (as the Nursery Gazette
Assures us) like a hero bore it.

And though, 'mong Thibet Tories, some
Lament that Royal Martyr*d*om
(Please to observe, the letter D
In this last word's pronounc'd like B),
Yet to the' example of that Prince
So much is Thibet's land a debtor,
That her long line of Lamas, since,
Have all behav'd themselves *much* better.

Turner's lasting legacy took another form too. He, like Bogle, had occasion to send back to England the living products of his Himalayan experiences, though in animal rather than human form. The business goes back to Hastings's private commissions to Bogle and is best explained in Turner's own words:

> I had the satisfaction to send two of this species [yaks] to Mr. Hastings after he left India, and to hear that one reached England alive. This, which was a bull, remained for some time after he landed in a torpid languid state, till his constitution had in some degree assimilated with the climate, when he recovered at once both his health and vigour. He afterwards became the father of many calves, which all died without reproducing, except one, a cow, which bore a calf by connection with an Indian bull.
>
> Though naturally not intractable in temper, yet, soured by the impatient and injudicious treatment of his attendants, during a long voyage, it soon became dangerous to suffer this bull to range at liberty abroad. He had at all times been observed to bear a marked hostility towards horses; and . . . he happened to gore a valuable coach-horse belonging to Mr. Hastings, which had the range of the same pasture with him, and, lacerating the entrails, occasioned his death. After this, to prevent further accidents, he was kept alone within a secure enclosure.
>
> An Engraving of this Bull, from a picture in the possession of Mr. Hastings, painted from the life by Stubbs, is annexed; the landscape was taken from a scene on the frontier of Bootan, by Mr. Davis.

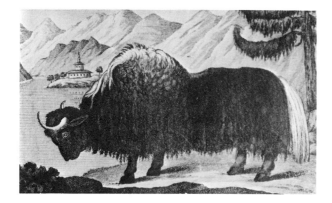

"Yak di Tartaria", coloured engraving in Samuel Turner, *Ambasceria al Tibet e al Butan*, trans. Vincenzo Ferrario, 3 vols. (Raccolta de' viaggi, xli–xliii, Milan, 1817), ii, plate 1. By courtesy of Braham Norwick.

The engraving referred to is plate 10 in Turner's *Embassy*, "The Yak of Tartary", and the original oil by Stubbs upon which it is based is reproduced opposite. Another version, in the collection of the Royal College of Surgeons, was commissioned from Stubbs by the famous anatomist and surgeon John Hunter (1728–93). The view by Davis owned by Hastings which provided the background to both versions has not yet been traced but a very similar one which was formerly in the possession of the artist's descendants is now in the India Office Library (WD 3270). It shows a distant view of the winter capital of Bhutan at Punakha Dzong seen from the south; the building is visible in this oil and greatly distorted in the *Embassy* engraving in both the English and Italian editions. The vegetable at bottom left which the yak is contemplating so mournfully in this oil is perhaps the Bhutan turnip which Hastings much admired and sought to introduce into England. The poor old yak also turns up in a painting (*c*. 1790) of Purley Hall in Berkshire, the house which Hastings rented for three years during his impeachment. This time the yak is in the "firm enclosure" mentioned by Turner, but within sight of his son-in-law the Indian bull and two shawl goats from Tibet.

Opposite: "Warren Hastings's Yak", oil painting by George Stubbs, 1791. Private Collection.

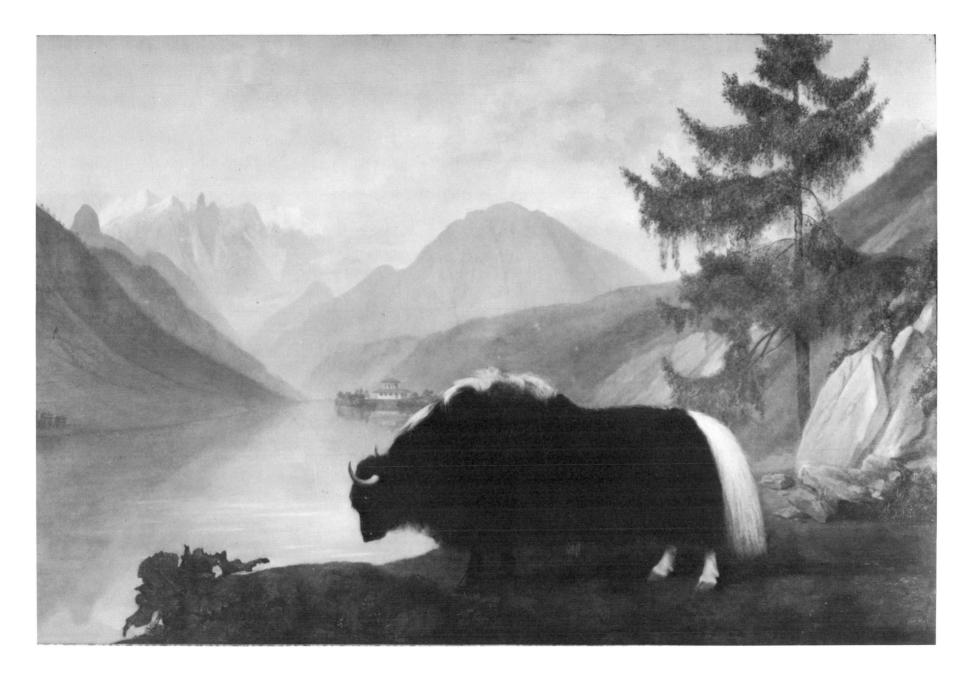

If to some extent the legacy of the Himalayan and Tibetan missions was transformed in Europe into a few fanciful parodies and harmless exoticisms, the effect nearer home was, for a short time at least, solid and far-reaching. The relations between Bengal and Tibet continued to favour an increase of trade. Purangir went to Tibet again in 1785 and came back with a detailed report of the Panchen Lama's official enthronement. He spoke of flourishing commerce at Tashilhunpo and of the exceptionally favourable rates of exchange which the Indian merchants found there for their British goods. Purangir himself settled down in the Buddhist temple at Ghoosery (or Bhot Bhagan) near Howra in Calcutta for the foundation of which the previous Panchen Lama had conducted successful negotiations with Hastings. It is likely that the temple served as a meeting place for monks and traders coming down from Bhutan and Tibet. These relations would doubtless have continued but for the outbreak of the Sino-Nepalese war of 1792 which brought them to a complete halt. While all official and most commercial contact with Tibet now ceased and was not renewed till after the Younghusband Expedition of 1904, relations with Bhutan continued to be maintained at odd intervals though these became more and more contentious as time passed. British imperial attitudes were hardening while on the Bhutanese side civil strife prevented those in authority from checking their subjects' depredations on the Indian border. Where Davis in 1783 had spoken of the Bhutanese as "strangers to extortion, cruelty, and bloodshed", Eden in 1865 talked of "an idle race, indifferent to everything except fighting and killing one another". Indeed the attitudes and observations expressed by the British in the eighteenth century could hardly have been more diametrically opposed to those they later professed in the nineteenth before the outbreak of the Anglo-Bhutan war of 1865. It is in the light of this fundamental contrast that the activities of Davis must be appreciated. It is also of some importance to see his work in the context of his own life and later career and to this we now turn.

★ ★ ★

Samuel Davis was born in 1760 in the West Indies as the younger son of John Davis whose commission as commissary-general in the West Indies was signed by George II in 1759. Samuel's elder brother John was a soldier who seems to have been killed in India in 1770. Their father died in the West Indies and Samuel and his two sisters returned to England with their mother (*née* Phillips) who came "of an ancient family in South Wales". Nothing is known of Samuel's upbringing but it is clear that despite his mother's poverty he was given a decent grounding in classics and mathematics. In 1778 he was nominated a cadet for Madras by Laurence Sullivan (*c.*

1713–86), a director of the East India Company, perhaps a friend of his father. He sailed for India in the "Earl of Oxford", the same ship which brought the artist William Hodges to India, arriving at Madras early in 1780. Several authorities claim he was in the Bengal Engineers but that is unconfirmed.

It is not known how he came to the notice of Hastings who as we have seen appointed him in 1783 to join Turner's mission to Bhutan and Tibet as "Draftsman and Surveyor". It must have been Hastings too who secured him a Writership in the Bengal Civil Service in August 1793 after his solitary return from Bhutan before the main body of the mission arrived back at the end of the year. His first appointment outside Calcutta came in *c.* 1784 when he became Assistant to the Collector of Bhagalpur and Registrar of the Adalat Court there. He was promoted to First Assistant in 1787 and Factor in 1788, remaining in this post till he became the Collector of Burdwan in 1793.

While Davis was at Bhagalpur he had two meetings that were to have a decisive effect on the development and scope of the interests which he was to pursue quite independently of his official career, namely astronomy and art. It was probably in October 1784 that he first met the brilliant lawyer and orientalist Sir William Jones (1746–94) who had arrived in India the year before and had just founded the Asiatic Society of Bengal (of which Davis became a member). Davis must have first met him at Bhagalpur when Jones was bedridden with fever for two months. Jones put this period to good use by having specimens of the local flowers brought to his bedside in order to compare them with the logical classifications of the Linnaean system. In this he was probably assisted by Robert Saunders, the clever botanist who had been to Bhutan with Davis and was now with him at Bhagalpur. From this date until Jones's death ten years later in 1794, Davis and he kept up a very regular correspondence, mainly on questions of Hindu astronomy (*jyotiṣa*). In fact among Jones's surviving correspondence there are more letters addressed to Davis than to any other individual. Assisted and encouraged by Jones and his own pundits Davis was to become the acknowledged expert of the period on Indian astronomy. It has been said by Jones's editor that "only Samuel Davis and Jones were able to collaborate in the humanistic sense of systematic research envisioned by Jones as the purpose of the Asiatic Society". Most of the letters from Jones to Davis are of a technical nature but written in a spirit of intimate friendship which makes them a delight to read. These letters and Davis's published works have been used by my friend David Pingree, author of the monumental *Census of the Exact Sciences in Sanskrit,* in compiling for me a note on Davis's studies in Hindu astronomy, of which the following is an extract:

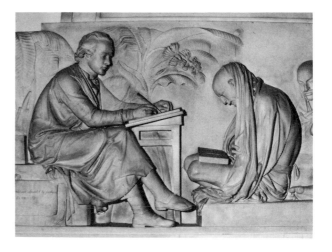

Sir William Jones and one of his pundits. Detail of a sculpture by John Flaxman (1794). By courtesy of the Master and Fellows of University College, Oxford.

Samuel Davis wrote two articles on Indian astronomy while he was at Bhagalpur. The first, dated 15 February 1789, was entitled "On the Astronomical Computations of the Hindus", and was published in *Asiatick Researches,* ii (1790). Its arrival in Calcutta had been greeted by a deservedly enthusiastic letter from Sir William Jones on 28 February 1789. Further letters refer to a copy having been made, to Sir William having read the paper before the Asiatic Society, and to the long process of seeing it through the press. The paper itself is an account of the time-divisions, planetary parameters, trigonometrical functions, the computations of the true longitudes of the planets, precession, and eclipse computations (with as an example the computation of a lunar eclipse for 3 November 1789 at Bhagalpur) according to the modern *Sūryasiddhānta*; the whole is technically superb though the conclusions and interpretations are in need of correction in light of the progress made in our understanding of the history of Indian astronomy during the last two centuries. Davis had one of Sir Robert Chambers's two manuscripts of the *Sūryasiddhānta*, though which one is not evident. Davis also procured from Jonathan Duncan at Benares a manuscript of the *Sūryasiddhānta* accompanied by a ṭīkā [commentary] – probably that of Viśvanātha; and he had access as well to copies of the *Makaranda* of Makaranda, the *Grahalāghava* of Gaṇeśa, and a Grahanamāla.

Between 21 March and 27 December 1791 Davis and Jones kept up a steady correspondence concerning jyotiṣa matters: a passage from Varāhamihira's *Bṛhatsaṃhitā*, the identification of the yogatārās, the Nāradasaṃhitā in 56 folia that Jones sent Davis, and Davis's proposed translation of the *Sūryasiddhānta,* which Jones believed would cap his triumph over Le Gentil and Bailly, the French scholars of Indian astronomy.

On 12 February 1792 Sir William wrote from the Gardens near Calcutta that he had, the previous Thursday, read Davis's latest paper before the Asiatic Society; this must be his "On the Indian Cycle of Sixty Years", dated Bhagalpur 1 December 1791 and published in *Asiatick Researches,* iii (1792). In this paper, which describes some of the way in which Indians determine the years of the Jovian twelve-year cycle and of the sixty-year cycle, is again based on the *Sūryasiddhānta* and its ṭīkā, though supplemented by passages from Varāhamihira's *Bṛhatsaṃhitā* and Bhattotpala's vivṛti [commentary] on that work and from the *Jyotistattva* – probably the work of that name composed by Raghunandana.

The correspondence between Jones and Davis continued till 24 March 1794. From it we learn that Davis wrote a description of an astrolabe that had been procured in Agra, and a treatise on the Indian constellations that Davis had prepared on the basis of a manuscript of doubtful authority provided by Francis Wilford. Neither of these works, nor that referred to by Sir Joseph Banks in a letter dated Soho Square 18 March 1790, seems to have ever been published. But some extracts from a translation of Wilford's manuscript were made available to Edward Strachey (*Bija ganita,* London [1813], p. 9) and were printed by him (*ibid.,* pp. 110–15).

The letter from Sir Joseph Banks referred to above invited Davis to apply for membership of the Royal Society and forwarded to him comments by Henry Cavendish on his first published paper. He was elected a Fellow of the Society on 28 June 1792 and his certificate of candidature was signed by Cavendish, Blagden, Marsden and Rennell, all of whom had developed interests in oriental science.

The other meeting in Bhagalpur to have important consequences for Davis was that with Thomas Daniell (1749–1840) and his nephew William (1769–1837), perhaps the greatest of the English artists who worked in the east. From the Farington Diary it is known that the connection between Davis and the Daniells went back about seventeen years to the period in London from 1763–70 when Thomas was employed as an apprentice at Maxwell's, the coach-painter in Queen Street. It is conceivable that Davis also received elementary training in art at that place. However that may be, during their long tour of India the Daniells arrived at Bhagalpur in October 1788 and returned there again to spend twelve months with Davis in 1790–1. At this time Davis had all his Bhutan drawings with him except those he had presented to Hastings; it is thought the sight of these and his verbal account of the Bhutan trip must have persuaded the Daniells to try to see the Himalayan foothills for themselves. This they eventually did, reaching as far as Srinagar (in Garhwal, not Kashmir) where the scenery and architecture reminded them of Davis's water colours of Bhutan. During their later twelve-month stay with Davis on their return from the journey west, they worked up over a hundred of their drawings into oil paintings for sale in Calcutta. Davis's own art must have benefited greatly from his close association with these masters and, as will be seen, the connection was later to have important results for Davis on his return to London. The Daniells also spent their time with Davis in making local excursions with him and it seems that when they left he accompanied them down the Ganges to Calcutta. They stopped on the way at the ancient city of Gaur where Davis joined them in sketching the magnificent ruins. It was perhaps on this occasion at Gaur that in the words of his son:

> Mr. Davis, while exploring some ruins . . . was attacked and wounded in the leg by a bear who had taken up his abode in a dark recess. As soon as Mr. Davis had recovered from his wounds, he returned to the spot, sought out the bear, and shot him. The wound Mr. Davis received was so severe, as to render him lame for life.

In 1793 Davis was appointed Collector of Burdwan. Several of the letters he wrote to the Board of Revenue are preserved at the India Office Library, illustrating such problems as "How should zemindars be dealt with who take advantage of the new Regulations not to provide supplies for

Detail of a watercolour by Samuel Davis of the Kotwali Gate at Gaur, 1791. It is presumed to be Thomas Daniell who is shown here sketching. Private Collection.

troops on the march through their estates?". While occupied with such problems he married Henrietta Boileau, member of a French noble family which had settled as refugees in England in the early eighteenth century. They were to have four sons and two daughters.

During his next posting as Magistrate of Benares (1795–1800) there occurred the incident for which he was best remembered in the nineteenth century. The deposed nawab of Oudh, Wazir Ali, who was living under British surveillance at Benares, organized a minor insurrection encouraged by the hope that his efforts would link up with those of other anti-British forces on the subcontinent. The plan was ill-conceived and came to failure but not without bloodshed on both sides. Among those killed on 14 January 1799 was the political agent Cherry. Davis however succeeded in defending his family single-handed by the simple expedient of placing them on the roof of his house and guarding the access to it with the aid of a pike. The whole episode which concluded finally with the nawab's capture and life imprisonment (in some comfort) was recorded by Davis's son J. F. (later Sir John) Davis in his *Vizier Ali Khan: or, The Massacre of Benares, a Chapter in British Indian History* (London, 1844; 2nd edn. 1871). The design of the pike is embossed on the outside cover, it turns up again in the coat of arms of his son (created a baronet in 1845) and may well be one of the two pikes still kept in the attic of a house belonging to his descendants today. Mountstuart Elphinstone (1779–1859) who began his career as an Assistant under Davis and later rose to the governorship of Bombay relates how every year on the anniversary of the insurrection he would go to visit Davis's widow at 7 Portland Place that he might do "pooja" to the revered pike.

According to one version of the investigation which followed the insurrection, a learned Brahmin who had assisted Davis in his astronomical interests was found to have been implicated in the plot, and so:

> . . . he was brought up for judgement before Mr. Davis. The Judge, seeing his old friend, could not contain his emotion and the tears fell from his eyes as he heard the proud Brahmin expressed his readiness to die, but entreated he might not be degraded, or anything done to him unworthy of his high caste and station.

Opposite: "Attack on the house of Mr. [Samuel] Davis at Benares", engraving by I. Picken after a drawing by "Major H[enry] S[amuel] Davis, H.M. 52 Regt.", in Sir John Francis Davis, *Vizier Ali Khan: or, The Massacre of Benares, a Chapter in British Indian History* (London, 1844), frontispiece. (Another view of the same house by Samuel Davis is in the Victoria Memorial, Calcutta, R 2157.)

However, this part of the story may well be a fanciful Victorian embellishment as it finds no mention in the account by his son. In fact there is no record of Davis continuing his astronomical studies after the death of his friend and collaborator Sir William Jones in 1794, five years before the insurrection. The notion that he had an observatory built for him in Benares can also be discounted.

The remainder of Davis's career in India is simply a catalogue of promotions. In May 1800 he was appointed First Magistrate of 24-Pargannas, also Superintendent-General of Police and Justice of the Peace at Calcutta. In April 1801 he became the third member of the Board of Revenue and in May 1804 he took office in his last post, that of Accountant-General of India. This he held for just under two years before resigning from the civil service in February 1806. On his return to England he stopped at the island of St. Helena. Six of the watercolours he painted there were later engraved into aquatints by William Daniell for Alexander Beatson's *Tracts Relative to the Island of St. Helena* (London, 1816). By July he and all his family were back in London.

On 12 February 1807 he dined with his old friend William Daniell and met there Joseph Farington (1747–1821), who recorded in his diary:

> He [Davis] continued in India 25 years, and did not arrive in England till July last. He said for 4 or 5 of the last years, he found his constitution labouring under oppression, a sort of dullness, a want of power. He felt the restoring power of the cool air of England even before he landed, and has been ever since sensible of its invigorating quality.
>
> He is about 50 years of age and was born in the West Indies. He is much attached to art and has practised drawing as his most favourite amusement.

The details of Davis's life after his return to London are just as sparse and formal as those relating to his time in India. In October 1810 Henry Dundas, President of the Board of Control of the East India Company, procured Davis's election to the directorship of the company, hoping to count on his vote; but to the disgust of Dundas, Davis always acted independently of him. Davis was re-elected in 1814 and again in 1819, the year of his death. According to Bogle's editor:

> At the time of the renewal of the [company's] Charter in 1814, the Committee of the House of Commons entrusted him [Davis] with the task of drawing up, in their name, the memorable "Fifth Report on the Revenues of Bengal", which remains a monument of his intimate acquaintance with the internal administration of India.

Davis's long friendship with the Daniells continued. In 1813 William published six aquatints after Davis, today the rarest of his engravings. They were entitled *Views in Bootan: From the Drawings of Samuel Davis, Esq.* and published at £4. 4s. There is evidence that the original intention was to extend the work to nine or ten plates by including among others "a map of the road to Tassisudon [Tashichö Dzong]" but no more than six plates ever appeared. An 1830 watermark on at least one copy of the engraved title indicates that Daniell was still making up copies at that date and needed to pull the title-plate to complete a set. Three years after the individual issue of the plates for *Views in Bootan* there appeared Daniell's engravings of Davis's St. Helena drawings, as noted

Opposite: Engraved dedication and title-plate of William Daniell, *Views of Bhutan: From the Drawings of Samuel Davis, Esq.* (London, 1813). By courtesy of Dr. Maurice Shellim.

VIEWS
IN BOOTAN
FROM THE DRAWINGS OF
Mr. DAVIS
RESPECTFULLY INSCRIBED
TO
WARREN HASTINGS ESQ.
LATE GOVERNOR GENERAL
OF INDIA
BY
WILLM. DANIELL
LONDON
JUNE 15.1813.

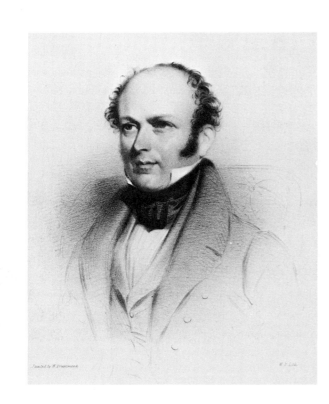

Engraved portrait of Sir John Francis Davis by William Drummond, in his *Portraits of Members of the Athenaeum* (London, 1835). By courtesy of the Trustees of the British Museum.

above. Daniell must have kept in close touch with Davis's widow after his death in 1819 because eleven more Daniell engravings after Davis appeared in Hobart Caunter's *The Oriental Annual*, 7 vols. (London 1834–40); several of these engravings are included here. The public had already become acquainted with the Davis drawings as long ago as 1798 and 1800 through the four engravings by Pococke and the nine by Basire which had appeared respectively in Thomas Pennant's *The View of Hindoostan* and Samuel Turner's *Embassy to the Court of the Teshoo Lama*, not to speak of the foreign editions of the latter. Thus for more than forty years Davis's work was made available to the public at irregular intervals and by the time Daniell produced his last engraving after Davis in 1839, Jones's letters to Davis and parts of Davis's own Bhutan journal had already been published by his son in the *Transactions of the Royal Asiatic Society* (1830 and 1835).

Davis died on 16 June 1819 at Birdhurst Lodge near Croydon, which was probably his country residence. Two of his sons, Sulivan and Lestock, died soon after in India in 1820 and 1821 respectively, after very brief periods of service in the East India Company. Another son Henry Samuel joined the army and finally became a colonel commanding the 52nd Light Infantry; he died in 1851 still a bachelor. The eldest son John Francis (1795–1890), whom we have already come across as the publisher of his father's papers, is well remembered as one of England's earliest sinologists and as the first governor of Hong Kong. His career, like those of his two brothers who died in India, had been founded on the patronage available to his father as one of the East India Company's directors. Of Samuel Davis's seven daughters, six (Henrietta, Anne, Maria, Elizabeth, Alicia and Julia) married between 1821 and 1839, respectively into the Ward, Campbell, Rivett Carnac, Willock, Lockwood and Lyall families. I have not attempted to trace their descendants since it is clear that the principal line of inheritance passed down through the issue of Samuel's first son Sir John Francis Davis, who married twice. His first marriage to Emily Humfrays produced a son Sulivan Francis, who died in Bengal in 1862, and six daughters. Emily died in 1866 and the following year Sir John aged seventy-two took a second wife, Lucy Rocke. In 1871 the ageing baronet produced an heir, Francis Boileau Davis. Unfortunately this late arrival produced no children in his turn (it seems that he had married a Lockwood cousin in 1891) and so the Davis baronetcy died with him. The date of his death is not known. Samuel's Bhutan paintings which had meantime been kept at Sir John's Gloucestershire home at Hollywood House near Bristol (now the property of Bristol Zoo) passed to the ownership of Emily Nowell Beaufort, the eldest surviving daughter from Sir John's first marriage. In 1851 Emily had married the Rev. D. A. Beaufort, eldest son of Rear-Admiral Sir Francis Beaufort. It was their son Sir

Leicester Paul Beaufort (1853–1926), Chief Justice of Northern Rhodesia, who in 1921 presented a large number of Samuel's watercolours and drawings to Lord Curzon. Five of these, all views of Bhutan, went to the Royal Geographical Society in London (in 1974 these were acquired by the India Office Library) and sixty-one were presented to the Victoria Memorial in Calcutta. There they were added to an earlier collection of seven of Davis's Bhutan watercolours which had belonged to Hastings and which had been acquired by the Victoria Memorial in 1916. A further collection of nineteen drawings which probably originated from Beaufort's gift to Curzon were passed on to the Victoria Memorial in 1932 by the Director-General of Archaeology in India. The rest of Davis's original collection was inherited by Beaufort's only child Marion who married Dr. James Spillane in 1904. Their daughter Mona, again an only child, married Brigadier-General Francis Fowle in 1930 and the drawings remained with the Fowle family until 1967 when they became part of the Paul Mellon Collection at the Yale Center for British Art. This constitutes the major part of Davis's surviving work, consisting of 144 watercolours and drawings executed between the years 1777 and 1808 in England, France, India, Bhutan, Madeira, South Africa and St. Helena.

Thus the original works of Samuel Davis are now distributed between three continents. Apart from the public collections mentioned above, a few strays can be found. From among the Bhutan views there is a watercolour at the Victoria and Albert Museum, one wash-drawing in the collection of the late Iolo Williams and one pencil drawing in my own possession. It is to be hoped that a few more will gradually come to light.

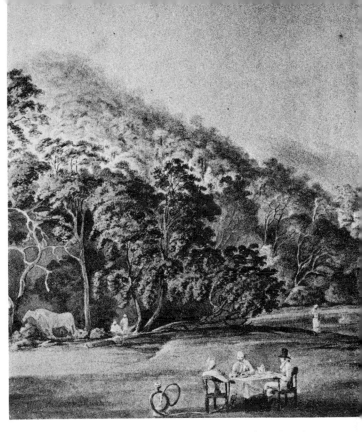

The Daniells picnicking at the hot springs of Sitakund with Samuel Davis. Detail of a wash-drawing by Davis, 1790. By courtesy of the Victoria Memorial, Calcutta (R 1544).

Extracts from the Bhutan Journal of Samuel Davis, 1783

These extracts are based on those read to the Royal Asiatic Society on 20 February 1830 by the author's son J. F. (later Sir John) Davis, and published by him under the title "Remarks on the Religions and Social Institutions of the Bouteas, or Inhabitants of Boutan, from the Unpublished Journal of the Late Samuel Davis, Esq. F.R.S. &c.", *Transactions of the Royal Asiatic Society of Great Britain and Ireland,* ii (1830), pp. 491–517. Two further short extracts were traced in Hobart Caunter, *The Oriental Annual,* 7 vols. (1834–40), iv, pp. 52–4, 105–7, where we learn that these passages were taken from the "manuscript account of Boutan, in the possession of the Asiatic Society". Efforts to locate the original manuscript in the Society's library and in other likely institutions in London have so far not been successful. It is likely that Davis himself referred to the manuscript of his journal in composing the texts accompanying the aquatints based on his drawings by William Daniell, *Views in Bootan.* Although these texts probably incorporate direct quotations from the manuscript they are not given here, but have instead been used for the captions to Plates 4, 5, 22, 23, 31, 36 below. Caunter's two extracts, however, are inserted in this version within square brackets where they seem to belong. Samuel Davis's own notes as reproduced by his son are followed here with the initials [S.D.]. Three notes supplied by his son have been removed because they were judged irrelevant. All remaining notes and subheadings have been added by the present editor.

Hindu "principles and forms" within Lamaism

1. See pp. 56–7 below for the description of such a ceremony; also my "'The Admonition of the Thunderbolt Cannon-Ball' and its Place in the Bhutanese New Year Festival", *Bulletin of the School of Oriental and African Studies*, xxxix (1976), pp. 614, 618, 632.

2. Sākyamuni, Mahāmuni, Shākya Thub-pa: epithets of the historical Buddha.

Many principles and forms of the religion of the Lamas are evidently borrowed from that of the Hindoos. They have similar ceremonies performed on the banks of rivers,[1] and the Ganges is held in equal veneration. A little of its water is a most valuable acquisition to one of their faquires or pilgrims, who carries it in a small brass or silver bottle, carefully corked, and tied to his girdle. Their supreme deity, called indiscriminately by the names Sijamony, Mahamony, and Sejatoba,[2] is said to have been brought many ages ago by one of the superior Lamas from Benares, and others of them must have been of foreign extraction; for although plain drawn and carved as females, the priests will not allow them of that sex; and often, as they think, decide the distinction with a pair of whiskers, when the turn of the features and swell of the bosom shew whiskers to be misapplied.

Certain forms of their devotion and principles of their religion bear almost as much resemblance to particular observances of the Romish church, such as the celibacy of the clergy, and the monastic life of societies of both sexes; to which might be added their strings of beads, their manner of chanting prayers, their incense, and their candles.[3] With regard to the first, it is strange that men should voluntarily impose so severe a duty on themselves as that of celibacy; or, if originally imposed upon them by others, "when old and past the relish of delight," it is equally to be wondered at that so large a proportion of the people as compose the class of Gylongs,[4] have at no time exerted that authority and that superiority of understanding which they certainly possess, in exploding so grievous and unnatural a custom. The inclination which every one of them must secretly feel for such a reform, one would think, might have pointed out the favourable circumstances under which it could be attempted in Boutan, where, from the strength of the country, they are in no danger of feeling the resentment of the church of Thibet, and where their other neighbours would certainly take no concern in the affair. The common people, it is true, would at first be under some astonishment at so great an innovation in the principles of their religion, made by those themselves who are the expounders and guardians of it; but they would soon be pacified when they found it productive of no injurious effects on society, but that, on the contrary, instead of the irregularities and licentiousness which must in the present case be continually practised, they would obtain settlements for their daughters and female relations, and profitable connexions for themselves. They would also be relieved from an unequal share of the concern of prolonging the race, which from time immemorial has been imposed as a drudgery on the lower classes of Zeen Caabs[5] and husbandmen. Or, should they on such an occasion be refractory, the principal stores of arms are in the possession of the gylongs, who assembled, would compose a numerous body, not less able in their strength, and animated by the peculiar nature of their cause to more arduous exertions. The women would undoubtedly incline to favour that party whose object it was to retrieve them from the degraded condition they now unjustly suffer, and to raise them to a rank in society which they merit, and which in some other countries they possess; and from a state of filth and misery to make them partners in such comfort, conveniences, and happiness as the country affords. The greater part of the Gylongs lodged in the castle of Tacissudon [Tashichö Dzong][6] are of an age and constitution which would induce one to think might easily be engaged in such a project, but when asked concerning this unpleasant part of their condition, they reply that it is impossible for any one who wears the red dress (the habit of the order) to find it irksome, or to feel the inconvenience supposed. Their religion in other respects seems less debased by superstitions, and ridiculous rites and ceremonies, and has the excellent quality of being tolerant in its sentiments of other principles and forms of worship. A faquire of any cast or nation who enters the country is treated with respect,[7] and they admit of proselytes, but are not anxious for their conversion, thinking with the Hindoos that the various roads to heaven, pointed out by other modes of faith, are equally practicable with their own; that is, by a due conformity to the manner of exterior worship

Lamaism and Catholicism: some resemblances

Monastic celibacy: "grievous and unnatural"

3. This is a very frequent comment on the part of Western observers of Tibetan Buddhism, first expressed in Bhutan by the Portuguese Jesuit Cacella in 1627; see my *Bhutan: The Early History of a Himalayan Kingdom*, pt. 5, text 4, fo. 11.

4. A 'gelong' is a fully ordained Buddhist monk.

Arguments for the abolition of celibacy

5. *gZim-'gag-pa* (pron. 'zingap'), literally "one who blocks [the door to the master's] chamber", a retainer, bodyguard.

6. The summer capital located in the Thinphu valley, now the permanent seat of government. See Plates 21–4.

7. Cf. the following statement from the Legal Code of 1729: "When it becomes necessary to receive petitions from or have personal meetings with people who [pursue] philosophical systems different [from our own], including those from India, Nepal and Tibet, careful enquiries should be addressed to such persons, in accordance with [the outcome of which] help should be rendered them": Aris, *Bhutan: The Early History of a Himalayan Kingdom*, pt. 5, text 3, fol. 108a.

Religious tolerance

Cosmological beliefs

8. For the wall paintings in Punakha Dzong illustrating these traditional cosmologies, see Blanche Olschak, *Mystic Art of Ancient Tibet* (London, 1973), p. 109 plates. The ones seen by Davis were probably those at Wangdütsé (Plates 34–5): Turner, *Embassy*, p. 158.

Buddhist temples and images

9. See note 2 above.

Monastic ritual

prescribed, and a strict discharge of the moral duties. The Rajah, pointing to the images and pictures of the deities that adorned his room, asked if we used such things, and being answered in the negative, said it did not signify, since it was the same Being we all adored.

Their system of the universe consists of, first, the celestial regions, described as situated on the summit of a square rock of immense magnitude and height, its sides severally composed of crystal, ruby, sapphire, and emerald.[8] Here dwells the Supreme Being, in a habitation to which good men after death have admission, and find clothes, provisions, and every thing they want and wish prepared for their reception. About half way down is the region of the sun and moon, placed on opposite sides of the rock, and constantly revolving round it for the purpose of giving day and night to the lower world. The vicissitudes of the seasons are also accounted for by the irregularity of the superior luminary's monthly revolutions. Beneath is the ocean, surrounding the whole, with seven stripes of dry land encompassing the foot of the rock, and some islands, the residence of mankind. The Rajah pointed out that island which comprehends Boutan, Bengal, &c., as situated in the south or sapphire side. The infernal regions are under the earth, where the wicked are to be tormented in everlasting fire; melted brimstone will be poured down their throats, and their cries neither pitied nor regarded.

The priests have no separate buildings erected purposely for the exercise of religious ceremonies, in the manner of our churches, the pagodas of the Hindoos and Chinese, or the mosques of the Mahometans. Their devotions are always performed before altars erected in large apartments appropriated to this use in the palaces or castles where the Gylongs are lodged – these residences themselves being, in fact, the temples. The supreme deity is here represented by a colossal figure, Syatoba,[9] gilt, and sitting cross-legged. His principal agent (or, as they express it) his vizier, of a much smaller size, is placed before him, and surrounded by images of the former Lamas, in rows one above the other, of a diminutive size. The destroying power appears a little lower in front, his countenance enraged, and his numerous arms uplifted, menacing with a variety of weapons. Before the altar is a bench with a row of small brass cups, filled with water, and some with rice: also a lamp burning, pots with flowers, and many trifling ornaments. Mirrors and glass-ware of any kind are thought a great embellishment. This apartment or chapel, of which there are more than one in every castle, often comprehends two stories of the building, a part of the upper one railed round as a gallery, whence spectators may view the ceremonies below. Here the priests assemble at their meals, receiving their portion of victuals as they sit cross-legged in rows, muttering over an abundance of graces and prayers, with the horns, drums, and bells sounding at intervals. Into these places any person may enter: all they require is, that the altar and its furniture be not approached too near, nor touched. Every individual of the priesthood, who has a house of his own in the religious villages, or an apartment to himself in either of the palaces, erects a small altar for his own particular use, decorated in much the same manner, though less splendidly than the others. Their forms

of devotion, as far as I have been a witness of them, chiefly consist of repeating long prayers in a sitting posture, occasionally bending before the altar, and touching the floor with the forehead; the horns, bells and drums being sounded at intervals. The chapel at these times is filled with Gylongs sitting in ranks, one half of the number fronting the other half and leaving a lane from the altar up the middle of the chapel. The Gylongs alone join in these practical forms of worship, nor are the rest of the people under any obligation to enter the chapels: an opening is however sometimes left, through which they can view the image and prostrate themselves before it. To maintain a proper sense of religion many small temples are built by the road-side: they are generally of a square form, and have either pictures of the deity within-side, to be viewed through gratings, or are of solid masonry, with the same figures cut on slate in relief, and fixed all round in a row near the top.[10] *At these places are also erected high poles with a narrow stripe of cloth fastened to each like a flag, on which is written and repeated from top to bottom the word* omanipeemehong.[11] *The same word, cut in relief on stone, is fixed in a row against a sort of wall, frequently found in the neighbourhood of the little temples. These fabrics are white-washed, and have a broad stripe of red round the upper part. The buildings with their flags are picturesque, and ornamental to the country. There is, besides, in use at these buildings a religious instrument with which all classes may amuse themselves, a sort of whirligig, or barrel set upright to turn on a spindle. The inside is filled with a roll of paper, printed all over with the above word. It is fixed in a recess against either of the previously mentioned buildings, with a hole to admit the hand, and every devout passenger, as he goes by, may give it a twirl. This might be thought of trivial regard, but with the natives it is held in so much consideration, that at the entrance of some of the castles are such things fixed in frames finely ornamented and gilt. At Wandepore* [Wangdü Phodrang][12] *was one with a crank to the spindle, and a man, every morning, sate keeping it constantly turning whilst he repeated the word* omanipeemehong. *Sometimes three of these barrels, of a larger size, are seen inclosed in a little building erected purposely for their reception, and kept continually in motion by the spindles passed through the floor and fixed each of them to a water-wheel below. The meaning of the word is said to implore a blessing, and they mutter it over as the Catholics do their 'Ave Marias,' dropping a bead at each repetition! The common people make themselves a little domestic altar near the house, consisting of a pile of stones about three feet high, before which they lay leaves, fruits, or blades of corn, in the manner of the ryots*[13] *in Bengal.*

As the priests are incapable by their own means of keeping up the number of their establishment, they receive from time to time boys taken from the most respectable families in the country, and from others who have interest to procure their children to be admitted of the order. It seems necessary they should be admitted at such an age, that by early habit they may be taught to endure the dull tasteless life they have to undergo. In the castle of Tacissudon are a number of these people, some of them employed as tailors, embroiderers, and painters, in preparing the sacerdotal habits, and the variety of religious furniture. Some few attend on the

Wayside shrines

10. See Plates 16, 28, 31.

11. Oṃ maṇi padme hūm: the famous mantra dedicated to the Bodhisattva Avalokitésvara.

Prayer-wheels

12. See Plates 48, 50.

13. "It is by natives used for 'a subject' in India, but its specific Anglo-Indian application is to 'a tenant of the soil'; an individual occupying land as a farmer or cultivator": *Hobson-Jobson*, p. 587.

Monastic recruitment and activities

Nocturnal discipline of the monks

14. For Turner's account of this practice, see his *Embassy*, pp. 84–6, and plate 5, "The valley near Tassisudon, with a procession of the religious to their ablutions".

Power and influence of the monks

Provincial monasteries and hermitages

person of the Rajah, acting as secretaries, and in such like confidential capacities, but the far greater part of them pass their time-with perfect insipidity. Between the intervals of devotion they are generally seen lolling over the balconies of their apartments, not being allowed to stir out of the castle except on every eighth day, when they walk out one by one in a line according to seniority, the youngest bringing up the rear, and proceed in regular order to an island in the river to bathe.[14] Their tedious moments are not much relieved by sleep, if they pass the night fixed in the posture which the Rajah informed us it was necessary for every Gylong to use. It is sitting cross-legged, with the feet brought to rest in the upper part of the opposite thigh. The body is stetched stiffly upwards, that the arms, without being at all bent, may be close to the sides, and the hands with the palms upwards rest also upon the thighs. The eyes are pointed towards the nostrils, to keep watch lest the breath should find an occasion to escape wholly from the body. They are allowed to place the back against the wall, but the body and limbs are in so distorted a position, that without much practice it is impossible even to stretch them to it. A watch goes regularly round with a light and a scourge to see that they are all in their places, and to discipline such as are not of the proper posture. When any one proves of a licentious disposition, he is expelled the class, and should he be convicted of a commerce with women, they say the punishment is death.

This sort of society, although apparently joyless and insipid, may admit of intrigue, and allow room for men of superior parts and address to aspire to places of trust and importance in public concerns, since the government of the whole country, as well as particular districts, is completely in the hands of the priests. They are, in fact, the noblesse of the country, exercising under the sanction of religion a pre-eminence over the common people, on whose labours they entirely subsist, and to whose services on all emergencies they lay claim. I could obtain no estimate of the number of persons composing this order in Boutan, but from the following observations it will appear how large a portion they must form of the entire inhabitants; for, besides those lodged in Tacissudon and other castles, there is scarcely a patch of land to be seen, admitting of considerable cultivation, where there is not a village on some adjacent height, inhabited by these people, who draw their support from the industry of the peasants beneath. These villages being always well built, and the houses lofty and whitewashed, are often beautiful objects as viewed from the road in travelling through the country. Each of these fraternities has its chapel, altar, and Lama-groo [-guru], or chief priest, who presides, and sees that the duties of the profession are regularly and properly discharged. There are besides a few who, in the character of faquires, pass their austere and solitary lives in lonely places high up among the rocks and jungle; and in some parts of Boutan are said to be religious societies of female devotees or nuns, who, like the priests, have their superior and other officers, but all of their own sex. Provisions and necessaries are regularly supplied to them, but no man dares be found after day-light in the precincts of the place, on pain of severe punishment.

Their belief in the Metempsychosis does not seem in Boutan very strictly adhered to, any further than as it respects the regeneration of the three principal Lamas, Lam-Sebdo, Lam-Geysey, and the Rajah Lam-Rimbochy, than which no religious truth (they say) can possibly be more certain.[15] *On some enquiry I made concerning their notions of heaven, I remember the Rajah said he had been there, but his manner of expression seemed to indicate a desire to put an end to that topic of discourse, under an apprehension, perhaps, that he might be asked to give an account of his adventures on the expedition. It is true we had it signified on our arrival that the Rajah would be displeased if we went shooting, but meat and fowls were constantly supplied to our table, and we often saw animals killed for the use of the Gylongs themselves. The spirit of the late superior Lama of Boutan made its appearance at Lassa [Lhasa], and the identity of the person on such occasions, we were informed, is thus determined. On the first discovery of the child, the servants and effects of the deceased Lama are sent for, and laid before him, when if he recognises the former, and challenges the latter as his own, no doubt remains, and he is universally acknowledged and received as the true and individual Lama, whose body they had perhaps a few years before consumed to ashes. His return from Heaven is not confined to any determinate period, but usually happens within the course of ten or eleven years, or rather, perhaps, as it may suit the convenience of those he left behind on earth. It is easy to conceive that the institution of this principle of faith had its rise in political as well as religious motives, to maintain under a proper subjection to the court of the Delai [Dalai] Lama the different countries where their faith is professed; for it must be remembered that the Lama-groo [-guru] is declared supreme in temporal as well as spiritual matters, although the influence of his former capacity seems considerably on the decline at Teshulombo, from the authority assumed by the Chinese, as well as at Tacissudon, from the disposition to independence manifested by the present Rajah. The name of the young Lama*[16] *from Lassa is certainly in the mouth of every one, even of the children of Boutan, and he is without exception acknowledged to possess an inherent right to the absolute dominion of the whole country, and that the Deib [Deb] Rajah is no more than his prime minister, vizier, or dewan;*[17] *and this claim was no doubt sufficiently enforced when Boutan was more dependent on Thibet, and obliged to receive both chief priest and governor in the person of the young Lama; but at present, I am persuaded to think the Rajah would not be inclined to admit the temporal control, or to share any part of the real authority with another, nor is it likely that the young Lama will at any time hereafter find himself in a condition to assert such a claim. He is occasionally present at ceremonials, but at other times seldom conversed with or seen; and as he grows up to manhood, there is little doubt that the policy of the government will provide that he be still secluded from any interference in public concerns, and wholly confined to the contemplation of his spiritual dignity. He does not even reside at Tacissudon, but is kept at a small castle in an unfrequented place, about a day's journey from thence, among the mountains.*[18]

Reincarnation

15. "Lam-Sebdo" (*Lama Shabdrung*) was the incarnation of the 'physical principle' of the founder of Bhutan, Ngawang Namgyel (1594–?1651). "Lam-Geysey" can probably be identified with the incarnation of his 'verbal principle' (see Plate 33, caption). "Rajah Lam-Rimbochy" was the incarnation of the great priest and statesman Tendzin Rabgye, who ruled as the 4th Deb Raja from 1680 to 1695 (see Appendix).

Recognition of a new embodiment

The Dharma Raja and the Deb Raja: their theoretical relations, and the actual situation in 1783

16. *Shabdrung* Chökyi Gyetsen (1762–88).

17. A dewan is "the prime minister of a native state": *Hobson-Jobson*, p. 239.

18. About eight miles above Tacissudon [Tashichö Dzong], where it is said he is to remain three years longer [S.D.]. (This must be the monastery of Cheri.)

The lay "servants of government"

The second order of the inhabitants of Boutan, called Zeen-Caabs, are, like the priests, received when young from families in the country, and bred up in the public castles or palaces. Their department lies in the performance of more active duties, and they are very properly styled "servants of government." They attend at the public buildings to see that provisions, firewood, and other necessaries are supplied regularly by the country people, and, in short, superintend every public service of labour, which they themselves, however, are exempted from. Two of these, attended by some of the superior class, were on the deputation from the Deib Rajah to the government of Bengal. Another was sent to escort us from Buxaduar to Tacissudon, and to see that we were properly accommodated upon the road; and one was stationed in waiting at our dwellings when we arrived, to be always at hand when any thing was wanted. In war, this class arm themselves and take the field, and are esteemed those on whom the Rajah can most depend for attachment, activity, and courage. They seldom arrive at any office or government of importance, such appointments being always occupied by the priests. They marry and possess farms, and are appointed to preside in some of the inferior districts; but are expected to be ready when called upon for duty, either at the palace or in the field. None of them, however, while residing in the public building where the Gylongs are lodged, can possibly have the society of his family; no females being admitted, except in the day time as coolies with loads, to stay no longer than is necessary for the dispatch of the business they are employed on. The gates of these buildings are regularly closed every evening about dusk.

The peasantry

The third class, or cultivators, seem to enjoy a more uninterrupted and rational mode of life than either of the former two. They have the comforts of domestic society, and are less liable to be summoned to attend on the pleasure of their superior. In war they must accompany their chief, or any one he may depute, wherever they are ordered, but at other times their condition seems very easy, the principal labour of tillage being performed by a race that can scarcely be called Bouteas;[19] they are evidently a breed mixed with the baser Bengalees, who inhabit towards the foot of the hills, and are distinguishable from the legitimate Bouteas by the difference of complexion and features, and the immoderate filthiness of their bodies and dress. These, with the women of all denominations, whose condition is equally menial and laborious, are the general drudges, and are seldom seen without either a load at their backs, or working in the fields. There being neither wheel-carriages nor cattle trained to transport loads in Boutan, the whole business of carriage is performed on the backs of the human species. I believe the women are in no part of the world treated worse than in Boutan: they seem just tolerated for the indispensable purpose of propagation, and for the labour they can be brought to undergo. In the latter every degree of age and condition is kept constantly engaged, from the child who has just acquired strength to support itself, to the matron who totters with age. The former are seen trudging with their little loaded baskets, and the latter seldom get rid of theirs till death releases them from the burthen. The superior class of the natives are bound by the most solemn injunctions of religion to hold no intercourse with

19. This is a reference to the former slave class in Bhutan, descendants of Indians captured by the Bhutanese in the plains, all of whom received their manumission in the 1950s.

the women, but on the contrary to shun them as objects of mortification and abhorrence; and those from whom they might expect a more tender regard, seem to possess but very imperfectly those sentiments in which consists the enjoyment of conjugal society, and to consider the women as meant by nature to relieve them from the most toilsome offices of life, and to take the largest share of their daily labours. The condition of the women in Thibet is said to be even more humiliating: they are there in so little estimation that the privilege of exclusive possession, which in most other parts of the world is a privilege so tenaciously desired in marriage, is a matter of such indifference, that "the same wife generally serves a whole family of males, without being the cause of any uncommon jealousy or disunion among them." This unworthy treatment of the women in both countries has the effect of rendering them so indifferent to the improvement of their personal charms, that they seldom wash either their clothes or skin. They bear, in short, no comparison in external appearance with the men, who are without exception the best formed, and, allowing for the complexion, the handsomest race I ever saw. Unlike most other countries, Boutan exhibits no difference of rank or circumstance among the women, they being here all alike, the same dirty, labouring objects, and all of them equally in a state of the most abject filthiness and slavery.[20]

The men on the contrary, at least those of the better sort, are much more polished in their manners, and intelligent in their conversation, than might be expected from their little intercourse with other nations. They seem to have strength of intellect, and a freedom of using it, that might make a rapid progress in useful knowledge, were it introduced among them. But of scientific information they are certainly very destitute, although possessed of voluminous treatises in print, which are carefully laid up in some of the chapels as in a library. These books chiefly relate to affairs of religion; they are also said to contain a history of the country, and a code of laws,[21] and the Rajah presented one to Mr. Saunders, which he said comprehends the whole science of medicine: they are printed in a large character on long slips of paper, and the leaves, which are parted when read, are at other times bound up between two flat pieces of board, cut to their size, and ornamented according to the value of that they contain. In surgery they may, perhaps, have some little skill, and the Rajah himself seems perfectly versed in the Boutan practice of physic. Mr. Saunders said he was surprised to see a difficult case of a fractured skull treated by one of their practitioners with great propriety.[22] The same operator gave a very satisfactory account of the use he made of mercury in veneral disorders. In architecture, I think, they make the best figure: there is a boldness in the design of many of their castles when they are not considered in the character of military buildings; and, with a little more attention to uniformity in the disposal of windows and doors, and such as, perhaps, they think unessential points, these might without partiality be thought perfect in their kind. The projection of the roof is extremely well proportioned to the extraordinary thickness and slope of the walls, and the large projecting balconies are much better adapted than windows to fabrics of so great an area and height. The apartments are lofty and of a good size, and the

20. The Rajah's sister was at Tacissudon. She was lodged in a part of the building appropriated to us [see Plate 23], and she differed in no respect or appearance from the other women of the country [S.D.].

Male qualities

21. The history referred to must have been the *Lho'i chos-'byung*, composed by Tendzin Chögyel in 1731–59. It contains a legal code which I have translated in my *Bhutan: The Early History of a Himalayan Kingdom*, pt. 5, text 3 (microfiche supplement).

Medicine

22. For Robert Saunders's own enthusiastic account of traditional Bhutanese medicine, which however contains no mention of a trepanation such as this, see his "Some Account of the Vegetable and Mineral Productions of Bootan and Tibet", *Philosophical Transactions of the Royal Society*, lxxix; reprinted in Turner, *Embassy*, pt. 4, pp. 385–416; see esp. pp. 407–16. See also p. 23 above.

Architecture

method of getting into them by ladders, instead of stairs, seems to me the only peculiarity that admits of improvement: but the inconvenience is less felt here, where men only are to mount them, and they take up less room where level ground is so scarce and valuable. [*Their timbers and planks are hewn, the use of the saw being altogether unknown. The beams are put together with mortises and tenons, and the boards by a piece let in across and dovetailed. Not a nail or bit of iron is to be seen in their buildings, nor even a wooden pin; yet their work is not deficient in firmness or stability.*]

Description of Tashichö Dzong

[*The palace of Tacissudjon really surprised me by the regularity and grandeur of its appearance, though I had previously conceived a favourable idea of it from similar buildings on the way. It is an oblong, two hundred yards in front and a hundred in depth, divided within two squares by a separate building raised in the centre, more lofty and more ornamented than the rest. In the latter the Rajah and some of his principal people reside; and upon the top appears a square gilded turret, said to be the habitation of one of the lamas. One of the squares comprehends the chapel and apartments of the priests, and the other is allotted to the officers and servants of the government. There are three stories of apartments, which communicate by handsome verandas continued round the inside of the whole building, and from the middle story communicating by a passage to the Rajah's apartments in the centre. From the windows of the upper chambers balconies project of a size to hold fifteen or twenty persons; but there are no windows below, as they would not contribute to the strength of the place. The walls are of stone and clay, built thick, and with a greater slope inwards than is given to European buildings. The roof has little slope, and is covered with shingles, kept down by large stones placed upon them in the manner the Portuguese fasten the tiles of their houses in Madeira: – it projects considerably beyond the walls. The apartments are spacious, and as well proportioned as any in Europe. The only singularity that strikes at first sight is the ladders instead of stairs; but the steps are broad, and after a little use are not found inconvenient. The Bouteas, however, are not ignorant of a more eligible method of ascent; for at one of the two gateways of the palace is a large and well-formed flight of stone steps. The pillars supporting the verandas are of wood, uniform and painted; but their shape is not such as would please an eye accustomed to better architecture: they swell too much towards the bottom, and have a capital like two long brackets joined together. The ornaments painted upon the pillars and walls are chiefly flowers and dragons in the Chinese taste; and, as in China, bells are seen hanging from the corners of the roof. It will here occur to the reader that the Bouteas are of the race of Tartars who conquered and still govern China.*]

[*The timber used in the palace and in the ordinary houses is chiefly fir. Though the beams and smaller parts are joined by mortise and dovetail only, without pins either of iron or wood, there appears no deficiency of strength and security in the work. Most of the floors in the palace are boarded; and from the great breadth of some of the planks, we judged the trees to have been of much larger size than any we had met with. They have also floors composed of pebbles, well cemented together. The walls are whitewashed, with a stripe of red*

Opposite: "Palace of Tassisudon [Tashichö Dzong], Bootan", engraving by J. B. Allen after William Daniell based on Samuel Davis, in Hobart Caunter, *The Oriental Annual*, 7 vols. (London, 1834–40), v, plate 12.

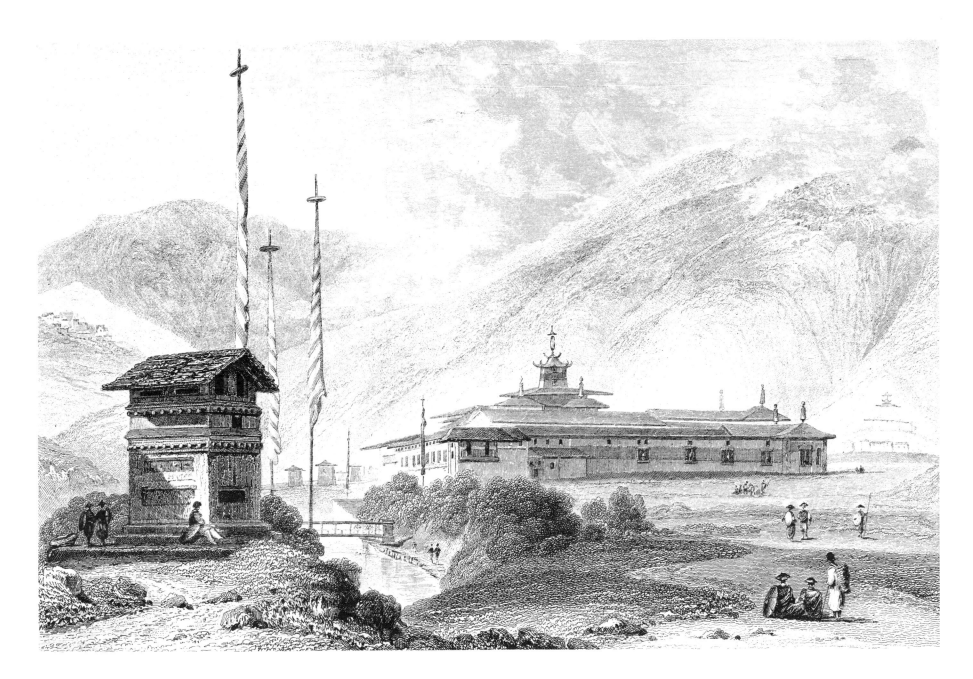

23. The above three paragraphs are quotations from the original manuscript of the Davis journal as found in Hobart Caunter, *The Oriental Annual*, 7 vols. (1834–40), iv, pp. 54, 105–7.

Description of Punakha Dzong

Opposite: "Castle of Ponaka [Punakha] in Boutan", engraving by J. C. Armytage after William Daniell based on Samuel Davis, in Hobart Caunter, *The Oriental Annual*, 7 vols. (London, 1834–40), v, plate 22.

24. *Ibid.*, pp. 52–3.

The arts and "useful knowledge": open opportunities

25. Previous to admission into the order, it is required of the candidate to pass a twelvemonth in preparation, the principal part of which is said to be counting his beads to the repetition of the sentence *omanipeemehon* [S.D.]. (See note 11 above.)

26. A killadar is "the commandant of a fort, castle, or garrison": *Hobson-Jobson*, p. 368.

all round, a little below the roof. Upon the top of every chapel, or other place where there is an altar and service performed, a small cylinder is placed, five or six feet long, usually covered with white cloth, with a broad ring of red, bordered by two of blue round the middle of it. Those upon the palace, and other houses belonging to the Rajah, are gilt, and become a showy ornament.][23]

[Panaka [Punakha] is one of the most ancient and most considerable of the Rajah's castles. The general form of all these buildings is alike; consisting of two courts or divisions, – the first surrounded with two or three stories of verandaed apartments, for the servants or government and fighting men; the other appropriated to the use of the priests, for their habitations, chapels, altars, &c.; – and in the centre always rises a more lofty fabric for the Rajah's particular use, crowned with a gilt turret, said to be his sleeping-room. This is also intended for the same purpose as the keep to old English castles, and might hold out for a time after the rest of the fortress should be lost. The walls are of great height, and the whole pile has a noble and majestic appearance. The outer court is filled with earth, and raised twenty or thirty feet above the level of the ground without. The rooms beneath this may serve as storehouses, as they have loopholes but no windows. It would be impossible to take such a place by assault, and not easy to break the walls by any artillery that could be conveyed through this country. The best way of forcing admission might be by breaking open the gate with a petard. To effect this would be an enterprise neither difficult nor dangerous; the entrance to this, as to all other castles in Boutan, being through a single gate, which is not flanked or defended by any part of the building. This place is esteemed by the natives a masterpiece of magnificence and strength. It has really some pretensions to the former, nor would it be easily reduced by arrows and matchlocks.][24]

The Boutea music consists of long flat notes swelled and sunk with the solemnity of psalm tunes, and they have the faculty of filling their wind instruments, at least to all appearance, with an uninterrupted current of breath. In painting and sculpture they are as far from excelling as the Chinese whom they imitate: of their proficiency in geometry and astronomy I had no means of inquiry. In these, however, as well as every other branch of useful knowledge, it is probable they only want teachers to equal, if not to surpass, their Indian neighbours, over whom they possess an advantage in an exemption from the restraint of caste, that insuperable bar to social improvements and national dignity. A man of merit would be at liberty to pursue the bent of his genius, whatever the employment or profession it might point to; even the priesthood is not confined to any particular rank or age, and men advanced in life sometimes assume the function.[25] On the approach of an invader, the defence of their little nation would not be entrusted to a small proportion of the inhabitants, who, born in the military tribe, might not be the better adapted by nature to the profession of arms; but the whole would rise together, and the priests turn out for its defence, should the exigency of the case require their assistance. The operations before Wandepore were conducted by a gylong. The Rajah's Dewan, and the Kelidar[26] of Tacissudon, who is also of that order, bear about them the marks of wounds received in former wars.

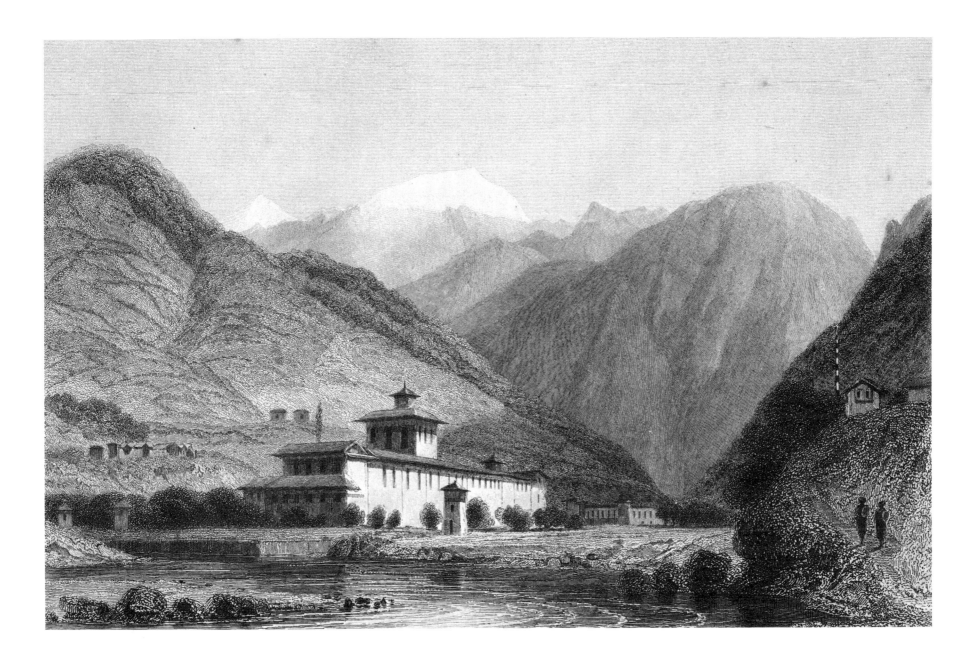

51

Character and qualities of the people and their government

I have already remarked the superiority of size and justness of form of the Bouteas: they have also a free openness of carriage and an apparent sincerity of behaviour, that might be thought incompatible with the despotism of the government. But the government, although in appearance as absolute as one can be, is not administered with that rigour and injustice which produces an abject servility and meanness in the manner of the people governed; and whether the disposition of mankind is naturally prone to evil, or left on an equipoise between right and wrong, it has as good a chance of turning to the practice of the social duties in Boutan, as in

Social equality

any country in the world: for the natives in their respective classes are so nearly on a level, and have so few means of raising themselves above it, that the passions of envy, hatred, and malice, if not dormant, must be less frequently excited there than in the bustle and contention among the inhabitants of more flourishing and affluent nations. Here are neither arts, manufactures, nor commerce, by which individuals have the means of acquiring riches; and the distinction of attendants, dress, and finery, to awaken the jealousy of their neighbours, are unknown.

Appointment of the Deb Raja; his great power

On the death of the Rajah, an assembly is convened of the priests, or, perhaps, the most eminent of them. In what manner their deliberations are conducted, and their opinions and suffrages taken, I have not discovered; but their choice of succession once determined, the person on whom it falls is presented in the name of the assembly with a white handkerchief, and is immediately recognized in possession of the exalted dignity. – No monarch on earth is more absolute, or has fewer actual restraints on his will than the present Rajah, owing partly to the infancy of the superior Lamas.[27] There is no one with whom he is bound to consult, or who can influence his conduct, except the kelidar, dewan, and others who were perhaps instrumental in his elevation, and in whom he may choose to place confidence. In judicial matters[28] he is the last appeal, and his opinion or pleasure ratifies or reverses the decision of inferior tribunals. But yet from the natural free spirit of the people, unbroken by tyranny, and from the respect that is due to the good opinion and venerable characters of the principal gylongs, it would be impossible for him, were he so disposed to persevere in any flagrant acts of injustice or dangerous schemes of ambition. – The fate of Deib Jedur may be urged in proof of this, and the supression of the late rebellion shews of what value is popularity among the common people.[29]

27. Lam Shabda [*Shabdrung*], said to be twelve years of age, and Lam Geysey, seven years [S.D.]. (See notes 15, 16 above. In fact according to the Bhutanese records the former would have been twenty-one in 1783, and the latter two years old.)

28. The zempin ['dzongpön'], or governor, is the judge in all criminal matters within his district. The accused and the witnesses are confronted and summoned before him, and when the charge has been established, he passes sentence according to a written code of laws. The sentence is referred to the Rajah for confirmation. Certain crimes are punished with the loss of sight:— theft with the loss of hand:— decapitation is also used; and, in some cases, the criminal is bound hand and food, and thus thrown into a river [S.D.].

29. On Zhidar, the 16th Deb Raja of Bhutan (r. 1768–73), see especially Bogle, *Narratives*, ed. Markham, index ('Deb Judhur'). For an account of the rebellion in support of Zhidar which Davis witnessed, see Turner, *Embassy*, ch. 6.

Government administration, taxes and trade

The administration of government must be contained in a narrow compass, as it has so little intercourse with other countries; and, with so circumscribed a commerce, and scanty circulation of coin, there can be but few money transactions, or duties to collect.[30] The rents of the land are chiefly received in kind, and appropriated to the subsistence of the numerous priests, faquires, and servants of government. The overplus of rice is exported to Thibet, from whence returns are brought in wool, tea, and a few other Chinese commodities; and in the musk, furs, and gold-dust which are carried annually to Rungpore.[31] The Rajah himself is the proprietor of the horses, and the produce of them furnishes no inconsiderable resource for the public exigencies: they are bred in most parts of the country, carefully reared and kept in the Rajah's stables, one of which

30. For a very useful account of Bhutanese currency, see Nicholas Rhodes, "The Coinage of Bhutan", Oriental Numismatic Society, *Information Sheet*, xvi (1977), pp. 1–14.

31. Rangpur is situated on the river Tista south of Cooch Behar. As a terminus for Indo-Tibetan trade it

adjoins to each castle, and from thence they are sent for sale to Bengal, Assam, and Nepal. The imports of tobacco, beetle[betel]-nut, dried fish, &c. from Bengal, and the coarse cloths from Assam, are carefully lodged in the castles, as in a public store, and dealt out for the subsistence and use of gylongs, zeen-caabs, and others dependent on the government. The most extensive and unremitting business seems to be that of regulating and superintending the affairs of religion. This, however, may be more in the province of the present Rajah, as in that station he also unites the dignity and office of a superior Lama, and because the other two Lamas, his exalted colleagues, are both children.

In the month of September is held a grand religious ceremonial, which lasts for twenty days. Most of this time is spent by the gylongs in prayers, confined to the chapel. On the seven last days an exhibition of dancing in masquerade is made in one of the squares of the palace; upon this occasion most of the zempins, or governors of districts, are summoned to Tacissudon, both to be present at the show, and to give an account of their administration. The gylongs and zeen-caabs also receive new clothes, which seem to come very seasonably at a time when the winter is approaching.

Were there any traffic or change of commodities among the natives worth mentioning, it would appear at this annual resort to Tacissudon, in the likeness of a market or fair; but there are seen only about a dozen loads of trifling things exposed to sale in a corner of the palace. If there were more, very few could be found with money to make purchases; neither are there many who have occasion to buy. The gylongs and zeen-caabs receive their food and raiment from the public stores; even their swords or daggers, which the latter wear as finery in their girdles, are in general only lent to them from the palace; and the wants of the common people, besides their daily sustenance, are small indeed. Their dress, composed of a scanty allowance of course strong cloth, with a red blanket, when once put on serves them without alteration until it drops to pieces, and they are careful not to hasten its dissolution by clearing it from the black and greasy coat of dirt which it soon acquires. Their extreme poverty precludes them from an acquaintance with those eastern luxuries, beetle and tobacco, which, having never enjoyed, they cannot feel the want of.

The Rajah, according to the probable origin of every chief magistrate, is here still seen merely in the character of trustee to superintend the management of the produce of the country, and to take care that it be justly applied to the subsistence and comfort of the inhabitants; and having so much less than others of the like station to draw aside his attention, it is probable that he acquits himself tolerably of the duty. At home he appears without any parade or throng of attendants, and would be taken rather for the master of a great family than for an independent prince. The prostration is the sole abject mark of subjection that the natives exhibit, and this is only used upon an introduction to the Rajah's presence after considerable absence; at all other times the zeen-caabs, and others of the palace, have access and converse with him without any ceremony, and it is the custom in Boutan for the meanest person, either when introduced, or on taking leave, to be presented with

probably predates the Anglo–Bhutan War of 1773–4. See "A List of the Usual Articles of Commerce between Tibet and the Surrounding Countries", in Turner, *Embassy*, pp. 381–4.

Festival of the Thinphu Dromchö

Minimal trade, few material possessions

The ruler's "character of trustee", his lack of ceremony, the ease of access to him, and his joys of office

32. The Rajah's principal attendants were, the kelidar, the dewan, and zempin, and a young man his nephew. They were all gylongs, and by their dress not distinguishable from the other priests. They had their respective apartments in the castle, consisting of a closet, with an altar for devotion, and an antichamber. In the latter, which is always hung round with matchlock pieces, and bows and arrows, are commonly seen a few persons in waiting, who attend on their chief when he goes out, which is seldom, unless to the adjacent river to bathe [S.D.]. (For Turner's account of the mission's reception by the main officers of the court, each in their own apartment, see his *Embassy*, pp. 76–7.)

33. Zembl(i)an: "Belonging to Nova Zembla, a group of islands in the Arctic Ocean north of Archangel in Russia; hence, arctic". (*O.E.D.*)

Absence of a cash economy extolled

An "equal distribution of the gifts of Providence"

a dish of tea or strong liquor, and to be asked to sit while he drinks it. When the Rajah travels, it is on horseback, preceded by some of the country musicians, and a guard armed with matchlocks; next follow some persons on foot, dressed in ceremonials, with red bushy caps, and a great many led horses.[32] *The Rajah apparently passes his life peaceably and agreeably, alternately moving about to his castles or palaces, of which he has many principal ones, besides the smaller villas, such as that above Ponaka; and so various are the situations and climates of these places, that he may suit his particular constitution or feelings in any season of the year, and by a few days' journey properly directed, experience all the different degrees of temperature between the extremes of Zembla*[33] *and Bengal.*

That the absence of money in a society excludes, in a proportionate degree, depravity of morals and vices of various kinds, is in some measure exemplified in Boutan, where there is no other coin than the Beyhar rupee, which finds its way into the country in so scanty a portion, as to leave the natives possest almost of the same advantages with those to whom money is wholly unknown. Under these circumstances, the governors of districts, and others employed under the Rajah, have not the same means of massing wealth, which in other countries excite peculation and proves the source of the most destructive crimes: for had they ever so much a natural propensity to such practices, insurmountable obstacles would arise to the gratification of their views. An exorbitant levy on the produce of the land would be a transaction impossible to conceal; or if practised with success, the different commodities must perish upon hand, as no means would occur of turning them into money but by exportation, which would require the Rajah's authority and passport. Wealth is, besides, less valuable to an individual in Boutan, than in countries where it not only procures the conveniences of life, but the distinctions due to merit. In Boutan it might create envy, but could not raise the possessor above the rank assigned him in one of the classes before described. The pride of dress and attendants is unknown to all except a few public officers, employed immediately under the Rajah, and the mass of the inhabitants are here more nearly upon an equality than they are in most other civilized parts of the world. The policy of the government seems also calculated to prevent them from changing their condition, or aspiring above their fellows. The dress of a priest is always the same, though he should hold the most distinguished civil employment. The zeen-caabs are all in uniform, nor dare they alter it with the addition of any extraneous finery. Even the embroidered gowns worn by the two of that order at Calcutta, which had been given them by the Rajah, were sold on their return to Buxaduar, being then become useless. They assemble at their meals, and have their provisions dealt out to them. The regulations and customs of the government seem calculated to promote an equal distribution of the gifts of Providence among each class of the inhabitants, and, as the country is certainly not distinguished by any superfluity, to prevent individuals from accumulating an exorbitant share to the prejudice of their countrymen. Ambition and vanity can have no objects of incitement in Boutan, where society is consequently little exposed to the disturbances incidental to the gratification of

those passions; and an ease and tranquillity may be supposed to prevail, of a nature not unlike that described in the golden age. The natives are strangers to extortion, cruelty, and bloodshed, in which several vices their Indian neighbours have so eminently distinguished themselves; there being no attainments by which the most licentious can be allured to commit such crimes. We had an instance of a rebellion, successful for some time before it was suppressed, which cost but few lives, and only one of them that could be called an execution, the zempin of Wandepore.[34] Instead of the ferocity and vengeance attendant on civil war, the Bouteas, upon several occasions during the course of the insurrection and attempt against Tacissudon, shewed a tenderness of each other's lives which, without scruple, I should have attributed to their want of courage, had they not given proof of the contrary in their war with us. They are upon the whole an exceeding poor, but, comparatively speaking, a happy people, neither in danger of any very outrageous oppression at home, nor of invasion and slavery from abroad. The nature of their government, entrusted to a set of men who can never have mischievous, sinister, and self-interested schemes of ambition or avarice to prosecute at the expense of the country, in the uncommon difficulty of the roads, secures them from the second. Food and clothes are found by all, and what little superfluity beyond this the country affords, is so managed as to make the most creditable figure in their different castles; and as this is a public concern, the public in this may be said to enjoy a share.[35]

But, after all, these advantages and this happiness are of a negative quality, and not such as would tempt the more enlightened part of mankind to change conditions with the inhabitants of Boutan. They are for ever excluded by the nature of the country from making any considerable progress in arts, manufactures, and commerce, and therefore not likely to acquire any very eminent degree of science, taste and elegance. They might, it is true, become better soldiers if they were more suitably armed, but such an improvement might only induce them to disturb the peace and invade the property of others, without contributing any needful security to their own, which is already, from the unchangeable ruggedness of the country, as unassailable as they can desire.

The best means of attaining an explanation of the principles of the Boutea religion, might be to translate some of their books on the subject: the ceremonial part would, perhaps, be best observed by a visit to the residence of the Delai Lama. There are ceremonies used at Tacissudon which are unknown at Teshulombo [Tashilhunpo], and it is not unlikely that the Bouteas, from a nearer intercourse with India, may have adopted more abundantly than the Thibetians the articles of Hindoo faith.[36] The natives of Thibet and Boutan differ in the disposal of the dead: the former expose the bodies on a building, erected for the purpose, to the action of the weather, and to be devoured by birds of prey;[37] but in Boutan they are reduced to ashes as in India. I saw one upon the funeral pile, but did not arrive till some time after the fire had been applied. About a dozen of gylongs sat in front under a shed (it being rainy weather) muttering prayers. At intervals their religious instruments were sounded, and an attendant was often sent with spoonfuls of oil and other consecrated

The mild insurrection witnessed by the British mission

34. Cf. Turner's statement that the "zempi ['dzongpön'] lost his life in the affray, being transfixed with two arrows; one entering his temple, the other his throat. His head and right hand were immediately cut off, and carried in triumph to Wandipore": Turner, *Embassy*, p. 148.

35. Property acquired under the government of Boutan devolves to the Rajah on the proprietor's decease, and becomes a part of the public stock. 'Privatus illis census erat brevis/commune magnum' [S.D.] (The quotation is from Horace, *Odes*, II, 15, ll. 13–14: "Small private wealth, large communal property/So ran the rule then": James Michie, *The Odes of Horace* (London, 1967 edn.), p. 123.)

Geographic seclusion denies them the "arts, manufactures, and commerce", also "science, taste, and elegance"

Bhutan and Tibet: religious interconnections

36. It is in fact unlikely that Bhutan came under direct Hindu influence in any period.

Funerals in Bhutan

37. This is like the Parsees [S.D.].

A "swammy-coach" and its ritual use

38. See Turner, *Embassy*, p. 65. The lama referred to has not been identified.

Monastic picnic and ritual by the river

39. In Tibetan 'Lama Khenpo', the designation of the head abbot in Bhutan, now usually referred to as the 'Je Khem'.

articles to throw into the flame. The women are said to receive the last office from the gylongs at their death, although so much slighted by them during their lives. The Bouteas have likewise an imitation of the machine used in India, commonly called a swammy-coach; but from never making wheels except on such occasions, they are so aukwardly contrived, as to perform but very imperfectly their intended office. A ceremony of this kind happened soon after our arrival at Tacissudon, in consequence of the decease of a very eminent priest of that class who, devoting their lives to the austere duties of religion, retire to some solitary habitation among the mountains.[38] Finding his end draw nigh, he expressed a wish to see the Rajah, and, as we were informed, advertised him of disturbances shortly to happen in his government, and warned him to avert both the calamities of war, and an impending blow with which he himself was threatened, by imploring the protection of the deity in a solemn and public invocation. These troubles were probably foreseen by others as well as the old gylong, for the prediction was understood to mean the insurrection occasioned by the zempin of Wandepore. A pyramidal pile was formed near the bank of the river, composed of slips of wood, stained papers, worsted of various colours wound upon frames, and other showy articles, the whole erected upon a frame of timber which had under it four clumsy wheels or rollers. The lower part was decorated with an abundance of ornaments and images of the deities, arranged in the manner of an altar, before which were placed upon the ground some larger figures moulded in clay, and painted to represent the deceased Lama, the Rajah, his dewan, and some of his principal attendants. When the fabric was completed, a large tent was pitched in its front, of a size to contain more than four hundred gylongs, who marched out of the palace to officiate therein. A small pavilion was built for the Rajah behind the pyramid, in a square inclosure of young trees. One whole night and part of the next day was spent in prayer, and in sounding the religious horns and drums. When this was ended, the gylongs moved away to a small island to bathe, leaving the pyramid to be disposed of by the throng of spectators, who, after many ineffectual attempts to drag it close to the river-side, which was impossible from the clumsiness of the wheels, fell upon it with enthusiastic fury, pulled it to pieces, and threw the fragments into the stream, the Rajah himself remaining upon the spot until the work of destruction was completed.

The same person directed that his image should, after his decease, be deposited in the hermitage upon the mountain, and it was accordingly carried in procession, placed on a sort of bier supported by four priests, and attended by others chanting prayers, with musical instruments, perfumes, and torches.

Some time after the above transactions, and on one of the bathing days, a ceremonial was performed upon the bank of the river, which had the appearance of being an offering to the stream. The approach of the priests from the castle was announced by three musicians who preceded the line. One of these beat upon the cymbal, another had an instrument like a hautboy, and the third a tabret or drum. In front came Lam-keb,[39] before whom was carried a chalice with perfumes, and about twenty of those following next in order carried, each of them, something concealed under a covering of embroidery and silks of various showy colours, and

they had all white handkerchiefs tied round their mouths. Next came the usual number of gylongs, amounting to upwards of four hundred, the youngest bringing up the rear. They passed the bridge and sat down in a throng upon the grass under the willows, on that side the river opposite our dwelling, with their faces to the water; while the loads were placed in a row close upon the edge of the bank. Some prayers were muttered, and every one produced his dish, which was filled with tea by zeen-caab attendants, who also presented each gylong with a piece of melon. When they had drank their tea, eat the piece of melon, and when those charged with the loads had again bound up their mouths, they all rose up, took off the embroidered cloths, and at a signal tumbled the articles which had been covered into the stream. These articles proved to be only large stones, and lumps of clay: I suppose consecrated for the occasion.

In the month of September is held an annual religious festival which lasts about twenty days. The ceremonies during the former part of the time consist of muttering prayers in the principal chapel, which is decked out for the occasion. A temporary altar is raised in the middle of it, adorned with silk flags and handkerchiefs of various colours, and other showy articles. The front of the gallery, and some of the pillars, were hung round with religious ensigns of satin, embroidered and painted, and not inelegantly disposed; and two other pillars supported martial trophies composed of arms of various kinds. A matchlock of an uncommon size formed the centre of each; some Indian pikes (for they have none of their own) and European muskets, with the bayonets fixed, contributed to form the body of the piece, which was terminated with lighter weapons, with swords, shields, and bows and arrows. On one side of the chapel stood a row of figures fantastically dressed as warriors, and on the floor sat the priests, disposed in ranks perpendicular with the front of the altar. One half of the number of ranks faced the other half, leaving a wide passage up the middle in which lay their large tabrets or drums. Before each priest was placed a small bell, and an instrument composed of a piece of wood, about a palm in the length, with an ornament at each end, shaped something like a little crown. These they often used, taking the bell in one hand and the wooden instrument in the other, presenting them forward with the inside of the hand turned upwards as they muttered their prayers. Lam-keb, who is fourth in rank, and commandant of gylongs, sat fronting the altar, and gave the word and signal for every thing that was done. I continued to view them about half an hour from the window below, and from the gallery above, and should have staid longer had the operations appeared to admit of any variety.

Festival of the Thinphu Dromchö: preliminaries

The season of praying being over, the exhibition of dancing began, and was performed entirely by the gylongs in their quadrangle of the palace. In one of the lower galleries or virandas an orchestra was partitioned off with silk curtains, where sat, upon a raised seat, thirteen gylongs dressed in satin robes, with large embroidered caps, such as are worn by the Lamas, in shape resembling a mitre. Lam-keb sat in the middle, and led the band, beating time with cymbals, while each of the others struck with a bent iron upon a drum which was held by an attendant standing behind. The galleries and the sides of the quandrangle were

First day of the sacred dance

40. This is the costume of the famous Black Hat dance *(Zhwa-nag)*, which is based on the legendary assassination of the 9th-century king of Tibet Langdarma, the persecutor of Buddhism. For the general background to this festival, see my "Sacred Dances of Bhutan", *Natural History*, lxxix, no. 3 (1980), pp. 38–47.

41. The description corresponds to the dance of "The Eight Classes" *(sDe-brgyad)* of malignant spirits who control the phenomenal world and who were tamed to act as protectors of Buddhism. It is still performed on the first day of the festivals at both Thimphu and Punakha.

The second day

42. This is the dance of "The Chief Goddess and her Retinue" *(lHa-mo gTso-'khor)*, dedicated to the female divinity Remati and her heavenly entourage.

crowded with spectators, among whom was the Rajah with his principal officers. A silk curtain was hung across before the chapel door, from whence, as from behind scenes, came out twenty figures fantastically but uniformly dressed, with broad brimmed hats, not unlike shields, tied upon the head, bordered with black fur and adorned with a high ornament or plume rising from the crown, and with tassels of handkerchiefs of different colours, tied to the crown, and hanging down low behind.[40] Over the shoulders was a tippet of gold and silver embroidery on the borders, and hanging half before and half behind. The gown or vest was of satin, girded round the waist, with a white handkerchief tucked in on each side. The sleeves were large, widening from the shoulder downwards to the hand. Round both the skirts of the gown, and the middle of the sleeves, was a broad stripe of red, broidered with a narrower one of yellow. Fourteen of these figures formed a circle, and the other five a smaller one within it; each person carried a tabret in the left hand, which he beat with a bent iron, touching it lightly first on one side, then on the other, as he danced about. The motions practised by these dancers were chiefly throwing themselves round upon one leg, at the same time tossing up the head, and flourishing with the arms, then sinking with an inclination of the body as they came to the ground. Every dancer kept his place, and the whole circle moving round with uniform gestures as they touched the tabrets together, their plumes and handkerchiefs or streamers flying loosely in the air, had a theatrical effect. After entertaining the spectators about half an hour in this way, they danced in one after the other to the chapel, and disappeared. Some of the audience then struck up a devout song, much in the style of our church psalms, the verses being given out by an old gylong.

The next dance was in masquerade.[41] First came out a figure representing the destroying power, whose visage is grimly enraged and surrounded with skulls. To the former music were added deeper toned drums, with gruff horns, and bells, to give the scene a more terrific effect. This figure was presently followed by six in the same dress, who came out in pairs, and by two who joined them afterwards. One of these had a head like a frog, the other wore a pale mask not unlike a sign-painter's representation of the full moon. Their motions were of the same kind as the preceding, but more brisk and more animated. A mat was spread in the middle of the square, and a small vessel placed upon it, round which the actors huddled together, as witches would have done round a cauldron, and when they had exercised themselves for about an hour in this mode, they danced in behind the curtain and the show ended for the first day.

The next morning the orchestra was filled as before, and the Rajah with his attendants took their places to behold the show, which opened with a grinning figure, the same as above-described, who was soon joined by thirteen more, five of whom had masks like the heads of hogs and tigers, and the other eight were masked with monstrous gaping beaks.[42] The whole together presented a collection of more fiend-like visages than ever painter represented in the temptation of Saint Antony, and the wild and clamorous sound of the instruments seemed well adapted to make such devils dance. Every mask was garnished with little ivory skulls, and each

figure held a symbolic instrument in either hand. The dresses were in other respects the same as on the preceding day. After flourishing about with "mops and mowes" for an hour they disappeared. Four figures only came out next.[43] They danced for some time round a mat that had a small triangular vessel placed upon it. They were then joined by those that had been seen before, in all amounting to twenty-one. What followed was dancing, such as we had been already entertained with, and the second day's amusement closed.

The third day was too nearly a repetition of the former two to deserve a particular description; the same masks danced again in the same manner, with the addition of a few more to the number.

On the fourth day the dancing was performed in the chapel before the temporary altar, the Rajah and Lam Geysey were present, and the common people were admitted to be spectators from the gallery above. The performers were the first set only: they held various symbolic instruments, instead of tabrets, and had not room for so much agility as was shewn without in the square. When it was over, the Rajah and Lam Geysey came forth on the way to their respective apartments. The latter answered the description I had received of him, appearing to be a boy of about seven years of age. He was carried on the shoulders of a priest, and the gylongs, as he passed, stopped and made an obeisance.

The fifth day was a repetition of the first.

On the sixth day a dance was performed by four figures with masks representing skulls.[44] The body and limbs were fitted closely with a white dress, and round the middle hung various coloured handkerchiefs and fringes. Their motions were more slow and solemn than before, and sometimes accompanied with a tremulous shaking of the limbs. They withdrew and returned again, bringing forth a hair cloth, held between them at each corner, containing a triangular vessel, round which they danced and quivered for some time, and then disappeared.

The seventh day closed the festival with an exhibition more splendid than any of the preceding. The orchestra was filled with an additional number of Lamas, and a procession commenced of the superior deity, in his character of Wizie Rimbochy, with many attendants, and with the grinning figures already described.[45] The dresses were extremely rich and showy, and the figures moved on in slow and solemn pace round the square. Wizie Rimbochy had an umbrella held over him, kept constantly twirling, and six inferior personages huddled round him as agents or domestics, awaiting his commands. He turned entirely round many times on the way, as if surveying the multitude with his smiling, gilded countenance, and afterwards took his seat upon a bench covered with carpets in front of the chapel, and his attendants, after dancing for some time, seated themselves on each side. Sixteen figures then made their appearance in dresses very different from any of the former.[46] These, as I was informed, personated females. Each of them wore a gilded coronet, the hair from under it falling in tresses upon the shoulders. Their robes were of the brightest coloured satin, girded round the waist with a white ornament formed of something like gimp, which hung with tassels before.

43. Probably the "Lords of Death, the Fathers and Mothers" *(gShin-rje Yab-yum)*.

The third day

The fourth day

The fifth day
The sixth day

44. These are the "Lords of the Cremation Ground" *(Dur-bdag)*.

The seventh day

45. "Wizie" must be an odd rendering of 'Urgyen', the Tibetan for Oḍḍiyāna, where Padmasambhava, the "superior deity" referred to here, is said to have been born.

46. This is the dance of the "Sixteen Rigma Goddesses" *(Rigs-ma bcu-drug)*.

The bosom was crossed over, and the sleeves tied up with some of the same material. They held painted tabrets in one hand, which they touched lightly to time with a bent iron in the other, and moved round the square with solemn, uniform, and graceful steps. When arrived opposite Wizie Rimbochy, and the company seated on the bench, they drew up facing them, and sung something like an hymn, occasionally separating and returning again to the same position, often bowing and falling on their knees as in adoration. They retired for a while, and came out again with rattles in their hands, instead of tabrets, and continued the same movements until Wizie Rimbochy and his attendants advanced and took another circuit round the square; the different masks flourishing about at the same time according to their respective characters. The contrast between the graceful figures just described, and those with fiend-like visages, was not unentertaining, and the whole scene, including the spectators who crowded the sides of the square and the galleries, together with the rude noise of the instruments sounding from different quarters, had a wild and theatrical effect, but not of a nature that could be well initiated on any stage. In the course of the performance the Kelidar and several other personages of note, who were on this occasion at Tacissudon, went, and standing in a row made three prostrations before Wizie Rimbochy, as he was seated upon the bench, and presented their handkerchiefs. When the performance had ended, the Rajah, followed by the gylongs, adjourned to one of the largest chapels, and took his seat on a pedestal or throne placed in front of the altar, with Lam Geysey on his right hand and Lam Keb on his left, each on separate seats something lower than that placed for the Rajah. The gylongs squatted in rows upon the floor. What passed here I was not allowed to see, but I understood that the ceremony consisted chiefly of eating and drinking, as the priests came out each with a portion of fruit in his hand. The zeen-caabs were at the same time regaled with liquors in the gallery. They said it was usual for a benediction to be conferred by Wizie Rimbochy on the multitude, who approach one by one to make their obeisance and to receive it, but on this occasion it was not observed.[47]

A festival of the same kind is held at Ponaka, Paragong [Paro], and Wandepore, but the Rajah said there is no such dancing used at Thibet. He did not seem willing to enter upon an explanation of what had been exhibited, and the account given by others was neither satisfactory nor perfectly intelligible, but by what little could be gathered from them it has an allegorical meaning, which refers to some former calamity, when the country was invaded and the inhabitants devoured by monsters, such as they imitate in masquerade, commissioned by an adverse deity for this mischievous purpose. On the interposition of Wizie Rimbochy, compassionate of the people's sufferings, and at their humble supplication, these plagues were withdrawn. These annual rites are therefore performed in honour of Wizie Rimbochy, and to implore continuance of his protection, that the people may prosper, and not again be delivered over to any such infernal agents.

The Bouteas have stories of flying dragons, and of nations of monsters, which they say are fully treated of in some of their religious tracts. A dragon is sometimes seen upon a rock near Ponaka, and the Rajah's

47. The dewan and the darogah [master of the horse], with a party of zeen-caabs, patrolled every day round the square while the performances lasted, to maintain order [S.D.].

The purpose of such festivals

Dragons, etc.

interpreter told me very gravely, that a young one of the same breed had been caught upon a mountain, and was still kept very carefully by the gylongs among the sacred things in the chapel. A ceremony, which by only a few weeks preceded the last, should not be omitted, as it seemed of some important meaning, although there was no getting it intelligibly explained.

We were alarmed early one morning with the firing of matchlocks from the roof of the castle by about twenty persons, who, when they descended, were found completely dressed in chain armour, with steel caps, from each of which rose a plume of feathers. They formed a wide circle in the gylong court round a capacious vessel of liquor, and, as they marched round it, one of the number continued giving out verses of eight syllables, which the rest repeated after him, often capering and flourishing their swords. All the explanation they would give of this business was, that it was proper to be done for the good of the country.

Ritual sword dance

The wild and domestic animals of Boutan are some of them peculiar to the hills, and the rest such as are equally found in Bengal. The horses come under the former denomination, and are so well known as to need no description;[48] *they seem of the same species as those brought from Acheen,*[49] *which are so much used on the coast of Coromandel, and are smaller and better adapted to the nature of the country than those from Thibet, of which there are many at Tacissudon. The native horned cattle, to all outward appearance, are the same species with those of England, except where the breed has been mixed with that of Bengal, and in this case the hump between the shoulders is perceptible. Of sheep, I believe they have no other than what are occasionally brought from Thibet. I never met with any, but my companions once saw a few near Tacissudon. Goats they have in plenty, which differ in no respect from those of India. The hogs are a small breed imported from Rungpore and Cooch Beyhar. The Bouteas use more of this than of any other sort of animal food. The dogs are the common Paria sort, with others of a different kind from Thibet. These last are of a large size, with a sharp snout and a fox-like head, long shagged hair, of a strong make, ugly, and extremely fierce. They are always kept chained, and serve as guards to the village and orchards. In some of the woods we saw monkeys of an extraordinary size, the face black, and surrounded with white bushy hair; the hair on the body grey. In the woods to the northward are said to be bears, and the* cheeta, *or hunting leopard. In Boutan are plenty of fowls, but neither ducks, geese, nor turkeys, wild or tame: it is too cold a climate for the latter, and the others would no where find water sufficiently placid to swim in. Pigeons both wild and tame; sparrows, kites, and crows from India. The latter however speak a different language from their low country relations, and in some of their notes might be mistaken for ducks. A bird found in the greatest plenty is the hoppoo, a native also of India, but no where seen so numerous as here. The size rather smaller than a pigeon; a long beak; the plumage beautifully variegated with brown, white, and black, and a high tuft of feathers on the head, which is expanded and elevated, or closed and depressed at pleasure. The cuckoo was heard no more after the setting in of the rains, but he returns at the same season and stays as long as he does in England. There are also*

Animals

Birds

48. Bhutanese horses are usually referred to by the British as of the 'Tangun' breed. The etymology of the term is uncertain. See Turner, *Embassy*, pp. 21–3; *Hobson-Jobson*, p. 898; Simon Digby, *War-horse and Elephant: A Study of Military Supplies* (Oxford, 1971), pp. 45–7.

49. "Acheen" is present-day Aceh, a province in the north-west of Sumatra.

Journal

Gnats, leeches, etc.

wag-tails and tom-tits, and I once saw a humming bird of a very beautiful plumage, red, blue, and yellow. The gnats which tormented us at Choka, as well as the luckes, are, I believe, met with in no other country. The bite of the former is much more tormenting than that of any other species of mosquito I ever heard of; the pain lasts at least a week, and the marks much longer: they were visible for a month after our arrival at Tacissudon. The Bouteas are plentifully stocked with rats, fleas, bugs, and mosquitos, but I believe snakes and the like venomous reptiles are no where seen, except in the southern parts bordering on Bengal.

Food

We staid at Tacissudon upwards of three months, and remained all the time lodged in the house we were shewn to on our arrival. The daily supply for our table was a kid, three fowls, and about a dozen eggs, which was neither varied, increased, nor diminished, except once or twice when the Rajah sent some of the dried mutton from Thibet. We had occasionally good butter, and after a while were brought to disregard the hairs and dirt with which it was abundantly mixed. The servants, except two or three of the upper class, were not so well off: their portion was two dried fish, a little rice and flour each, and sometimes a goat divided among them; – this, however scanty when compared with more plentiful countries, was by no means an illiberal allowance at Boutan, where meat is so scarce, and sparingly consumed. We had fruit sent from the castles, but vegetables were difficult to be met with. Turnips are a native root, although they do not grow in the same perfection as in Europe. The potatoes which Bogle left must have been neglected, for there were

Bogle's potatoes

50. See the caption to Plate 52 below.

Fruit

none on our arrival.[50] We had strawberries and raspberries, and in the beginning of July apricots, from, I believe, the only tree in the country. At the latter end of August the pears and peaches begin to ripen, and by the middle of September they are in the greatest perfection at Boutan, but certainly inferior to those of Europe. It must, however, be observed that the Bouteas are ignorant of the art of engrafting, and never either prune the trees or thin them when overloaded; neither do I believe that they consider much the soil or aspect. Were they skilled in these points, and desirous of the trial, there is scarcely a vegetable production in any quarter of the globe which might not be cultivated with success in some part or other of Boutan. But perhaps it is more suitable that, in their present simplicity, they remain occupied in the production of what nature more immediately craves, since there is so little ground to spare for speculative purposes. – Except in the Rajah's orchards, the fruit seems to be at the disposal of the public, and we found it impossible to preserve that which hung upon the few trees near our dwelling until it was fit to gather. – The melons from Ponaka were good, and the pomegranates the finest I ever beheld. In October the oranges there and at Wandepore ripen, and are laid up for a winter store.

The situation of Tacissudon, elevated into so pure a region of the air, must certainly be healthy in every season of the year; even in the rains, as there is no place where water can lodge and become stagnate, neither is the surface so closely covered with wood as to produce unwholesome vapour.

62

The weather on our arrival was delightful. The mornings and evenings clear, and the air sharp. I never **Climate**
slept under less than a quilt, blanket, and a great coat. Early in June the rains set in, and were so constant that during an interval of seven or eight days that we were at Ponaka, there generally fell a shower in some part or other of the twenty-four hours, and the tops of the hills were constantly involved in clouds. The rivers and torrents swell in this season, but the roads are never impassable, unless for a short time, by the demolition of a bridge or a slip of earth, which is soon repaired. About the middle of September the wet season ends, and the weather continues fine till November, when the snow begins to fall and to whiten the mountains. The Bouteas then put on their blankets and boots, and the Rajah and his attendants retire from Tacissudon to a milder climate in the valley of Ponaka, which must be during the winter months a charming residence. The whole face of the country would be found at this time to wear the most curious and interesting aspect, and to afford scenes for a painter in a style truly sublime, but of which words could convey but a very inadequate idea.

To call this a mountainous country merely would not sufficiently distinguish it from others of a like denomination, nor give a proper impression of its true character, when that term is understood to imply an intermixture of hills and valleys. But if a country of mountains be an intelligible phrase, it may with great justice be applied to Boutan, or at least to that part of it through which I have travelled.

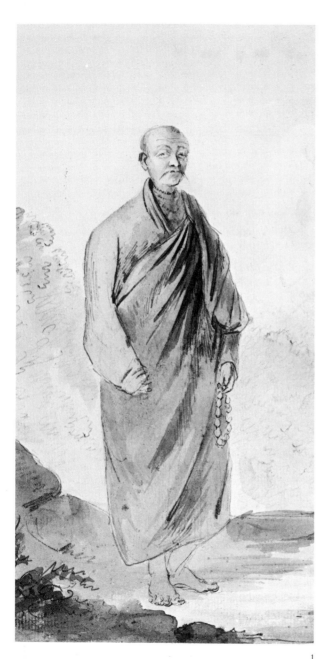

1

1. "TASEE PUNCHOU [Tashi Phuntso] the . . . in office next to the Soubah at Buxadewar . . .", 1783, watercolour, 14⅛ × 10⁷⁄₁₆ in. Yale Center for British Art, Paul Mellon Collection, B1977.14.195, formerly in the possession of the artist's descendants, purchased 1967.

This is one of only two portraits among the Bhutan drawings of Davis. The monk official portrayed was perhaps the same one who welcomed Bogle's mission to Buxaduar in 1774.

The commander (Pasang Katam, vulgo Buxa Subah) being at Bahar, I was visited by his dewan with presents, a white Pelong handkerchief (the general nazir throughout Bhutan), butter, rice, milk, and some coarse tea. We were detained for a day for want of coolies: Bogle, *Narratives*, ed. Markham, pp. 16–17.

opposite

2. The village of Buxaduar, wrongly titled "Thibet", 1783, watercolour, 6⁷⁄₈ × 9³⁄₄ in. Yale Center for British Art, Paul Mellon Collection, B1977.14.231, formerly in the possession of the artist's descendants, purchased 1967. An engraving of this view by James Basire is found in Turner, *Embassy*, plate 1, "Buxadewar".

Buxaduar, or Pasakha (see Map) as it is properly known to the Bhutanese, is the first village on the old route north from Bengal, and is populated today by people of mixed descent. In the eighteenth century it was reckoned among the eighteen *duars* (passes or "gates") extending into what is now Indian territory, over which Bhutan had territorial rights.

The road became uneven; and we reached the foot of the hills at about two o'clock; walk; ascent at first easy; way through a wood; some fine groves of first-rate trees; grows steep; narrow path zigzag up the hill; what a road for troops!; about four miles to climb; many little springs to drink at; from the bottom of the hills to their summit covered with wood; variety of well-grown trees of the largest size; some grand natural amphitheatres, with the noise of waterfalls. We arrived at Buxa-Dúar towards evening; situated on a hill, with much higher ones above it, glens under it, and a 3-feet walls of loose stones about it; a fine old banian tree; that's all: Bogle, *Narratives*, ed. Markham, p. 16.

Mr. Davis had taken a view of Buxadewar [untraced], which was lying on the table: the soobah was instantly struck with it, and recognized all the different parts of his habitation; the beams, the stairs, the people looking out at the windows, and *even the packages that lay beneath. He staid with us till the servants came to prepare for dinner*: Turner, *Embassy*, p. 30.

overleaf left

3. "Murichom to Choka", 1783, watercolour, 9¹¹⁄₁₆ × 6⁷⁄₈ in. Yale Center for British Art, Paul Mellon Collection, B1977.14.196, formerly in the possession of the artist's descendants, purchased 1967.

We had now to climb on foot up a very high mountain; the road led along its side, in a serpentine and exceedingly steep direction, the ascent almost all the way being by stone steps, which in some places were sustained only by beams let into the rock, and secured with cramps of iron.

It was after much labour, and repeated halting, that we reached the summit. At every pause we beheld a different prospect, each of which, perhaps, might justly be reckoned amongst the grandest and most awful in nature. Cascades of water issuing from the bosoms of lofty mountains, clothed in noble trees, and hiding their heads in the clouds: abrupt precipices, deep dells, and the river dashing its waters with astonishing rapidity, over the huge stones and broken rocks below, composed the sublime and variegated picture: Turner, *Embassy*, pp. 53–4.

overleaf right

4. William Daniell after Davis, "View between Murichom and Choka", 1813, aquatint, 8¼ × 7 in. Source: William Daniell, *Views in Bootan* (London, 1813), plate 5. India Office Library and Records, Dept. of Prints and Drawings.

The figure seated in the foreground with bow and quiver is wearing a costume rarely seen in Bhutan today called a "pakhi", woven from the fibre of nettles and crossed over the chest. Cane helmets such as he is wearing are now found only in temples dedicated to the guardian divinities, where they were deposited as offerings. This is the only one of Daniell's six Bhutan aquatints for which the original by Davis has not been traced. For the originals of the other five, see Plates 5, 22, 23, 31, 36 below.

This view occurs on the third stage towards Tassisudon [Tashichö Dzong]. The mountains in this part of the road appear as if separated by violence to give a passage to the river Teenchoo. The side up which the road ascends is precipitous, and of an height to render the climbing of it intimidating to those less accustomed to it than the natives. The hoarse murmurs of the Teenchoo are heard, though the river is not always seen as the traveller ascends: William Daniell, *Views in Bootan*, caption [by Davis ?] to plate 5.

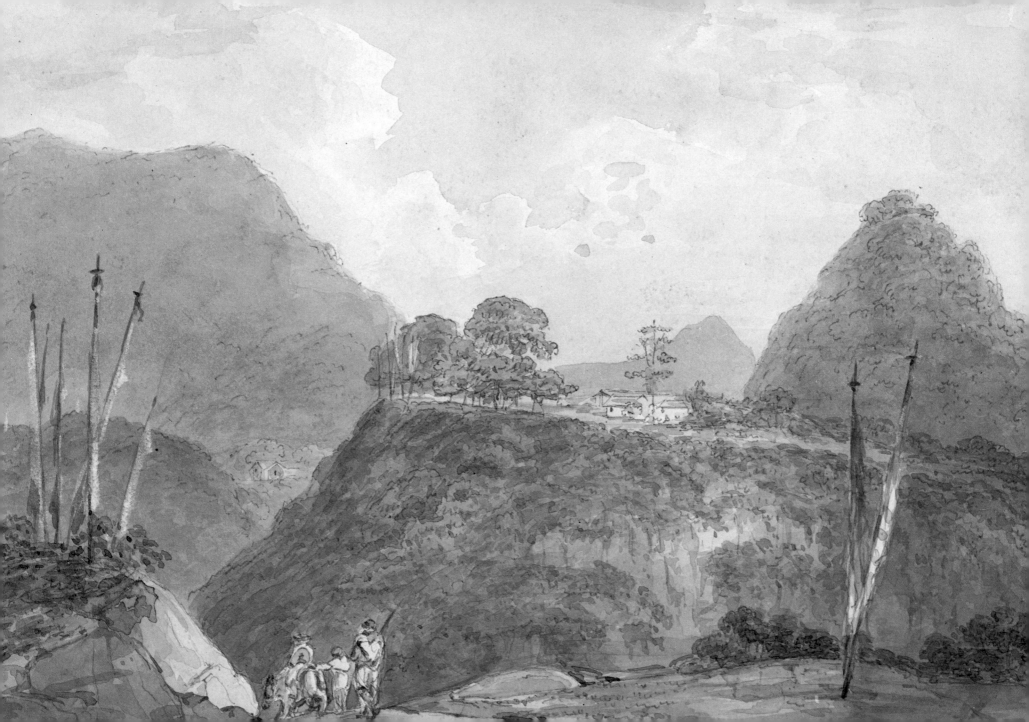

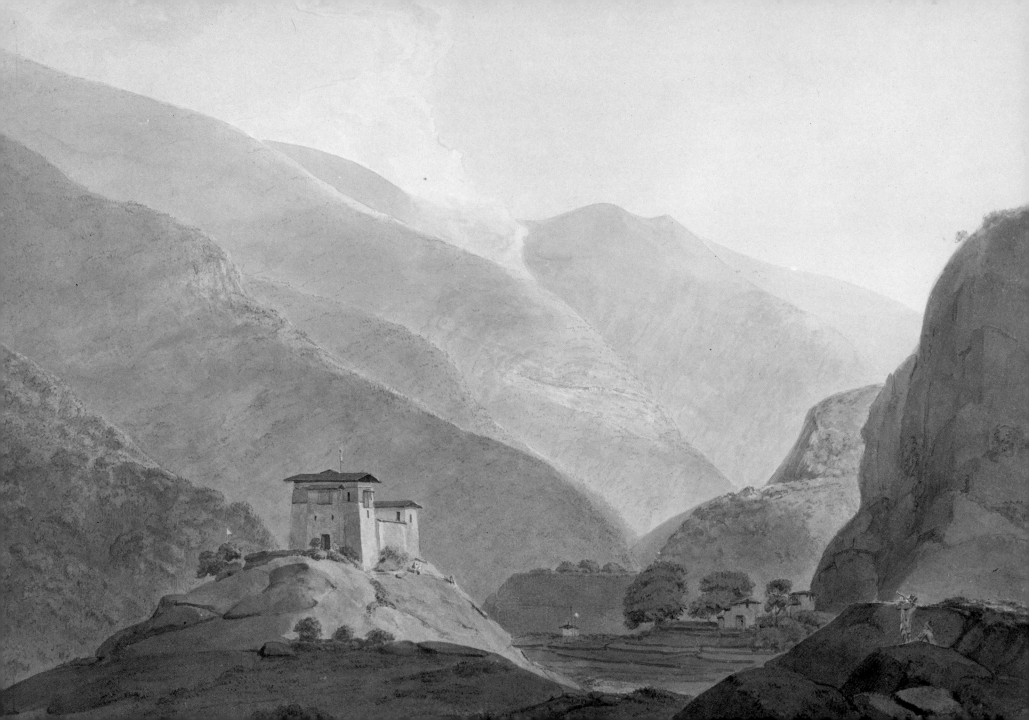

5. "Choka Castle in Bootan", 1783, watercolour, 13⅝ × 19³⁄₁₆ in. Yale Center for British Art, Paul Mellon Collection, B1977.14.266, formerly in the possession of the artist's descendants, purchased 1967.

This fort (see Map) was probably built in the late seventeenth century to guard the trade route south to India and to control the surrounding district, but its foundation finds no mention in the local records. Its ruins were quarried in the mid-1960s when the motor road was being constructed. An aquatint by Willaim Daniell based on this view is found in his *Views in Bootan* (London, 1813), plate 2.

The castle of Chuka makes a very respectable appearance. It is a large square building, placed on elevated ground; there is only one entrance into it, by a flight of steps, and through a spacious gateway, with large heavy doors: it is built of stone and the walls are of a prodigious thickness. We were conducted hither, on our entrance, and lodged by the commandant in a large and lofty apartment, in which there were two or three loop holes towards the river, and on the other side, a projecting balcony: the floor was boarded with thick planks that were pretty well joined together: Turner, *Embassy*, pp. 55–6.

Choka castle, the prominent feature in this view, is composed of three separate buildings, which, with a wall on the fourth side, enclose a quadrangle court-yard, and form altogether a post of ample dimensions, and of sufficient strength, for any purpose of defence that is likely to be required in a region so difficult of access, and possessing so few qualities to invite hostile intrusion as this part of Bootan. The Teenchoo is sunk too deep in its rocky chasm to be seen in this view. The strong vegetation afforded by a warm climate and abundant moisture, is here seen on the sides of the mountains in a degree not perceptibly diminished from what was observable on the preceding stages from Bengal: but on the next stage, which leads up the hill on the right hand, in the middle distance of the view, the great acclivity of the road is soon found to produce a change of temperature and a difference in the vegetation: William Daniell, *Views in Bootan*, excerpt from caption [by Davis?] to plate 2.

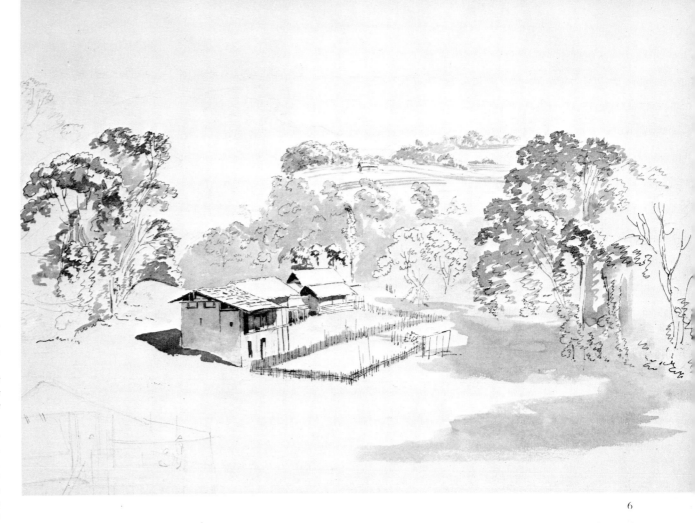

6

6. "Murichom", 1783, pencil and wash drawing, 13¼ × 18⅞ in. Yale Center for British Art, Paul Mellon Collection, B1977.14.199, formerly in the possession of the artist's descendants, purchased 1967.

We arrived at Muri-jong ["Murichom" of the Map] *as they were beating the evening tom-tom. It consists of twenty houses, some of them stone; many inscribed banners; and a good deal of arable land and cattle. I planted fifteen potatoes:* Bogle, *Narratives*, ed. Markham, p. 20.

Murichom consists of about twenty houses, in their structure much superior to any I had yet seen in Bootan. They are built of stone, with clay as cement, of a square form, and the walls narrowing from the foundations to the top. The roof is supported clear of the wall, has a very low pitch, and is composed of fir boards placed lengthways on cross beams and joists of fir, and confined by large stones laid upon the top. The lower part of the house accommodates hogs, cows, and other animals. The family occupies the first story, to which they ascend by a ladder, composed of one half of a split fir tree; into the flat side of which, rude holes are cut at proper distances to serve as steps: Turner, *Embassy*, p. 50.

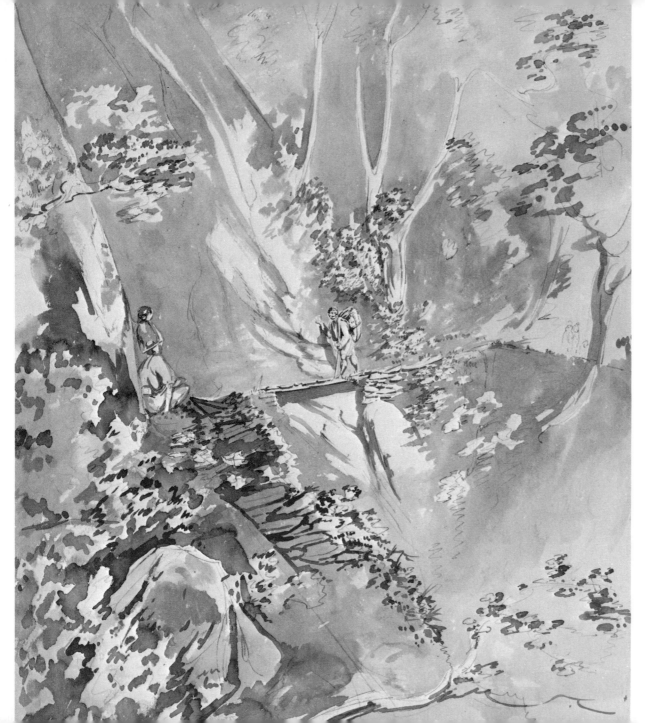

7. Figures crossing a bridge over a ravine, no title, 1783, wash–drawing, 13⅝ × 19¹/₁₆ in. Yale Center for British Art, Paul Mellon Collection, B1977.14.245, formerly in the possession of the artist's descendants, purchased 1967.

Three or four fine waterfalls were passed; one fell perpendicular about 40 feet from the top of a rock; another a stream foaming and tumbling over large stones; another embosomed in a fine grove, with arches formed by the trees and rocks. There were wooden bridges over all the rivulets which ran from them: Bogle, *Narratives,* ed. Markham, pp. 19–20.

8. "View from Murichom looking northward up the Channel of the Teenchoo on the road to Tasissudon, Butan", 1783, watercolour, 14¹³/₁₆ × 19¹¹/₁₆ in. Victoria and Albert Museum, London, WD. 127, acquired 1938.

May 22 and 23 [1783]. . . . *Many European plants are to be met with on the road to Murishong; many different sorts of mosses, fern, wild thyme, peaches, willow, chickweed, and grasses common to the more southern parts of Europe; nettles, thistles, dock, strawberry, raspberry, and many destructive creepers, some peculiar to Europe.*

Murishong is the first pleasant and healthy spot to be met with on this side of Boutan. It lies high, and much of the ground about it, is cleared and cultivated; the soil, rich and fertile, produces good crops. The only plant now under culture, is a species of the polygonum of Linnaeus, producing a triangular seed, nearly the size of barley, and the common food of the inhabitants. It was now the beginning of their harvest; and the ground yields them, as in other parts of Boutan, a second crop of rice.

May 25. On the road to Chooka found all the Murishong plants, cinnamon tree, willow, and one or two firs; strawberries every where and very good, and a few bilberry plants: Saunders, "Account", in Turner, *Embassy,* pp. 390–1.

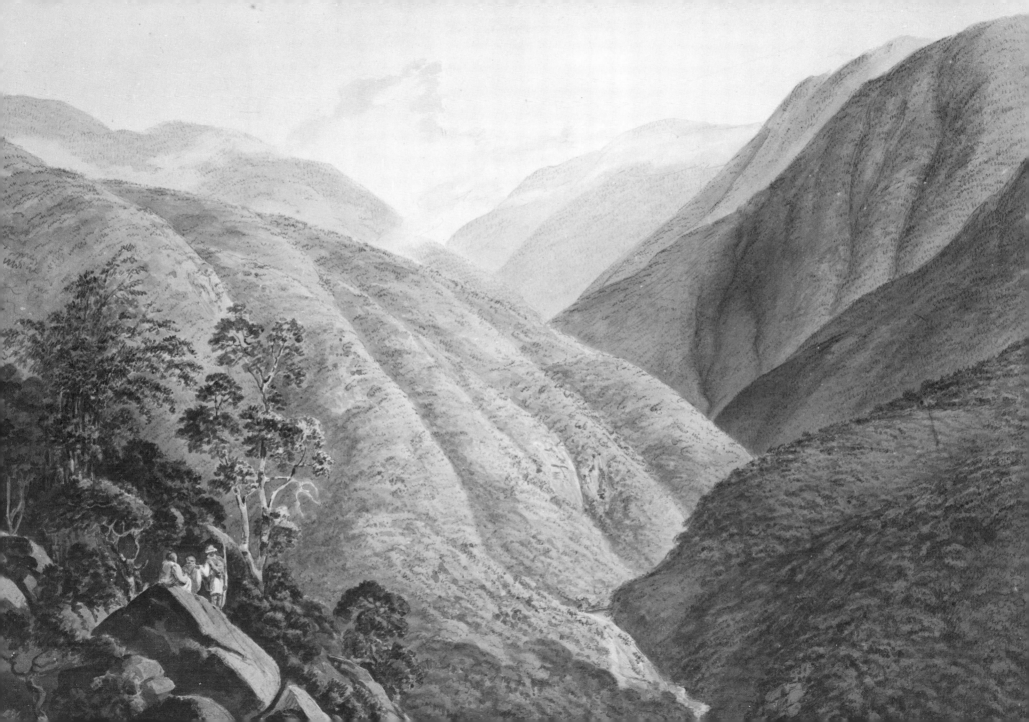

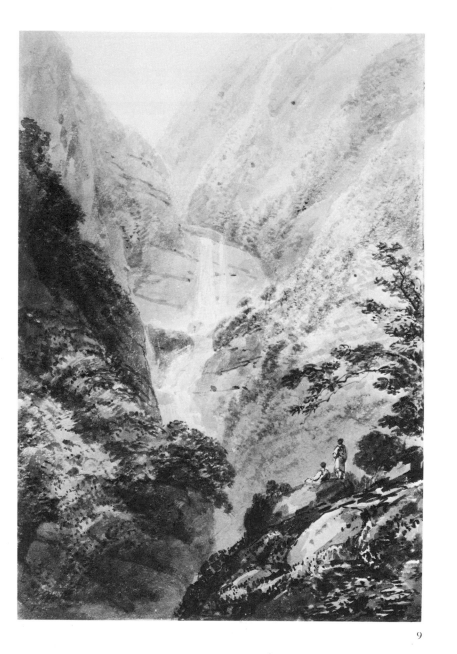

9

9. Waterfall, no title, *c.* 1800, wash-drawing, British Museum, Dept. of Prints and Drawings, 1944–10–14–196, gift in 1944 of Miss M. H. Turner, descendant of J. M. W. Turner.

An engraving of this view by James Basire is found in Turner, *Embassy,* plate 2, "The Cascade of Minzapeezo". The ascription to Davis is improbable since it forms a collection with another three stylistically identical views which formed the immediate basis for Turner, *Embassy,* plate 7 ("The Residence of Lam' Ghassa-too", after Davis, see Plate 33 below), plate 9 ("The Palace of Punukka", after Davis) and plate 12 ("The Dwelling of Tessaling Lama . . .", after Turner, see p. 25 above). The four British Museum views may therefore have formed part of a set prepared by another painter from nine originals by Davis and two by Turner, as a first step towards having them engraved. The original in this case is in the Victoria Memorial, Calcutta, R. 1249, formerly in the possession of Warren Hastings, deposited 1916.

On the face of the opposite mountain is a water-fall, called Minzapeezo, which issues in a collected body, but descends from so great a perpendicular height, that before it is received in the thick shade below, it is nearly dissipated, and appears like the steam arising from boiling water: Turner, *Embassy,* p. 53.

10. "On the Road near Choka in Bootan", 1783, pencil drawing, 21¼ × 14¾ in. Author's collection, gift of Fritz and Monica von Schulthess, 1979.

11. William Daniell after Davis (see plate opposite), engraved by J. Redaway, "Crossing a Torrent in Bootan", 1837, engraving on steel, 8¼ × 5¾ in. Source: An untraced work based on Hobart Caunter, *The Oriental Annual,* 7 vols. (London, 1834–40), iv, plate 3.

A very curious and simple bridge, for the accommodation of single passengers, communicated between this and the opposite mountain. It consisted of two large ropes made of twisted creepers, stretched parallel to each other, and encircled with a hoop. The traveller, who wishes to cross over from hence, has only to place himself between the ropes, and sit down on the hoop, seizing one rope in each hand, by means of which he slides himself along, and crosses an abyss on which I could not look without shuddering. Custom, however, has rendered it familiar, and easy to those who are in the practice of thus passing from one mountain to the other, as it saves them, by this expedient, a laborious journey of several days: Turner, *Embassy,* p. 54.

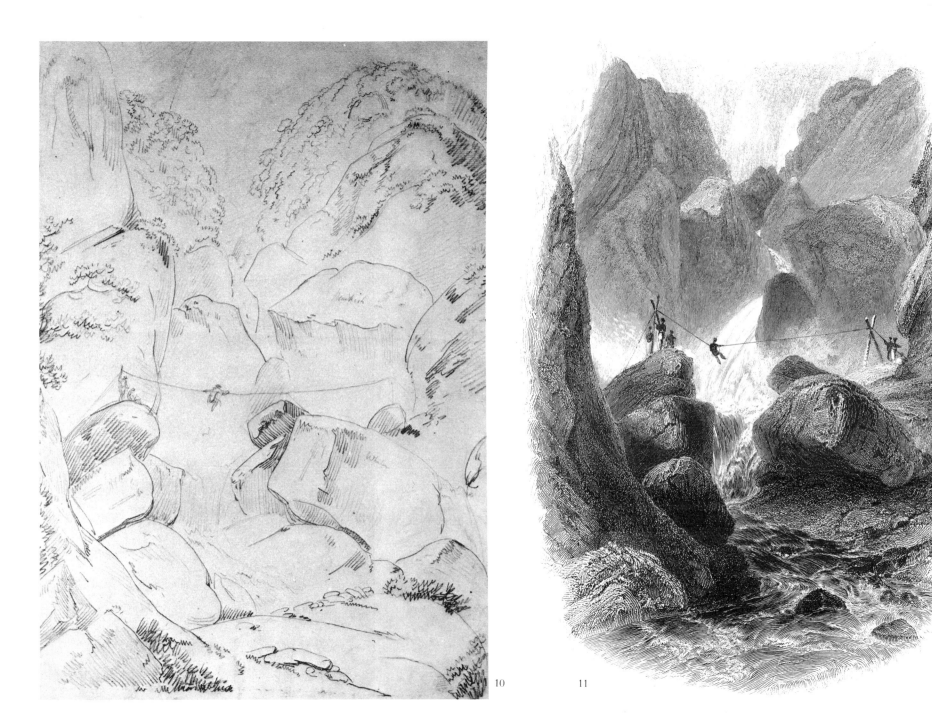

10 11

73

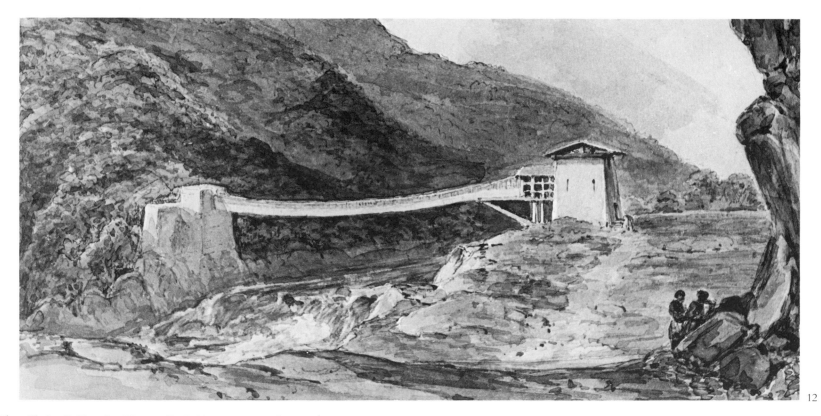

12

12. "The Chain Bridge in Bhootan", 1783, water-colour, 11 × 6¹¹/₁₆ in. Victoria Memorial, Calcutta, formerly in the possession of Sir Leicester Beaufort, deposited by Lord Curzon, 1921. An inscription on the back reads: "about 150′ long, height from water at lowest pt about 35 ft. breadth 5 ft. Ht 10′″. Engravings of this view are found (1) after a copy by "Pococke", in Thomas Pennant, *The View of Hindoostan*, 2 vols. (London, 1798), ii, plate 13, "Iron Bridge near Chooka", and (2) by James Basire, in Turner, *Embassy*, plate 4, "Chuka".

This is one of several iron-chain suspension bridges attributed locally to the great Tibetan saint Thangtong Gyalpo (1385–1464), who is now reckoned by historians of bridge building to be "the earliest known builder of iron chain bridges": Tom F. Peters *et al., The Development*

of Long-Span Bridge Building (Zurich, 1980), p. 51. There is however no mention of this particular bridge in his Bhutanese biography (see my *Bhutan: The Early History of a Himalayan Kingdom*, pp. 185–90). None of the saint's bridges in western Bhutan are still standing. A single link from the bridge at Tamchogang, destroyed by a flood in *c.* 1969, has been analysed, with some surprising results, by W. Eppsecht, "Kurzbericht über die metallkundliche Untersuchung eines eisernen Kettenbrückenstückes aus Bhutan", in Tom F. Peter *et al., op. cit.,* pp. 148–151.

We descended the mountain, and crossed the chain bridge called Chuka cha-zum, stretched over the Tehintchieu [Thinchu] river, a short distance above the castle of Chuka, which is reckoned eighteen miles from Murichom . . .

In a nation where no records are kept to perpetuate the memory of the achievement of genius, and in which the minds of the

people are remarkably prone to superstition, perhaps more than a century may not be necessary, to deify the author of a great work. Thus it is, that the bridge of Chuka is reckoned to be of more than mortal production. No less a being than the dewta Tehuptehup [= Tibetan "drubthop", Sanskrit *mahāsiddha*, "great magician", title of Thangtong Gyalpo] *could possibly have contrived so curious a piece of mechanism. Neither the origin nor the history of this renowned Tehuptehup, can be traced with any degree of certainty; but the works they assign to him, the road up the mountain we lately passed (many parts of which are held, it may be said, upon a precipice, by pins and cramps of iron uniting together the stones that form it), and the bridge at Chuka, do credit to a genius, who deservedly ranks high upon the rolls of fame, and justly claims from the inhabitants, decided tokens of respect and gratitude*: Turner, *Embassy*, pp. 54–6.

Plan Section and Elevation of the Bridge of Chains at Chuka

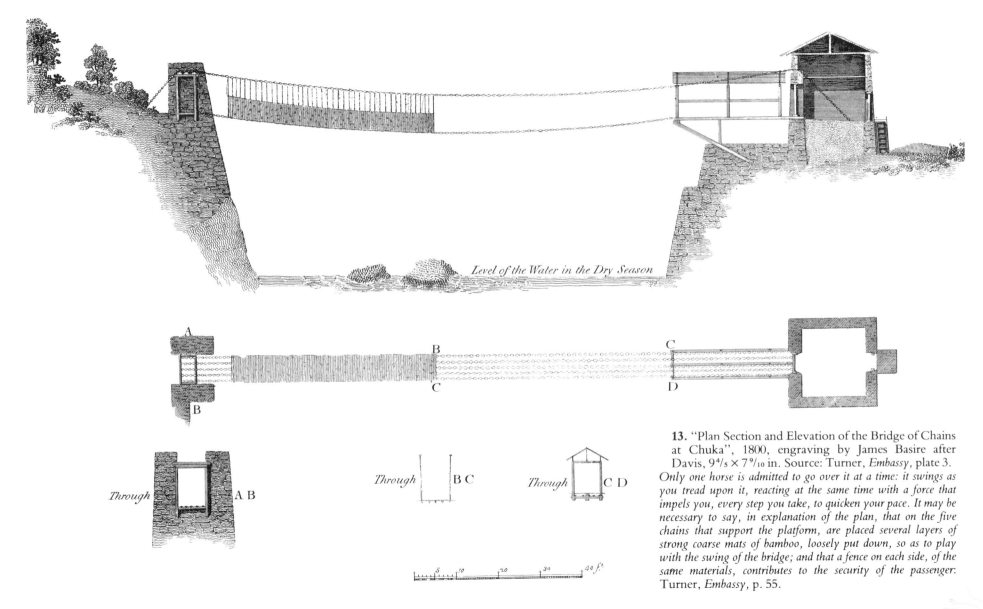

Level of the Water in the Dry Season

A

B

B

C

C

D

Through A B

Through B C

Through C D

5 10 20 30 40 f.t

13. "Plan Section and Elevation of the Bridge of Chains at Chuka", 1800, engraving by James Basire after Davis, 9⁴/₅ × 7⁹/₁₀ in. Source: Turner, *Embassy*, plate 3. *Only one horse is admitted to go over it at a time: it swings as you tread upon it, reacting at the same time with a force that impels you, every step you take, to quicken your pace. It may be necessary to say, in explanation of the plan, that on the five chains that support the platform, are placed several layers of strong coarse mats of bamboo, loosely put down, so as to play with the swing of the bridge; and that a fence on each side, of the same materials, contributes to the security of the passenger.* Turner, *Embassy*, p. 55.

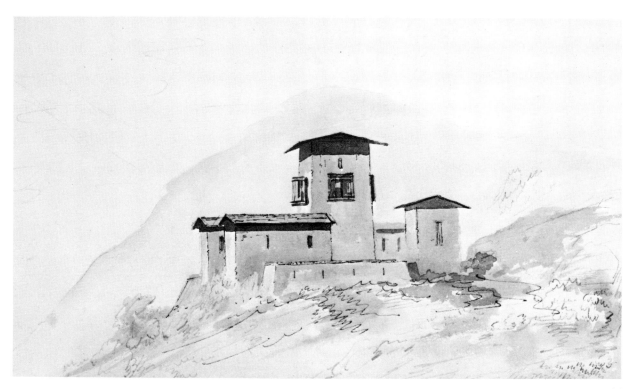

14

14. "Kapta [Chapcha] Castle", 1783, wash-drawing, $6^{15}/_{16} \times 10^{13}/_{16}$ in. Yale Center for British Art, Paul Mellon Collection, B1977.14.206, formerly in the possession of the artist's descendants, purchased 1967.

15. William Daniell after Davis (see plate opposite) engraved by J. Cousen, "Capta Castle, Bootan", 1837, engraving on steel, $5^3/_4 \times 3^3/_4$ in. Source: Hobart Caunter, *The Oriental Annual,* 7 vols. (London, 1834–40), iv, plate 7.

Like the earlier Chukha Dzong, this fort was probably built in the late seventeenth century to guard the trade route and control the surrounding district. The central tower would have contained two storeys of temples. Formerly the seat of a minor "pönlop" (district governor), the building survives today in a somewhat altered condition as a centre of local government.

The castle of Chupka, or Kepta, is built about half way up the mountain, in a bleak, but beautifully romantic situation: the mountains in its neighbourhood, I judged to be the highest we had yet seen in Bootan. The light clouds in some parts swiftly glided past their sides; in others they had assembled, and sat with deep and heavy shade upon their brows: and as they were continually shifting their position, they varied and improved the views. On the summit of Lomeela mountain, bearing from hence to the east, and in direct distance about five miles, there lay a great deal of unmelted snow: we felt the cold even at noon: Turner, *Embassy,* p. 58.

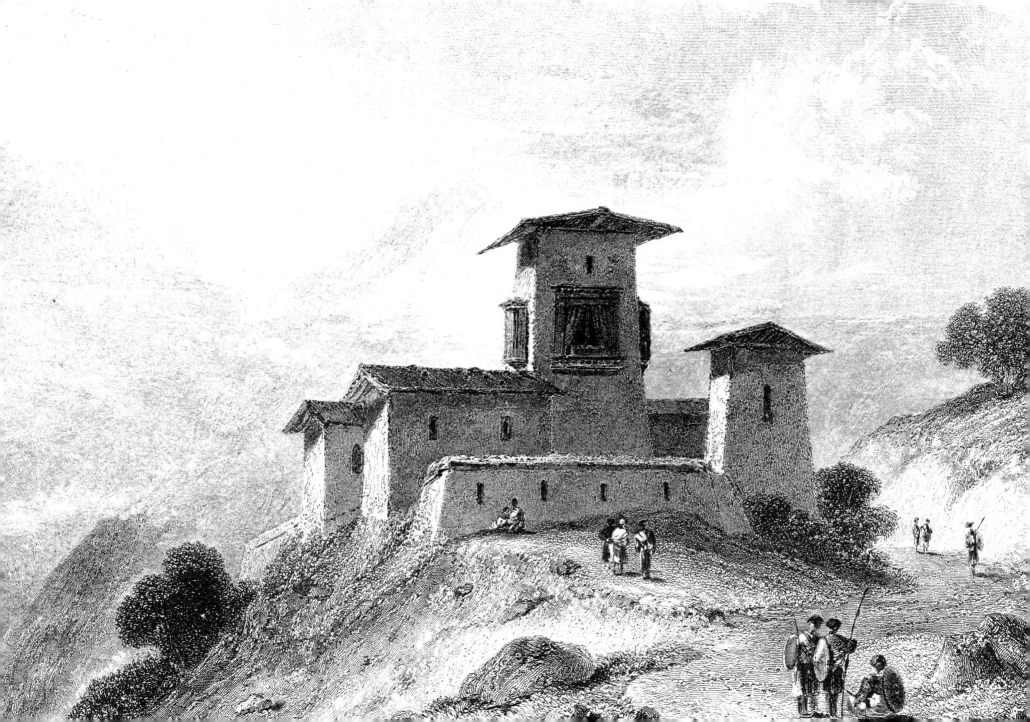

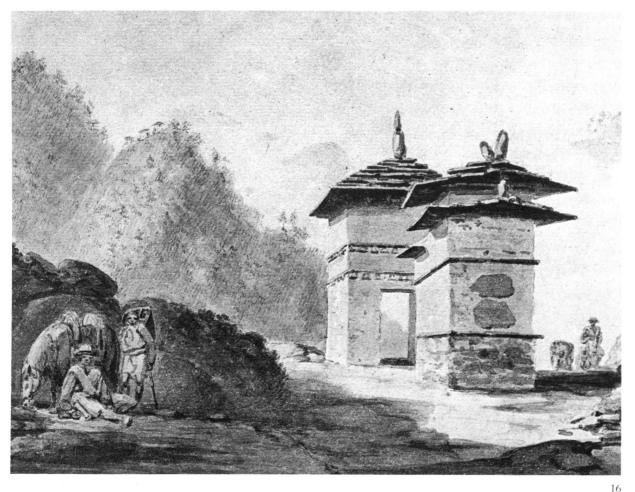

16

16. "Near Chepta [Chapcha] in Bhootan", 1783, water-colour, 12 × 9¹/₁₆ in. Victoria Memorial, Calcutta, R. 1731, formerly in the possession of Sir Leicester Beaufort, deposited by Lord Curzon, 1921. A wash-drawing of the same view is in the Yale Center for British Art, Paul Mellon Collection, B1977.14.182.
In the foreground stands a wayside shrine in the form of a *mani*-wall, and behind it a typical gateway "chöten" through which all travellers pass in order to obtain the

blessings of the *maṇḍala* on its ceiling.

I remember to have seen one of these buildings, which was dedicated to the junction of the Hatchieu [Hachu] with the Tehintchieu [Thinchu rivers] near Kepta [Chapcha]. They are often placed at the meeting of two principal roads. I have seen them also at the base of a remarkable mountain, and they are invariably met with, at the entrance of every capital village: Turner, *Embassy*, p. 97.

17. "View of the mountain Downgala [Dongkarla] (On the summit, a religious habitation Downgachine), Taken in the village Puga [Paga] on the road to Tassisudon in Bhootan", 1783, watercolour, 26 × 17¹¹/₁₆ in. Victoria Memorial, Calcutta, R. 1250, formerly in the possession of Warren Hastings, deposited 1916.
An engraving of this view at Paga ("Pauga" of the Map) based on a copy by "Pococke" is found in Thomas Pennant, *The View of Hindoostan,* 2 vols. (London, 1798), ii, p. 353, head-piece, "The Mountain Doungala". There is also a steel engraving of this view by T. Jeavons after William Daniell in Hobart Caunter, *The Oriental Annual,* 7 vols. (London, 1834–40), vi, plate 6, "A Mountain Village".

. . . a view of the great naked mountain Doüngala, of the town, and the various entrenchments cast up, on the slope of its site, for its defence [in fact field terraces]. *A precipitous road leads to the top. On the summit of a lower sterile hill, is the religious house Doünga chin* [unidentified]. *This view is taken near* Vuiga Puga *on the road to* Tassisudon: Pennant, *View of Hindoostan,* ii, p. 351.

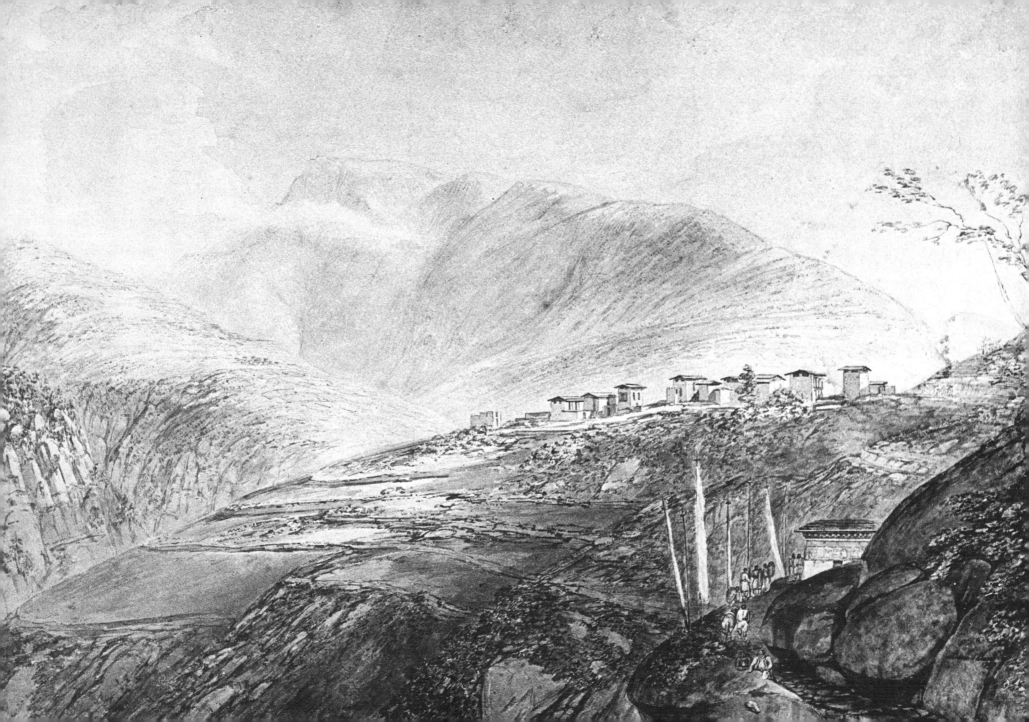

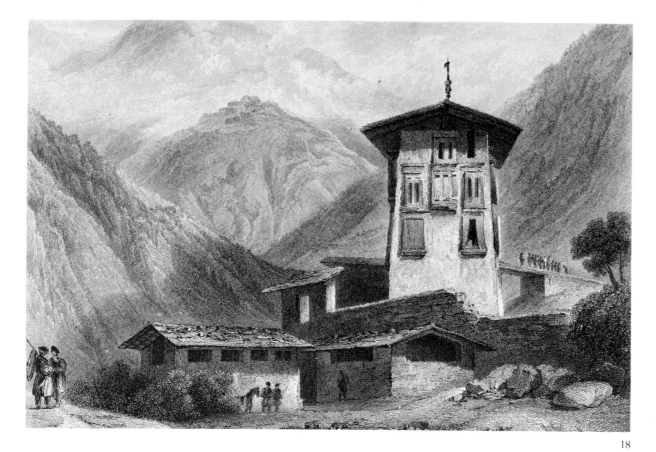

18

18. William Daniell after Davis (Victoria Memorial, Calcutta, R. 1716 watercolour, and R. 1724 pencil sketch), engraved by M. J. Starling, "Loomno, looking towards Tassisudon", 1839, engraving on steel, 5³/₄ × 3³/₄ in. Source: Hobart Caunter, *The Oriental Annual*, 7 vols. (London, 1834–40), vi, plate 11; also in Linney Gilbert, *India Illustrated* (n.p., n.d.), plate 6. "Loomno" can be identified with Turner's "Nomnoo" (see Map) where the mission spent the night of 30th May.

As we approached Nomnoo, the husbandmen were busied in the fields; the reapers were cutting down the corn with sickles, which others collected in handfuls, and bound up with a wisp of straw: we saw also oxen yoked in a plough, which was guided by a boy at the plough tail. We came early to Nomnoo, and were lodged in a large apartment in a spacious house, the walls of which were black from the smoke of a fire, which in the winter they commonly burn upon a large flat stone, in the middle of the room; the commodiousness of a chimney being here unknown: Turner, *Embassy*, p. 61.

19. "A Bhootan Landscape", 1783, watercolour, 19⁵/₁₆ × 14³/₁₆ in. Victoria Memorial, Calcutta, R. 1713, deposited by the Director-General of Archaeology in India, 1932.

Unidentified village with soldiers in foreground, probably on the first stage beyond the Pachu-Thinchu confluence towards the capital at Thinphu.

The road, on Friday the 30th of May, led by the river along the sides of the mountains, and there were few inequalities from hence to Nomnoo, and easy stages of about eight miles. We saw hermitages and villages spread over the sides and summits of the mountains, to each of which is allotted a spacious portion of cultivated ground: still much more appeared capable of improvement; for over the whole of these mountains, except where precipices or steep points project, there is a great deal of soil; yet vegetation is not so strong as the neighbourhood of Bengal. The trees are no where so numerous or flourishing, nor do the pines grow with that luxuriance, which might be expected in a favourable soil: Turner, *Embassy*, pp. 60–1.

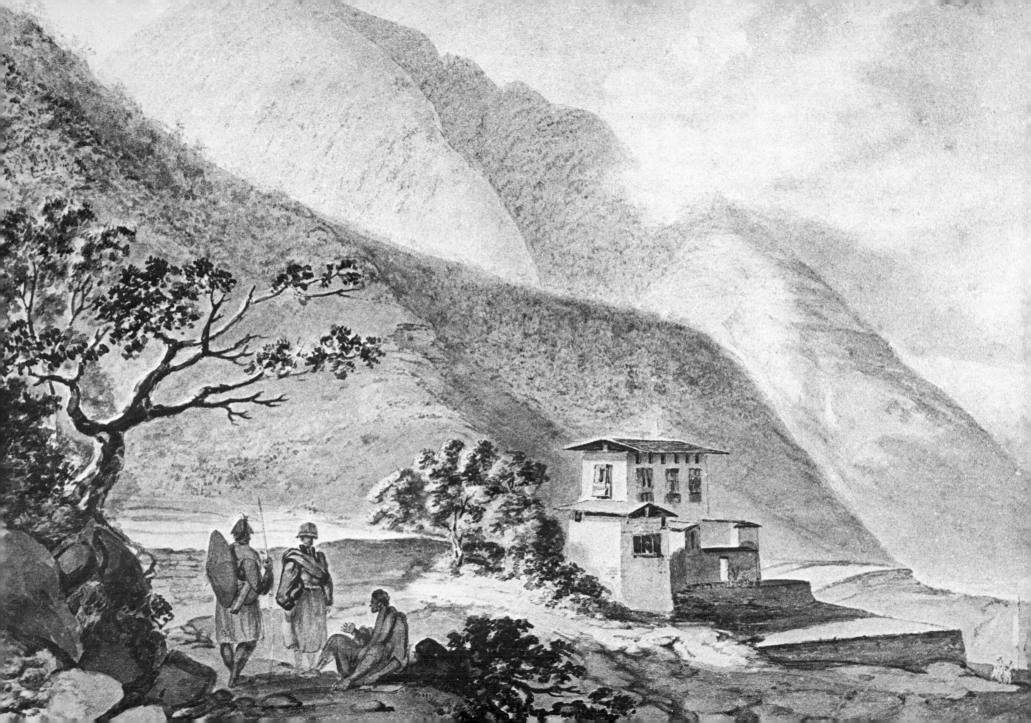

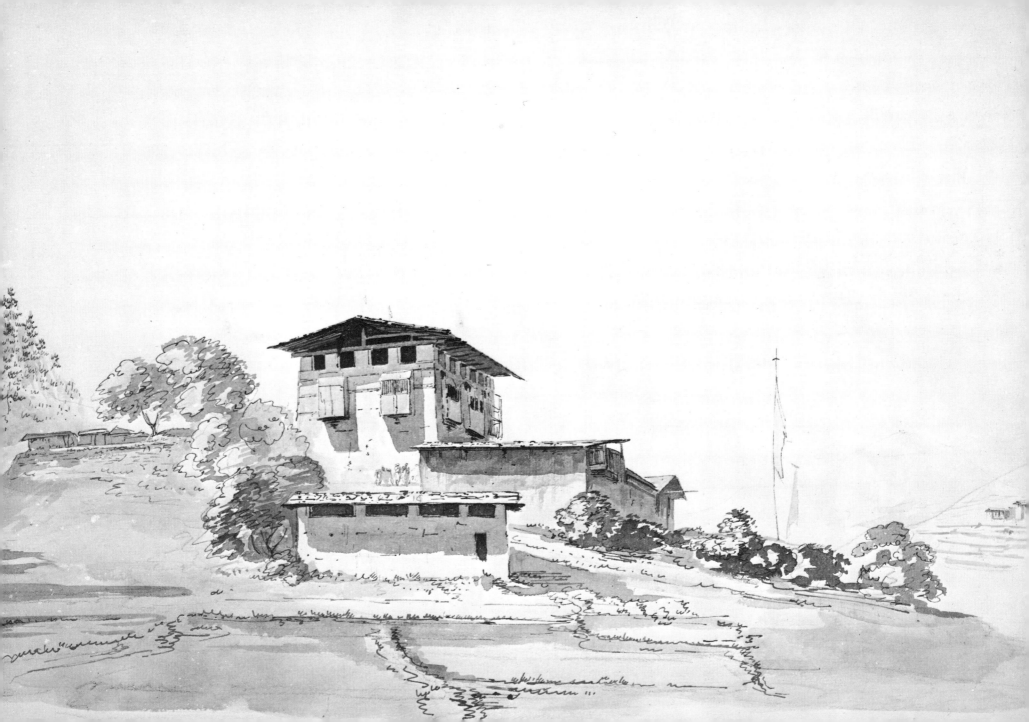

20. "Wankaka", 1783, wash-drawing, $13^5/_8 \times 9^1/_8$ in. Yale Center for British Art, Paul Mellon Collection, B1977.14.202, formerly in the possession of the artist's descendants, purchased 1967.

Unidentified monastery. "Wankaka" is Turner's "Wana-kha" ("Wangoka" of the Map), on the last stage before reaching the capital at Thimphu.

The road from hence [Paga] to Tassesudon [Tashichö Dzong], presents us with little that we have not met with; fewer strawberries; some very good orchards of peaches, apricots, apples, and pears. The fruit formed, and will be ripe in August and September. Met with two sorts of cranberry, one very good. Saw the fragaria sterilis and a few poppies. At Wanakha found a few turnips, shallots, cucumbers, and gourds. Near Tassesudon, the road is lined with many different species of the rose, and a few jessamine plants. The soil is light, and the hills in many places barren, rocky, and with very little verdure. The rock in general laminated and rotten, with many small particles of talc in every part of the country, incorporated with the stones and soil. Some limestone, and appearance of good chalk. Several good and pure springs of water: Saunders, "Account", in Turner, *Embassy*, pp. 393–4.

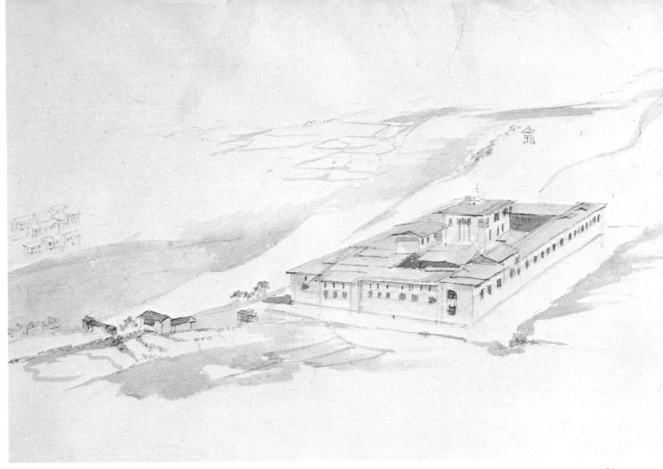

21

21. View of Tashichö Dzong from above, no title, 1783, wash-drawing, $10^7/_{16} \times 14^3/_8$ in. Yale Center for British Art, Paul Mellon Collection, B1977.14.205, formerly in the possession of the artist's family, purchased 1966.

Although the building was entirely rebuilt, except for the central "citadel" and one temple, in the late 1960s in order to convert it into the permanent seat of the modern government of Bhutan, it retains the basic layout seen here in the reconstruction of 1772. Bogle wrote that, "The building of it stripped naked several mountains".

The palace is divided into courts, flanked with galleries, supported on wooden pillars running round them, like the inns in England. The different officers have each their apartments. The gylongs [Buddhist monks] live in a large church, besides which there is a smaller one where they officiate, and where the larger images are kept. These images are mostly decent and well-proportioned figures, sitting cross-legged. There is a large gallery above the church, painted with festoons of death's-heads and bones, where folks go to see the ceremonies. I went once or twice myself; and the Rajah, thinking I was fond of it, used to send for me to church by break of day and at all hours, and congratulated me greatly on my good fortune in happening to be at Tassisudon during the grand festival [the "Thinphu Dromchö"]. All the governors of provinces repaired there to the presence, and there were [monastic] dances every day in one of the courts of the palace: Bogle, *Narratives*, ed. Markham, p. 27.

opposite

22. "The Palace of the Deib Rajah at Tassisudon [Tashichö Dzong]", 1783, watercolour, 17 ½ × 27 in. Yale Center for British Art, Paul Mellon Collection, B1977.14.285, formerly in the possession of the artist's descendants, purchased 1966. For a coloured aquatint of this view, see William Daniell, *Views in Bootan*, plate 1, "The palace of the Deib Rajah at Tassisudon".

The castle, or palace, of Tassisudon [seen here from the south] stands near the centre of the valley, and is a building of stone, of a quadrangular form. The length of the front, exceeds that of the sides by one-third: the walls are lofty, and as I conjecture upwards of thirty feet high, and they are sloped a little from the foundation to the top: above the middle space, is a row of projecting balconies, to each of which are curtains made of black hair, which are always drawn at night: below, the walls are pierced with very small windows, which I judge to be intended rather for the purpose of admitting air, than light. There are two entrances into the palace: the one facing south is by a flight of wooden steps, edged with plates of iron, beginning on a level with the ground on the outside, and rising to the more elevated terrace within, the whole being comprehended within the thickness of the wall. The other, the grand entrance, is on the east front, which is ascended by a flight of stone steps . . . We passed through this gateway, and came opposite to the central square building, which I must call the citadel; and this is the habitation of the supreme Lama: Turner, *Embassy*, pp. 90–1.

The magnitude, regularity, and showy decorations of this edifice, combined with the numerous clusters of houses and well cultivated state of the adjacent land, produced a favourable contrast with the wild and solitary aspect of the country through which the embassy had yet advanced, and afforded a favourable impression of the intelligence and civilization of the inhabitants of Bootan . . . On one of the adjacent hills is seen the rajah's villa of Wandechy [Plates 34–5], to which he occasionally retires by the zig-zag road which is visible on the side of the hill. The building seen lower down is a small castle or fortified house, the residence of a lama, or priest of high rank [Plates 32–3]. The red stripe observable on all these buildings, has a reference to the religion of the inhabitants: it invariably occurs where there is a chapel, or where the place is specifically dedicated to Budha: William Daniell, *Views in Bootan*, excerpt from caption [by Davis ?] to plate 3.

overleaf left

23. "Tassisudon [Tashichö Dzong], Bhutan / House where embassy was Lodged / Covered Bridge / the Palace", 1783, watercolour, 13 ½ × 18 ¾ in. Yale Center for British Art, Paul Mellon Collection, B1977.14.275, formerly in the possession of the artist's descendants, purchased 1967. For a coloured aquatint of this view, see William Daniell, *Views in Bootan* (London, 1813), plate 3, "View at Tassisudon".

The summer capital of Tashichö Dzong in the Thimphu valley was built in 1642 on the orders of *Shabdrung* Ngawang Namgyel, unifier of Bhutan, on the foundations of an older fort called Dongön or Donyuk Dzong. Nothing of the original building remains. After its destruction by fire in 1772, a new site was found and the fortress was very quickly rebuilt by command of the 16th Deb Raja. The hardship caused to the local population, and his consequent unpopularity, contributed to his downfall in 1773. By the time the first British mission led by Bogle arrived in 1774 the building, seen here from the north, had been standing for only about a year. The house where the missions of 1774 and 1783 were accommodated, seen here to the right above the river, was undoubtedly much older.

We were accommodated in a good house near the palace; and soon found it so cold that I was glad to hang my room, which was a wooden balcony [visible here], with Bhutan blankets. The window looked to the river, and commanded the best prospect: Bogle, *Narratives*, ed. Markham, p. 23.

Our habitation, which was within a stone's throw of the palace, was extremely commodious, and well adapted to our use. We entered, by a door on the south side, into a square court-yard; not very large, but it served to confine our cattle, and, indeed more than we wished to have there . . . We inhabited the upper story, which displayed a good suite of rooms, boarded, and divided by doors that turned on pivots. The eastern front next the river had a commodious balcony, which projected sufficiently to command a view of as much of the valley as was visible from any one point . . .: Turner, *Embassy*, pp. 93–4.

Though the ambassador's house exhibits no appearance of diplomatic dignity, it was clean and commodious, and formed with the adjoining buildings a square court-yard, with stabling for the horses, and lodging for the servants and native attendants . . . The trees near this building are intended to be portraits of

two pear-trees and a peach-tree. *The latter hides the view of part of the Palace. The bridge leads to a level lawn or meadow, formed on the margin of the Teenchoo by alluvion, and ornamented with willows planted in rows. To this spot the order of priests from the castle occasionally repair for the purpose of religious ceremonial, and at other times for recreation. Two of these persons are represented in their usual dress, made of woollen cloth, of which there is abundance, and some of good quality, manufactured in Bootan. The rapid descent of the river, when swoln by the rains, renders it necessary to secure the bank, which is done in the manner represented in the view:* William Daniell, *Views in Bootan*, caption [by Davis ?] to plate 3.

overleaf right

24. "Tassisudon [Tashichö Dzong] – House in which the Embassy was Lodged", 1783, watercolour, 18 ³/₁₆ × 25 ⅞ in. Yale Center for British Art, Paul Mellon Collection, B1877.14.283, formerly in the possession of the artist's descendants, purchased 1967. Other views of this fortress not included here are: (1) India Office Library and Records, London, WD 3267; (2) Victoria Memorial, Calcutta, R. 1719?; (3) Turner, *Embassy*, plate 6; (4) Pennant, *The View of Hindoostan*, vol. i, head-piece.

The palace of Tassisudon is situated in a valley about five miles long and one broad, entirely surrounded with high mountains. The river Chinchu [Thinchu] gallops by; the low grounds near it being covered with rice, and well peopled. Villages are scattered on the brow of the hills. Immediately behind Tassisudon there is a very high mountain . . . and some solitary cottages, the retreat of dervises, are here and there dropped as from the clouds. In these airy abodes they pass their days in counting their beads, and look down with indifference on all the business and bustle of the world, from which they are entirely excluded.

The palace is a very large building, and contains near 3000 men, and not a woman. Of these about 1000 may be gylongs [Buddhist monks], some of the former chief's [the ousted 16th Deb Raja] adherents, who are kept in a kind of imprisonment, and the rest the Rajah and Lama's officers, and all their train of servants. A tower, about five or six stories high, rises in the middle, and is appropriated to Lama-Rimboché [the acting head of state – see Appendix]: Bogle, *Narratives*, ed. Markham, pp. 23, 26.

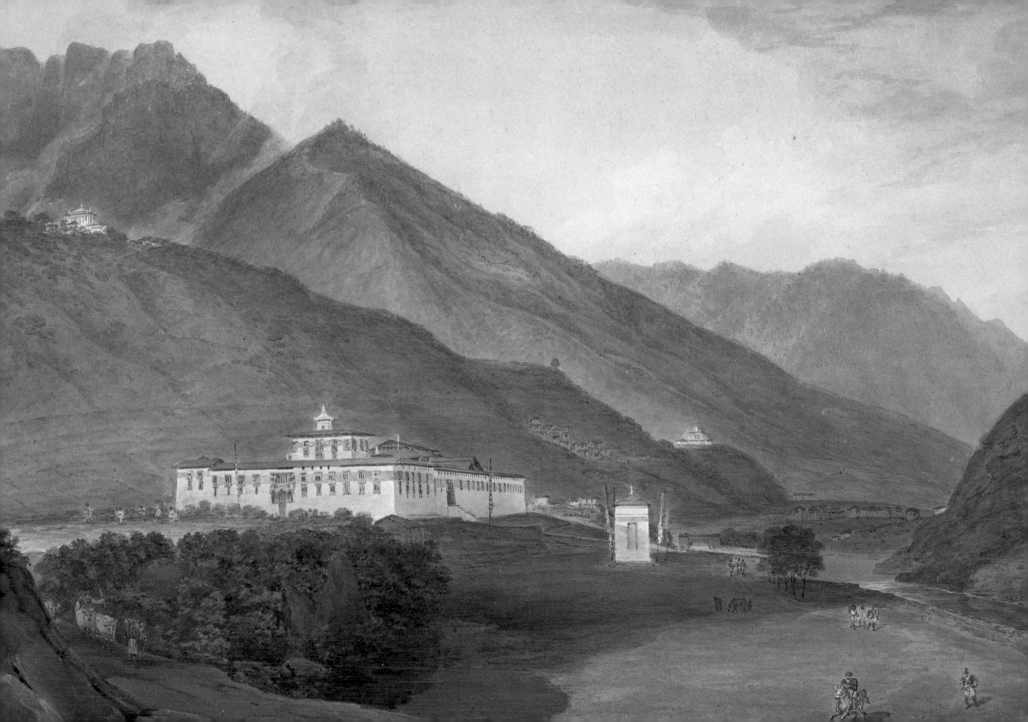

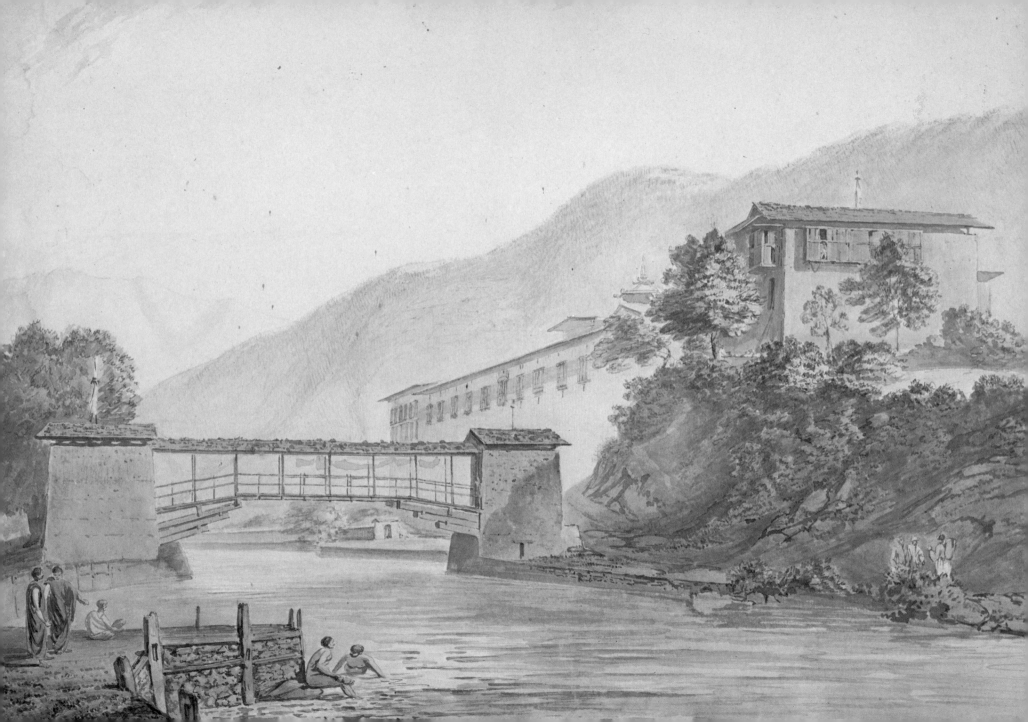

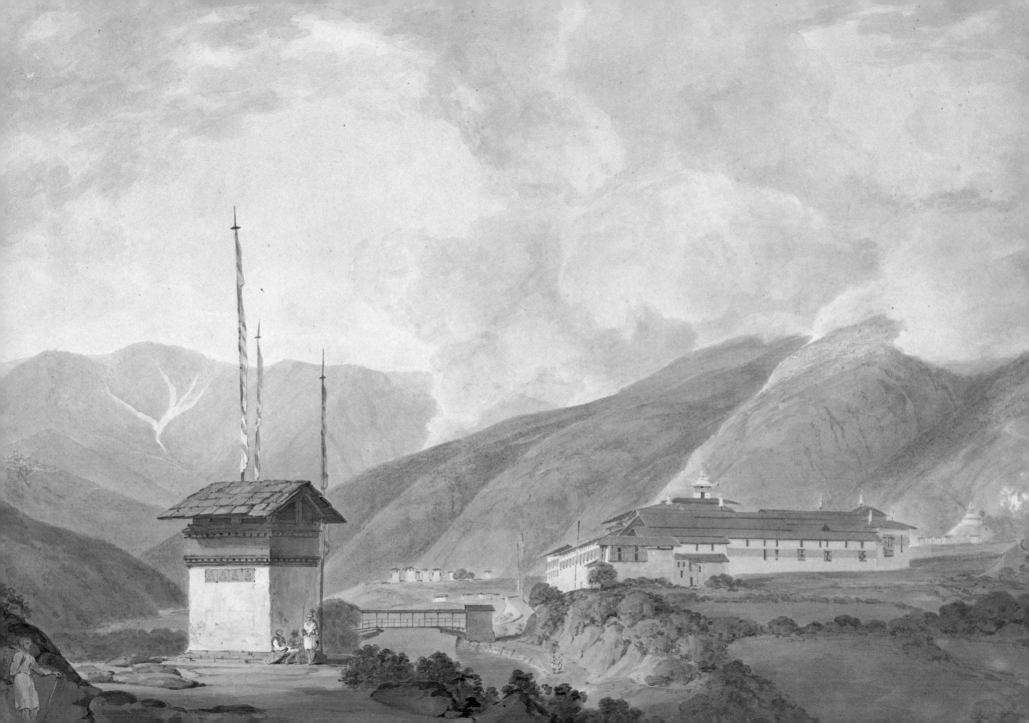

25

26

25. Detail of the watercolour illustrated in Plate 52.
26. Detail of the watercolour illustrated in Plate 28.
27. "Bootan", three pencil studies of a Bhutanese warrior. Private Collection.

The Booteeas are a strong and hardy race, by no means deficient in manly courage. Their feeble mode of attack and defence is, therefore, imputable only to their want of discipline; to their not fighting in compact files or platoons; and to their consequent distrust of each other; and something must also be attributed to their utter inexperience of war: for indeed, among this crowd of combatants, we find merely husbandmen and villagers, called at once from their peaceful occupations to the field of battle.

Every kind of discipline and order is totally disregarded in their mode of warfare; stratagem is more practised than open assault: they engage in general as marksmen, and wait their opportunity to fire unobserved. Both parties are so careful to conceal themselves, that seldom any thing is visible but the top of a tufted helmet, or the end of a bow: no wonder, therefore, that in their contests very few are killed.

The accoutrements of a fighting man, fully equipped, are extremely cumbrous. A prodigious deal of loose clothing surrounds the body: besides the common mantle, he wears very often a blanket, or thick quilted jacket. This, as well as the helmet, (which is made either of stained cane, coiled conically, or else of cotton rope, quilted between two cloths, with flaps that occasionally turn down over the ears, and a piece to cover the nose,) if not absolutely proof against the stroke of a sword or arrow, must at least considerably weaken its force. He carries upon his arm a large convex shield of painted cane, coiled close, and a long straight sword is worn across the body, thrust through the belt before. To these arms must be added, a bow, and a quiver of arrows, slung by a belt behind the back; the arrows being commodiously drawn from it over the left shoulder. The bow is held in the right hand; it is commonly six feet long, made of bamboo, and, when unstrung, is perfectly straight . . .

. . . Their fire-arms are very contemptible; evidently of no use, but in the fairest weather, when the match will burn, and the priming, in an open pan, take fire. In the management of the sword and shield they are sufficiently dexterous, and undoubtedly most excellent archers: Turner, *Embassy,* pp. 117–20.

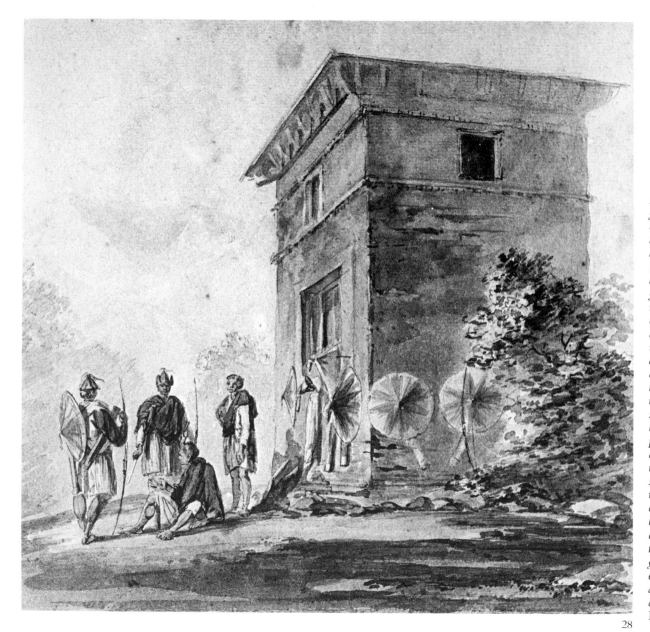

28

28. "View of Bhootan", 1783, watercolour, 19¹/₈ × 12 in. Victoria Memorial, Calcutta, R. 1254, formerly in the possession of Warren Hastings, deposited 1916.
29. William Daniell after Davis (see opposite), engraved by W. J. Cooke, "Guard House near Tassisudon", 1838, engraving on steel, 5³/₄ × 3³/₄ in. Source: Hobart Caunter, *The Oriental Annual*, 7 vols. (London, 1834–40), v, plate 21.

A soldier in Bhutan has not a distinct profession. Every man is girt with a sword, and trained to the use of the bow. The hall of every public officer is hung round with matchlocks, with swords and shields. In times of war or danger, his servants and retainers are armed with these; the inhabitants, assembled from the different villages, are put under his command, and he marches in person against the enemy. The common weapons are a broadsword of a good temper, with shagreen handle; a cane-coiled target, painted with streaks of red; a bow formed of a piece of bamboo; a quiver of a junk of the same tree, the arrows of reeds, barbed, and often covered with a poison said to be so subtile that the slightest wound becomes mortal in a few hours. Some few are armed with a pike. They put great confidence in firearms; but are not so cunning in the use of the matchlock, as of their ancient weapons, the sword and the bow. Their warlike garb is various and not uniform. Some wear a cap quilted, or of cane and sugar-loaf shape, with a tuft of horse-hair stained; others, an iron-netted hood, or a helmet with the like ornament; under these they often put false locks to supply the want of their own hair, which among this tribe of Bhutanese is worn short. Sometimes a coat of mail is to be seen. In peace as well as in war, they are dressed in short trousers, like the highland philabeg; woollen hose, soled with leather and gartered under the knee; a jacket or tunic, and over all two or three striped blankets. Their leaders only are on horseback, and are covered with a cap, rough with red-dyed cowtails [yak-tails]. They sleep in the open air, and keep themselves warm with their plaids and their whisky. When they go to war or to an engagement, they whoop and howl, to encourage each other and intimidate the enemy. They are fond of attacking in the night time. As to their courage in battle, those can best speak who have tried it. I saw only some skirmishes: Bogle, *Narratives*, ed. Markham, pp. 62–3.

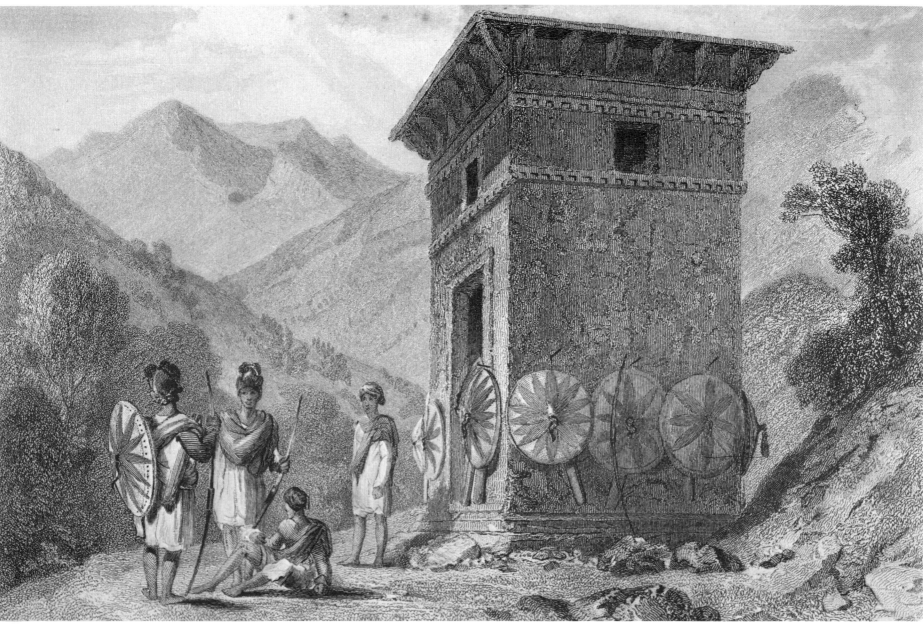

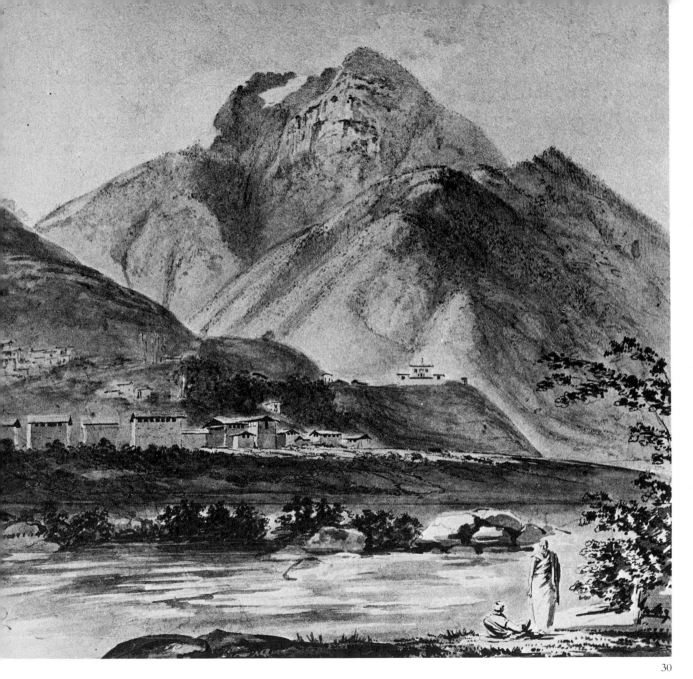

30

30. View of part of the Thinphu valley, looking north-west, the temple of Dechen Phodrang (Plates 32–3) visible on a hillock in the middle distance, and two monks in the foreground, no title, 1783, watercolour, 18⁷/₈ × 13 in. Victoria Memorial, Calcutta, R. 1722, deposited by the Director-General of Archaeology in India, 1952.

31. "Near Tasissudon", 1783, wash-drawing, 13⁹/₁₆ × 19¹/₈ in. Yale Center for British Art, Paul Mellon Collection, B1977.14.250, formerly in the possession of the artist's descendants, purchased 1966. For a coloured aquatint of this view, see William Daniell, *Views in Bootan*, plate 6, "A Temple of Bode".

This "chöten" shrine has a most unusual bulbous form that is not seen in Bhutan today. The imposing structure seen here stood on the banks of the Thinchu river, a few hundred yards east of the fortress of Tashichö Dzong. No trace of it remains today.

A similar building is seen, placed like a centinel, as it were, by the road side, on each approach towards every consecrated habitation, proportionate in its dimensions to the magnitude and importance of the edifice with which it is connected: on each of the three great roads, that lead to Tassisudon, a very spacious one is found. They have one small doorway, which always remains closed [evidently not this one], at least I never could succeed in my endeavour to obtain a view of the interior; yet such is the superstitious respect of the inhabitants for its contents, that they constantly uncover their heads, and if travelling on horseback, dismount and walk while they pass by them: Turner, *Embassy*, p. 97.

The temples of Bode in Ceylong, Siam, and Pegu, as described by travellers, are generally solid structures of different forms. The temple shewn in the view is of this class, but enclosed in a building to defend it from the weather. It is erected on a level slip of alluvial land formed on the side of the river Teenchoo, about a mile below Tassisudon, and it serves the adjacent villagers for the exercise of their devotion. The idol is to be viewed in a niche on the side of the vase-shaped temple. In the distance is seen a small villa of the Rajah's [see Plates 34–5], and the view terminates with the mountain behind Tassisudon. The high poles erected at the angles of the building are such as occur throughout the country on elevated points of the road, or near temples and public edifices. They carry a strip of cloth, on which, in repetition from top to bottom, is printed the devout sentence – Om-ane-pee-mee-hon [Oṃ maṇi padme hūṃ]: William Daniell, *Views in Bootan*, caption [by Davis ?] to plate 6.

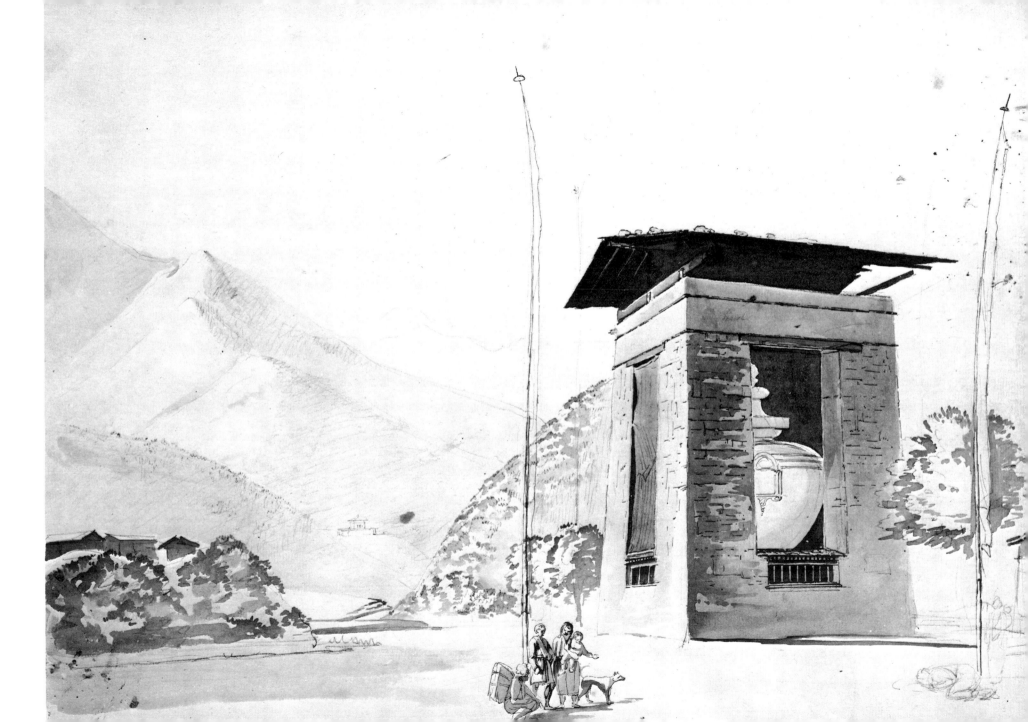

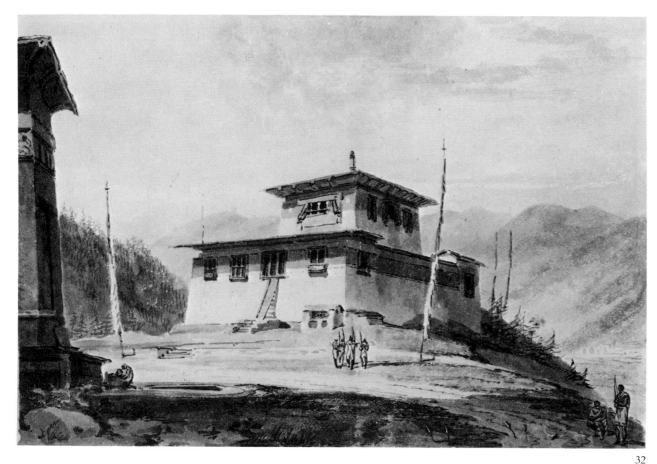

32

32. The temple of Dechen Phodrang, Thinphu, no title, *c.* 1800, wash–drawing by an unknown artist after Davis, 6⅞ × 10 in. British Museum, Department of Prints and Drawings, 1944–10–14–194, gift in 1944 of Miss C. M. Turner, descendant of J. M. W. Turner. The original watercolour, much faded, upon which this view is based is in the Victoria Memorial, Calcutta, R. 1728.

33. Engraving by James Basire after a copy of Davis (see opposite), "The Residence of Lam' Ghassa-too", 1800, 9¾ × 6⅞ in. Source: Turner, *Embassy*, plate 7.

The 'Palace of Great Happiness' (Dechen Phodrang) may have been the seat of the incarnations of Jampel Dorje (1631–?81), who was the son of the founder of Bhutan, *Shabdrung* Ngawang Namgyel: "Lam' Ghassa-too" is Turner's rendering of the title by which these incarnations were addressed (Tibetan *Bla-ma rGyal-sras sPrul-sku*). However, the incumbent in 1783, Jigme Namgyel, was twenty years old, which does not accord with Turner's description of him as "an infant in arms", the nephew of the reigning Deb Raja. The child referred to by Turner may perhaps be identified with the third incarnation of the 'verbal principle' of the founding *Shabdrung*, Yeshe Gyeltsen (1781–30).

The low hill on which the palace, or residence, of Lam' Ghassatoo stands, is upon the left [of the site of the previous fortress], *and as long as they lasted, we were induced to loiter away many an evening, in picking strawberries from its sides, which were clothed with them from its foot to the very foundation of the palace walls. The Gylongs* [Buddhist monks] *used to look at us from the windows with amazement . . .*

Our return, when we chose to vary from the road by which we came [on our walks back to our lodgings], *was in front of the palace of Lam' Ghassatoo, on the south side of which was a long narrow tract of level ground, supporting many tall flagstaffs, that had narrow banners of white cloth reaching nearly from one end to the other, and inscribed with the mystic words,* Oom maunie paimee oom: Turner, *Embassy*, pp. 95, 96–7.

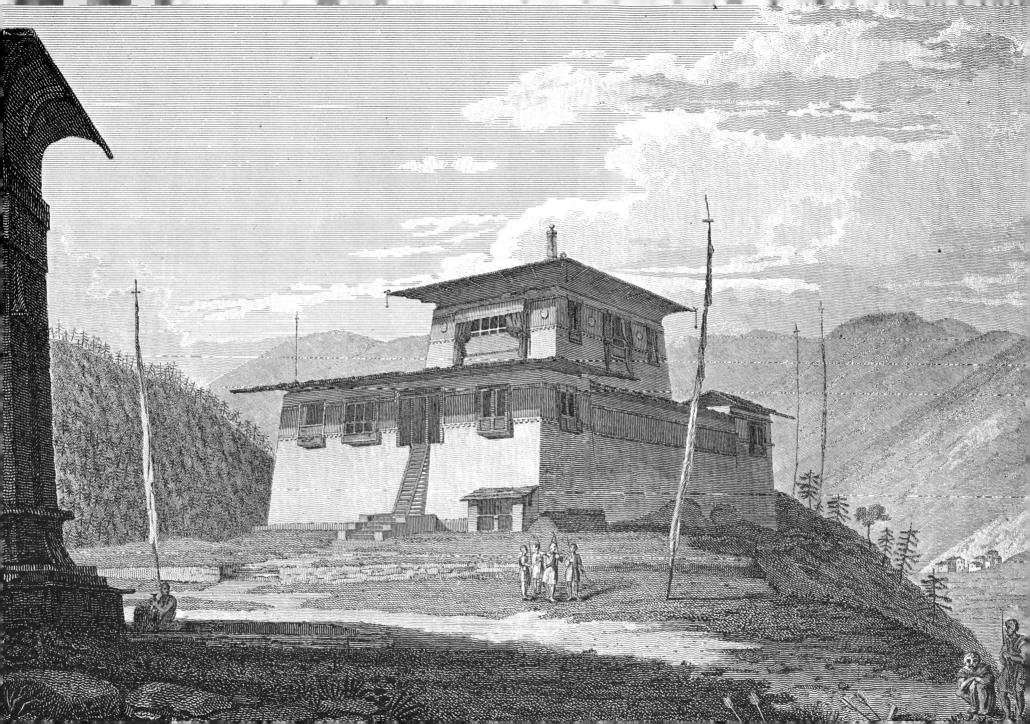

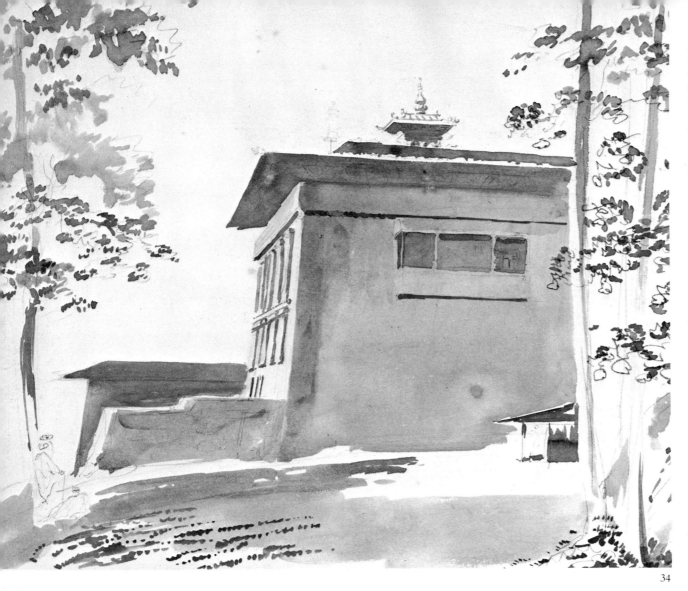

34

34. The temple of Wangdütse, no title, 1783, wash-drawing, 13½ × 19 in. Yale Center for British Art, Paul Mellon Collection, B1977.14.246, formerly in the possession of the artist's descendants, purchased 1966. *The Raja [Jigme Senge] having determined, before the great festival, to retire to his villa ["Wandechy" of the Map]*

situated upon the ridge of the western mountain, he invited us to come early one morning, and pass the day there, which we agreed to; and soon after he had left the palace, a time was fixed for our visit . . . Having ascended to the gates of the villa, we did not enter it; but, turning to the left, found the Raja seated in a pavilion erected upon the edge of a deep precipice, which it partly

overhung, commanding a beautiful prospect of the valley, the castle, and the river, with many populous settlements, distributed over the surrounding mountains . . . Two musicians, placed at a distance, played upon reed instruments, in wild and not unharmonious strains, while the Raja held us in conversation, on the customs and produce of foreign countries; subjects on which he sought for information, with insatiable avidity. [The Raja speaks to them about "a race of people, of uncommon stature, inhabiting a prodigiously high mountain" east of Bhutan, also another race who live in the same area north of Assam who have "short straight tails, which, according to report, were extremely inconvenient to them, as they were inflexible"; and about "a sort of horse, with a horn growing from the middle of his forehead". The Raja continued with an account of his own pilgrimage incognito to Lhasa.] *As the hour of dinner now approached, we were desirous awhile to stroll and look about us, which as soon as the Raja understood, he recommended to us to view the inside of his villa . . . On the lower floor we found a superb temple, in which some of the Gylongs [Buddhist monks] are perpetually employed in reading their sacred writings . . . Some mythological paintings, and symbols of their system of creation, decorated the walls; and in a large hall adjoining, were hung up representations of the city of Lassa, and the monastery of Pootalah, the residence of Dalai Lama; of Lubrong, the residence of Teshoo Lama, in Tibet; and of Cattamandu, the capital of Nipal, and Patan, in the same kingdom, as well as of other places of famed resort. Their representations partook both of plan and perspective; and, without the advantages of light and shade, a pretty good idea of the stile of building peculiar to each country might be collected from them . . . Some time elapsed, though we hastily ran over the different rooms; and when we descended to the pavilion, we were immediately called to dinner . . . The Raja supplied a dish of strange heterogeneous composition, for which, not all his rhetoric could give us a relish. It was an olio, consisting of rancid butter, various vegetables, rice, spices, and fat pork: a meat against which, our experience in this country, had inspired us with an invincible prejudice. The fermented infusion, called Chong, was more acceptable, and we drank of it plentifully.* [The day ended with] *a bull fight, between two animals, the strongest and fiercest of the species I ever beheld:* Turner, *Embassy*, pp. 154–9.

35. William Daniell after an untraced original by Davis, engraved by J. Redaway, "The Palace at Wandechy – Bootan", 1837, engraving on steel, 5¾ × 3¾ in. Source: Hobart Caunter, *The Oriental Annual*, 7 vols. (London, 1834–40), iv, plate 12.

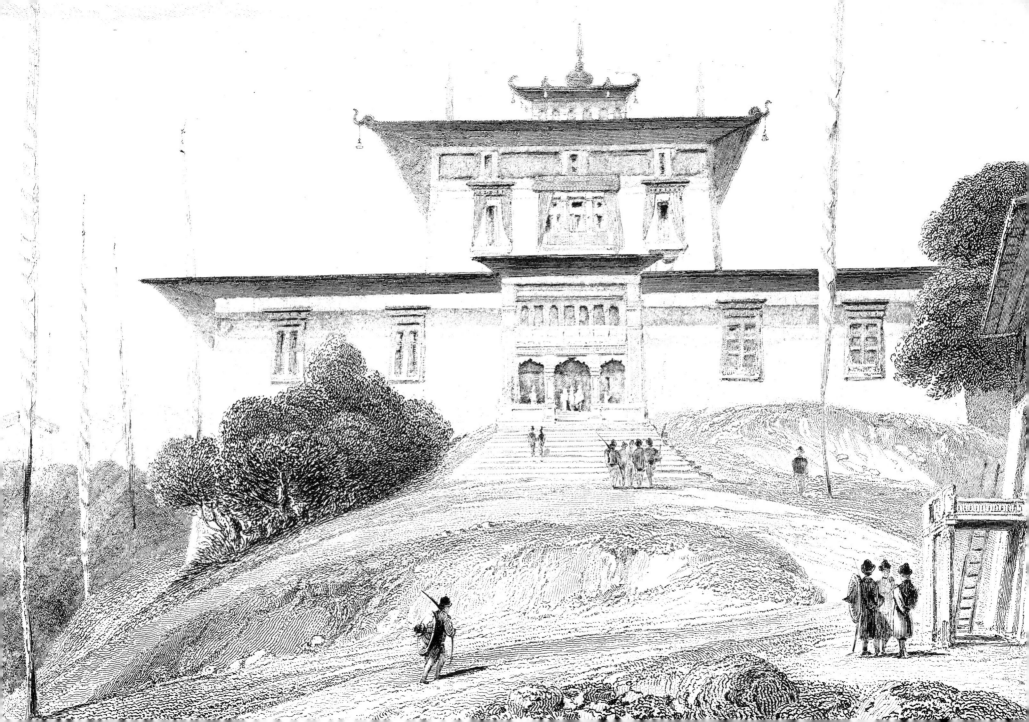

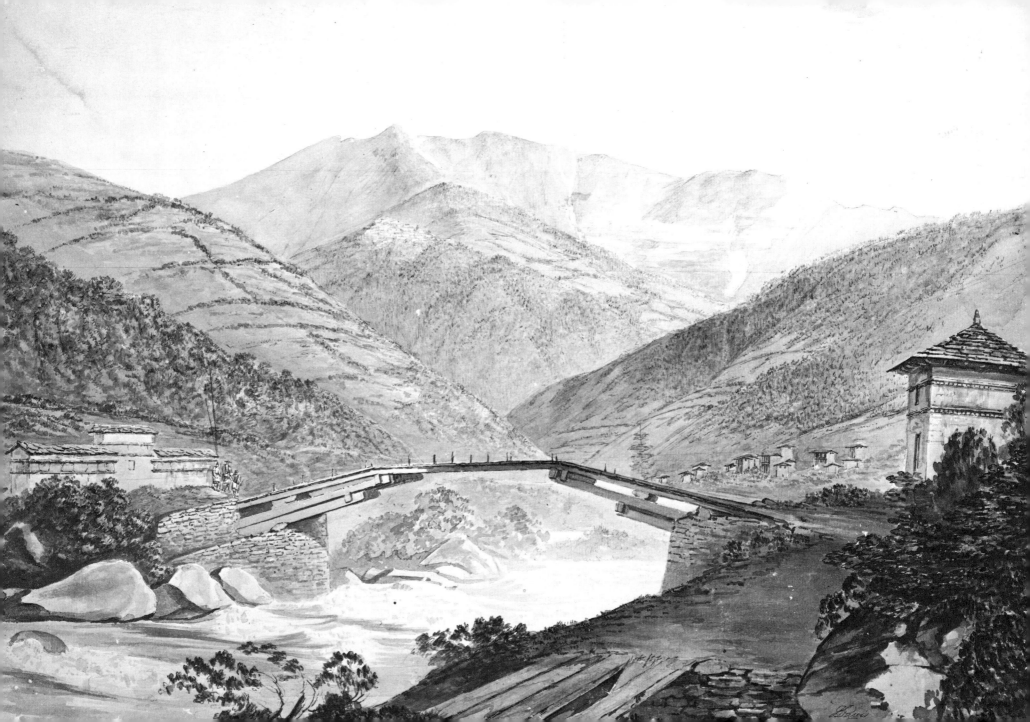

36. "View near Tasisudon [Tashichö Dzong] in Butan", 1783, watercolour, $13^3/_{16} \times 18^7/_8$ in. Yale Center for British Art, Paul Mellon Collection, B1977.14.259, formerly in the possession of the artist's descendants, purchased 1966. For a coloured aquatint of this view, see William Daniell, *Views in Bootan* (London, 1813), plate 4, "View on the river Teenchoo".

The cantilever bridge seen here across the Thinchu river has been replaced with a modern motor-bridge. It retains its old name, "The Bridge of Prophecy" (Lungtenzam).

A narrow slip of three or four miles in length, and in its widest part not exceeding one mile in breadth, has been made choice of for the situation of the capital. It may rather be termed, I think, a softened glen, which lying betwixt the vast mountains that give a passage to the river Tehintchieu [Thinchu], ornament its border, by an easy slope of their bases to its sides; thus forming a bank of the richest soil, which the industrious Bootea well knows how to cultivate. It was, upon our arrival, luxuriantly clothed with the most promising crops of rice, which, in defect of rain, all the springs of the surrounding mountains, are artificially conducted to fertilize. There is no town, nor indeed any house, except that which we occupied, within a mile of the palace; but a few clusters of houses, distributed in different parts among the fields, when the eye is weary of contemplating the bold features of near and distant mountains, and scanning their wonderful combinations, serve as points of rest, and call back the wandering mind from a rude incoherent chaos, to repose amidst the fruitful and ingenious efforts of husbandry and population: Turner, *Embassy*, pp. 89–90.

The direction of this view, taken three miles below Tassisudon, is on the course of the Teenchoo in its rapid descent towards Bengal. Seen in profile, the breadth of the bridge, which is about fifteen feet, scarcely appears. The buildings on each side of the river are such as often occur in Bootan by the road side: the most distant is of that class, which consists of a solid wall built to receive the red stripe, which is symbolical, and never fails to adorn religious structures. It bears likewise inscriptions in a character which appeared to the travellers to be deva-nagri, *conveying, as they were informed, religious and moral instruction. It has niches, in which are sometimes placed idols, to be viewed through gratings, in a mode not dissimilar to what is observable in Roman Catholic countries, or the niche may be found to contain a wheel, the barrel of which encloses a roll of paper, printed all over with the sentence* Om-ane-pee-mee-hon [Oṃ maṇi padme hūṃ]. *This sentence is repeated by probationers for the priesthood during their noviciate, and by other devout persons as they tell their beads. Travellers are expected as they pass to give the wheel a twirl. The building on the foreground was converted into a post to command the passage of the river, in the course of the insurrection which happened when the embassy was at Tassisudon.* [See Plate 28.] *In the village seen on the summit of the hill in the middle of the view, resides a fraternity of Gylongs or Priests of Budha, or Bode:* William Daniell, *Views in Bootan*, caption [by Davis ?] to plate 4.

following 4 pages overleaf
37. "Near Tassisudon", $13^7/_{16} \times 18^7/_8$ in. B1977.14.194.
38. "In the Village near Tassisudon", $13^9/_{16} \times 18^3/_{16}$ in. B1977.14.241.
39. "In the Village near Tassisudon", $13^7/_{16} \times 19^1/_{16}$ in. B1977.14.242.
40. "Near Tassisudon", $13^{11}/_{16} \times 19^{13}/_{16}$ in. B1977.14.243.

These four wash-drawings are all devoted to examples of village architecture in the Thinphu valley. They are from the Paul Mellon Collection, Yale Center for British Art, formerly in the possession of the artist's descendants, purchased 1966. A steel engraving of the last view by W. J. Cooke in 1837, based on a version by William Daniell, is found in Hobart Caunter, *The Oriental Annual*, 7 vols. [London, 1834–40], iv, plate 8, bearing the incorrect title of "Near Buxaduwar, Bootan". Caunter, *op. cit.*, p. 54, says the building is "the dwelling-house of the chief of a small village in Boutan . . . The houses in general are not much inferior to this. Its situation is highly romantic". The building in Plate 37 is probably a mill. The phallic symbols hanging below the eaves as seen here are still found in many houses in Bhutan today; their purpose is said to be to ward off "malicious gossip *(mi-kha)*".

These typical examples of Bhutanese domestic architecture share the common features of tapering walls of *pisé* construction, shingle roofs, and projecting wooden balconies supported on pillars. Generally, the ground floor is used for domestic animals and storage, the middle floors for the family's living quarters, and the attic below the roof for storing fodder and grain.

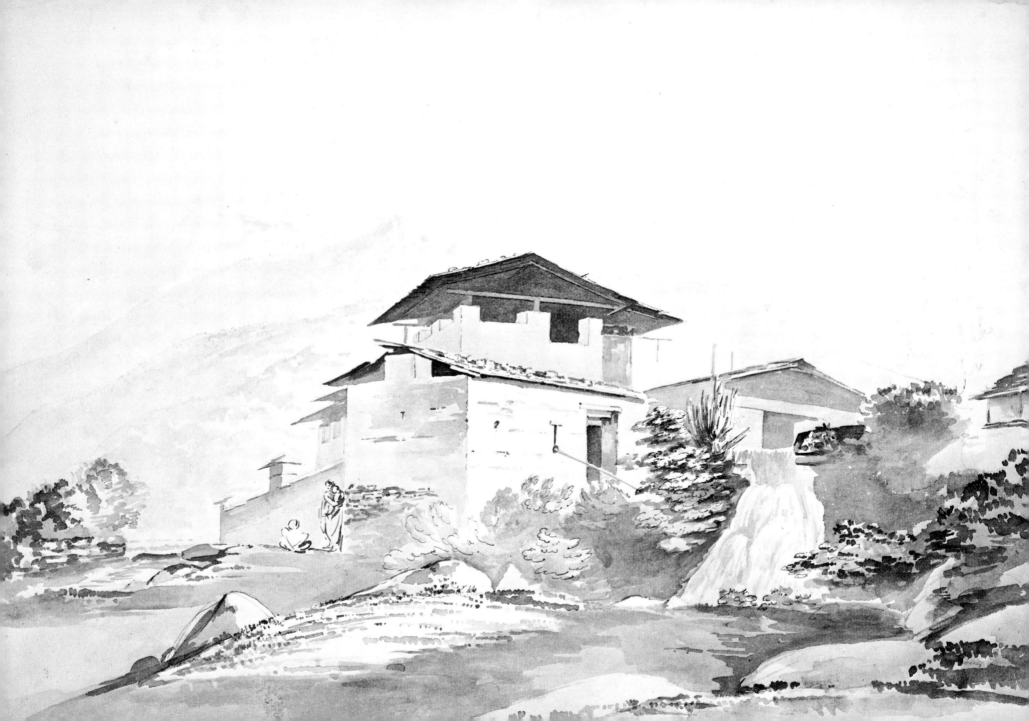

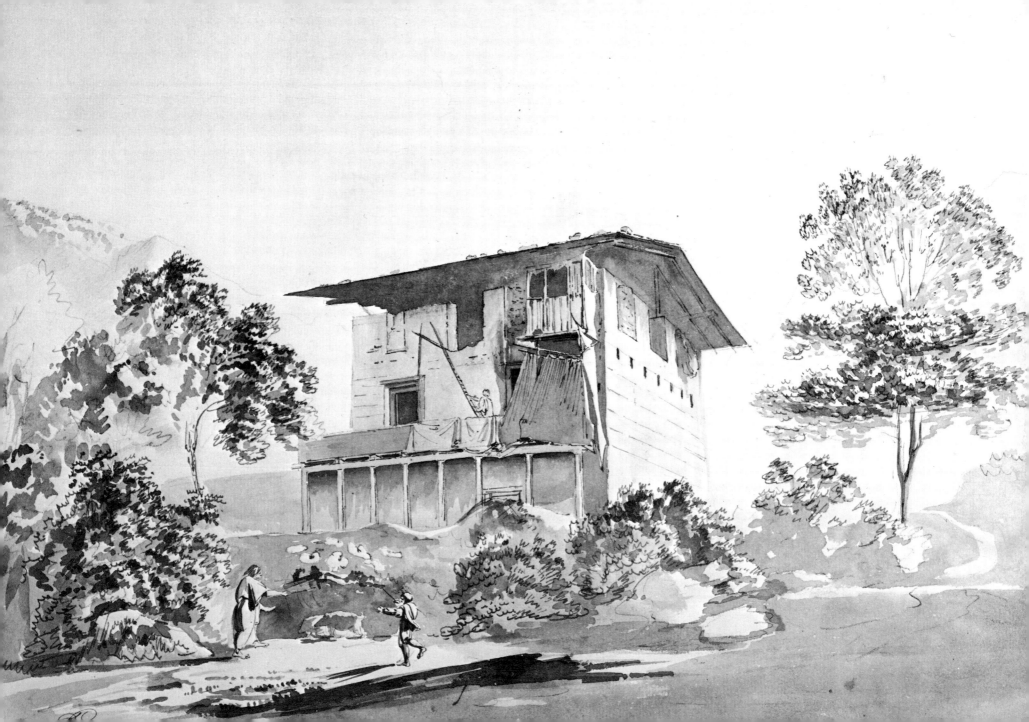

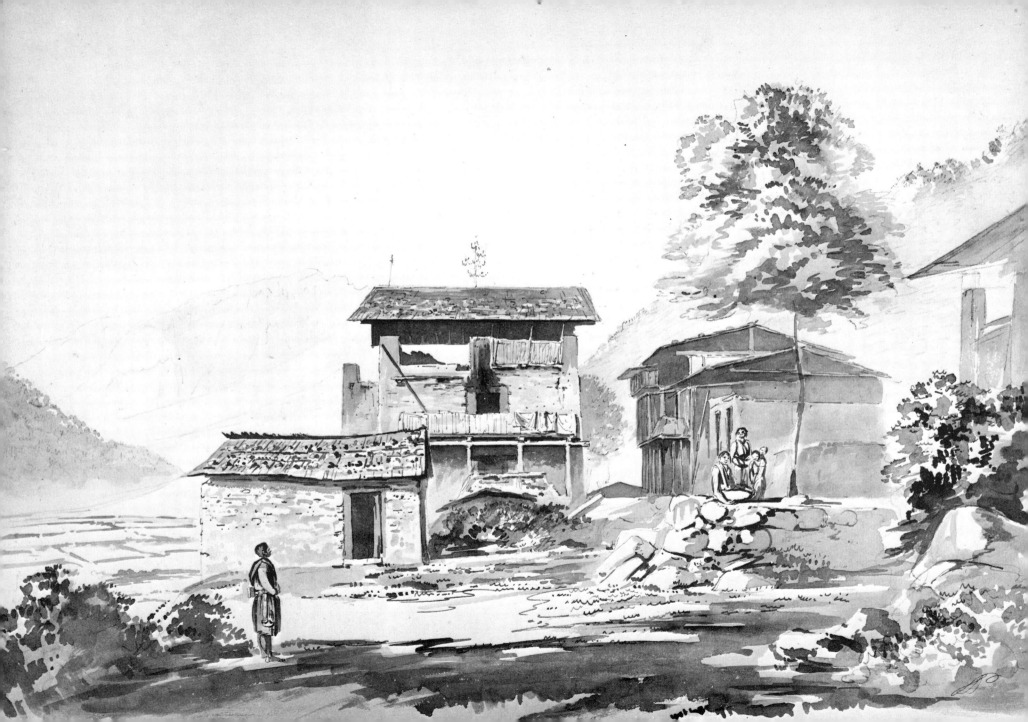

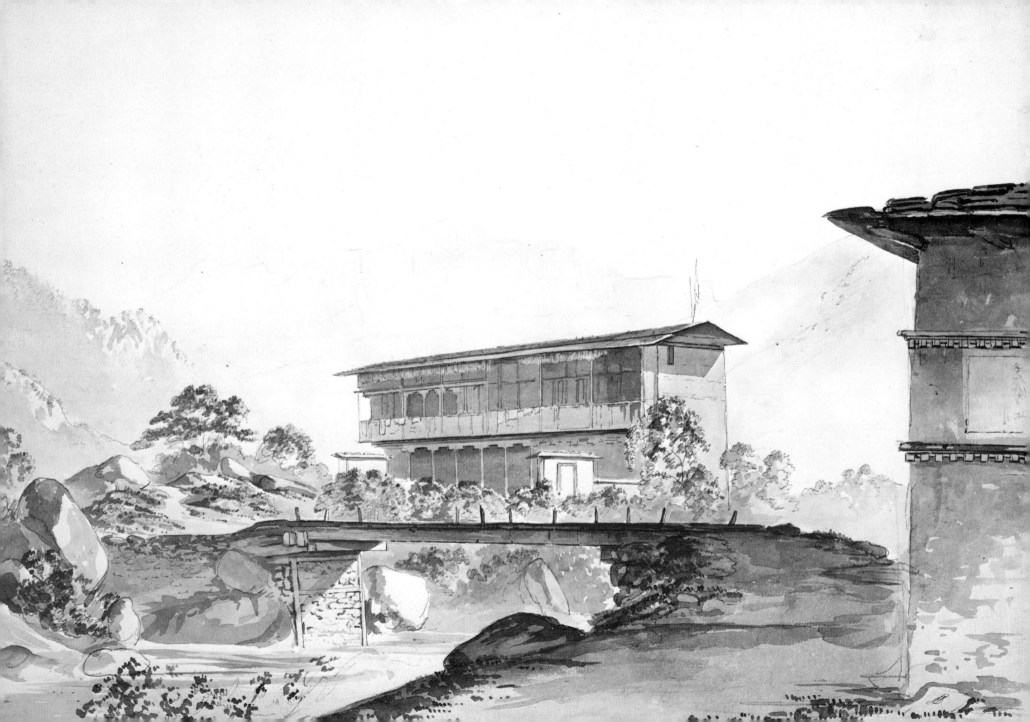

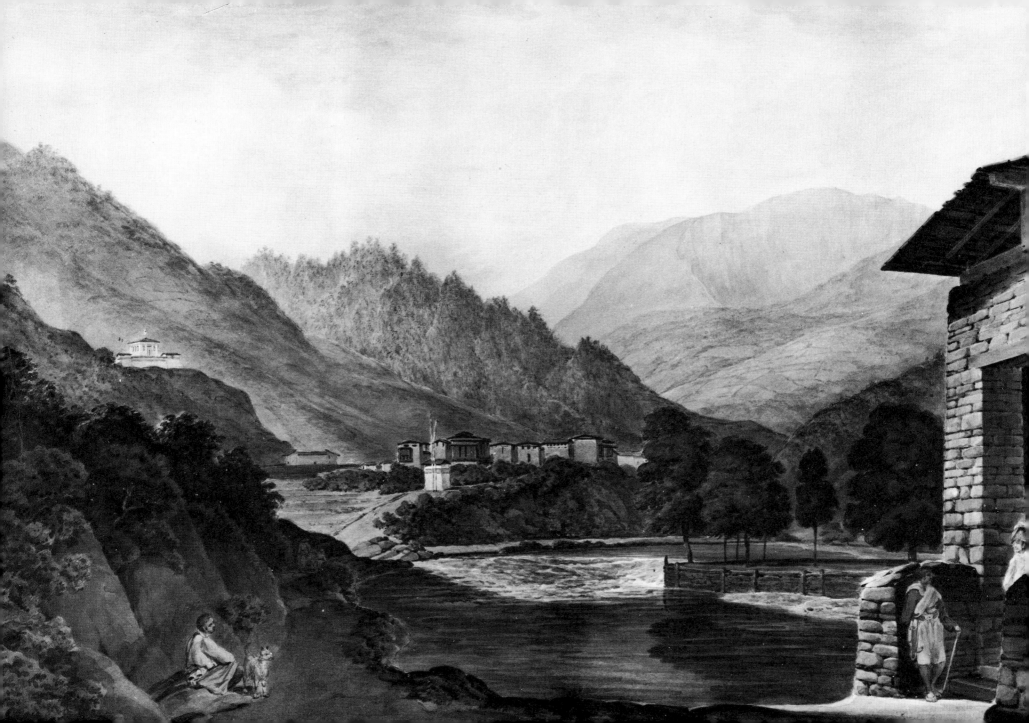

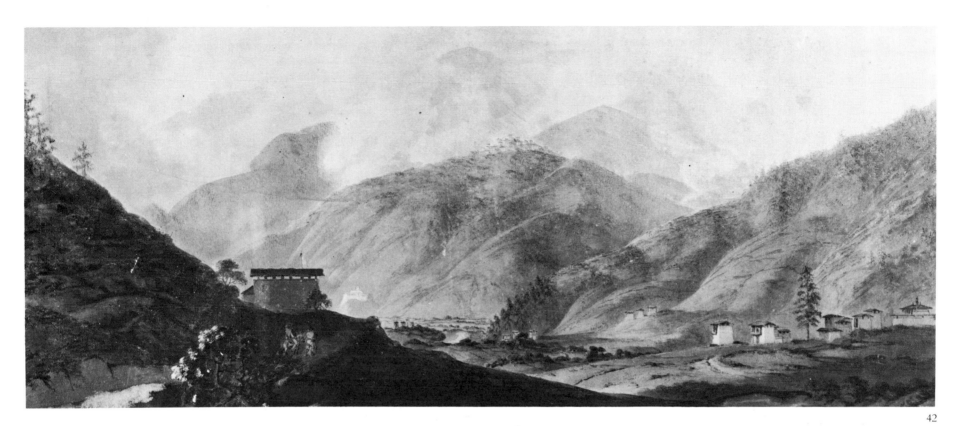

42

41. Scene in the Thinphu valley, no title, 1783, watercolour, 17³/₄ × 25³/₄ in. India Office Library, Department of Prints and Drawings, WD 3268.

42. "Near Tacisudon", 1783, detail of a watercolour, 19 × 28 in. India Office Library, Department of Prints and Drawings, WD 3269.

The drawings in both Plates were acquired in 1974 from the Royal Geographical Society, together with the view of Punakha in the Frontispiece and two others. They had been presented to the Society in 1921 by Lord Curzon, who had received them from Sir Leicester Beaufort, great-grandson of Samuel Davis. Plate 42 shows a temple which still stands in the Thinphu valley and a distant view of Simtokha Dzong, founded by *Shabdrung* Ngawang Namgyel in 1629 as the first of his fortresses. Plate 41 is a view of the northern end of the Thinphu valley, with the temple of Dechen Phodrang (see Plates 32–3) visible on a hillock to the left and the bridge-house (see Plate 23) of Tashichö Dzong in the foreground to the right.

While I was at Tassisudon an insurrection broke out in favour of Deb Judhur [Zhidar], the former chief [see pp. 15–17 above]; and the disturbances which this occasioned protracted my stay. The malcontents, after a fruitless attempt on the palace of Tassisudon, seized Simptoka [Simtokha], a castle in its neighbourhood, in which they found arms and ammunition . . . The castles [of Bhutan] . . . want but the mote and the bridge to resemble the Gothic castles of our ancestors. There are only two ways of reducing them - by fire or by famine . . . But Simptoka having been built by Deb Seklu [?], a very popular Rajah, and being full of furniture and effects belonging to the government, it was resolved to blockade it. Troops were accordingly collected from the distant provinces, and three of the roads were stopped up. The fourth, however, was still open. The Deb Rajah's force increased every day. Deb Judhur's party saw no prospect of assistance; and after a siege of ten days they abandoned Simptoka, and being favoured by moonlight, escaped over the mountains into Teshu [Panchen] Lama's country.

I left Tassisudon on the 13th of October, 1774, the day of their retreat . . . We passed Simptoka, and came up with a party of the Deb Rajah's men. They halted at a little village, and their leader sent for us . . . He enjoys the first place in the chief's favour, and his sagacity and superior abilities entitle him to it. In anything that relates to the government of his own country, he might be pitted against many a politic minister. As a philosopher, he would twist him round his finger. Of a truth, an ounce of mother-wit is worth a pound of clergy: Bogle, *Narratives,* ed. Markham, pp. 61–2.

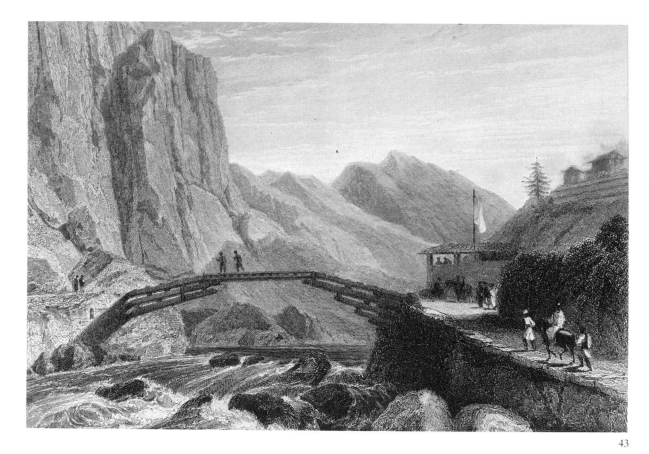

43. William Daniell after Davis (see Plate opposite), engraved by J. C. Armytage, "View near Wandepore", 1837, engraving on steel, 5³⁄₄ × 3³⁄₄ in. Source: Hobart Caunter, *The Oriental Annual*, 7 vols. (London, 1834–40), iv, plate 10.

44. "Bhootan Scene", 1783, wash–drawing, 18¹⁄₈ × 13 in. Victoria Memorial, Calcutta, R. 1714, deposited by the Director–General of Archaeology in India, 1932.

Bridges, in a country composed of mountains, and abounding with torrents, must necessarily be very frequent; the traveller has commonly some one to pass in every day's journey. They are of different constructions, generally of timber; and, if the width of the river will admit, laid horizontally from rock to rock [see Plate 7]. Over broader streams, a triple or quadruple row of timbers, one row projecting over the other, and inserted into the rock, sustain two sloping sides, which are united by an horizontal platform, of nearly equal length: thus the centre is, of course, raised very much above the current, and the whole bridge forms the figure nearly of three sides of an octagon. Piers [see Plate 45] are almost totally excluded, on account of the unequal heights, and extreme rapidity of the rivers. The widest river in Bootan has an iron bridge [see Plates 12–13], consisting of a number of iron chains, which support a matted platform . . .: Turner, *Embassy,* p. 191.

43

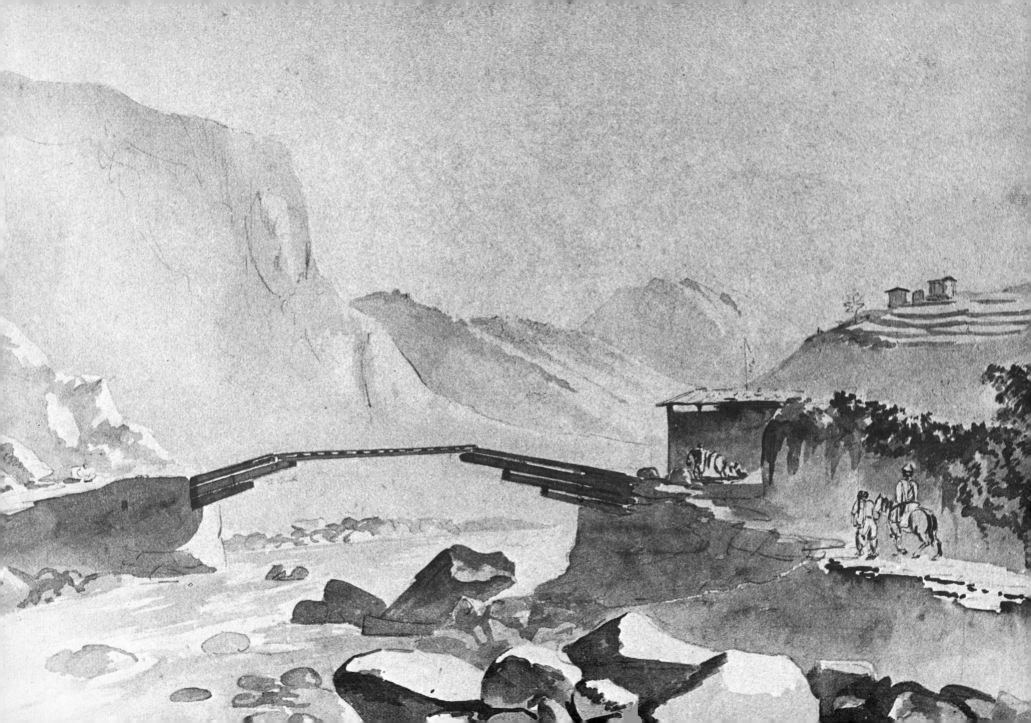

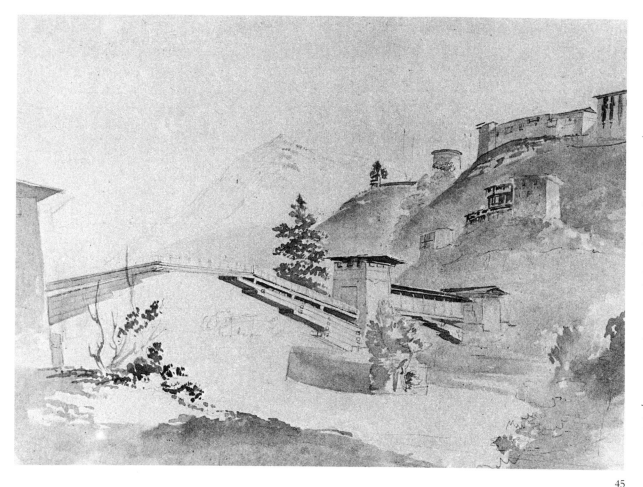

Bridge": W. Westhofen, "The Forth Bridge", *Engineering,* xlix (28 Feb. 1890), p. 217 and fig. 9.

The bridge of Wandipore is of a singular lightness and beauty in its appearance. I am happy to annex a view of this structure, taken upon the spot by Mr. Davis [engraved by James Basire, in Turner, Embassy, plate 6, "The Castle of Wandipore"], and comprehending also the highly picturesque scenery around, as another proof of the talent, fidelity and taste, with which my friend seized on every appropriate feature, that marks the character of this peculiar country. The bridge is composed entirely of fir, and has not the smallest piece of iron, or any other metal, to connect its parts. It has three gateways; one on each side the river, and another erected in the stream, upon a pier, which is pointed like a wedge towards the current, but is on the opposite side a little convex; below it, the eddy, produced by the re-union of the divided water, has thrown up a large bed of sand, on which grows a large willow, that flourishes extremely. The gateway on the Tassisudon side, is a lofty square stone building, with projecting balconies near the top, bordered by a breast work, and pierced with a portcullis. [This description accords better with the view of the bridge-house in Plate 47.] The span of the first bridge, which occupies two thirds of the breadth of the river, measures one hundred and twelve feet: it consists of three parts, two sides and a centre, nearly equal to each other . . . The beams and planks are both of hewn fir: and they are pinned together by large wooden pegs. This is all the fastening I could observe: it is secured by a neat light rail . . . The sound state of this bridge, is a striking instance of the durability of the turpentine fir; for, without the application of any composition in use for the preservation of wood, it has stood exposed to the changes of the seasons for nearly a century and a half, as tradition goes, without exhibiting any symptoms of decay, or suffering any injury from the weather: Turner, *Embassy,* pp. 132–3.

45

45. "The Bridge at Wandepore, Bhootan", 1783, wash-drawing, 18 1/8 × 13 in. Victoria Memorial, Calcutta, R. 1729, formerly in the possession of Sir Leicester Beaufort, deposited by Lord Curzon, 1921.
This famous bridge, Wangdü Zam, survived in almost exactly the same form as seen here until the early 1970s, when it was demolished and replaced with a steel structure for motor traffic. William Westhofen, an engineer employed by one of the main contractors responsible for the Forth Bridge, held the surprising view that the bridge at Wangdü Phodrang "may fairly be looked upon as the prototype of the proposed Forth

46. "Ponte e Castello di Uandipore", coloured engraving, based on plate 6 of Turner, *Ambasceria al Tibet e al Butan,* trans. Vincenzo Ferrario, 3 vols. (Raccolta de' viaggi, xli–xliii, Milan, 1817), in Giulio Ferrario, *Il costume antico e moderno,* 14 vols. (Milan, 1827), *Dell' Asia,* iv, plate 7. Collection Braham Norwick.

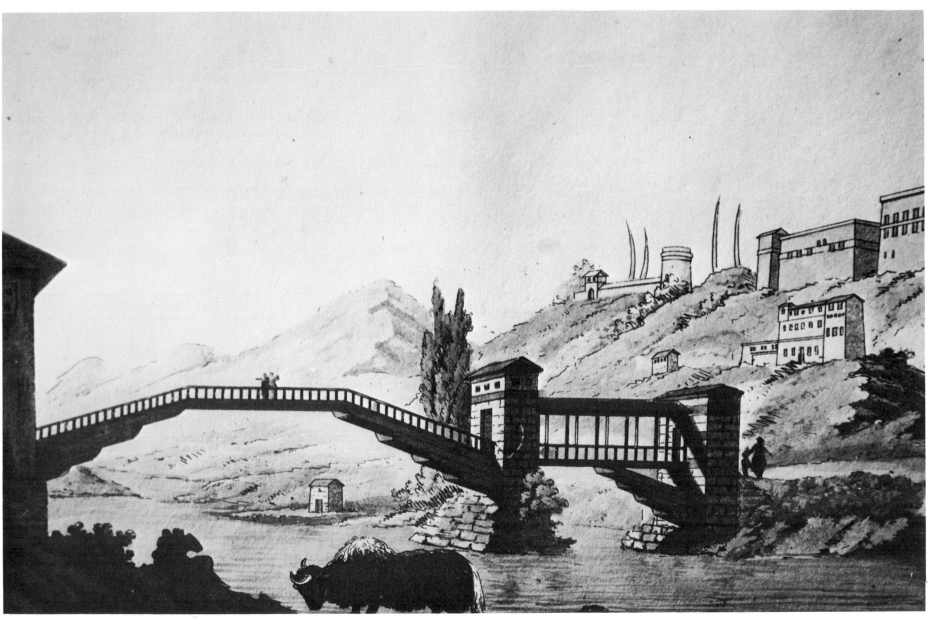

46

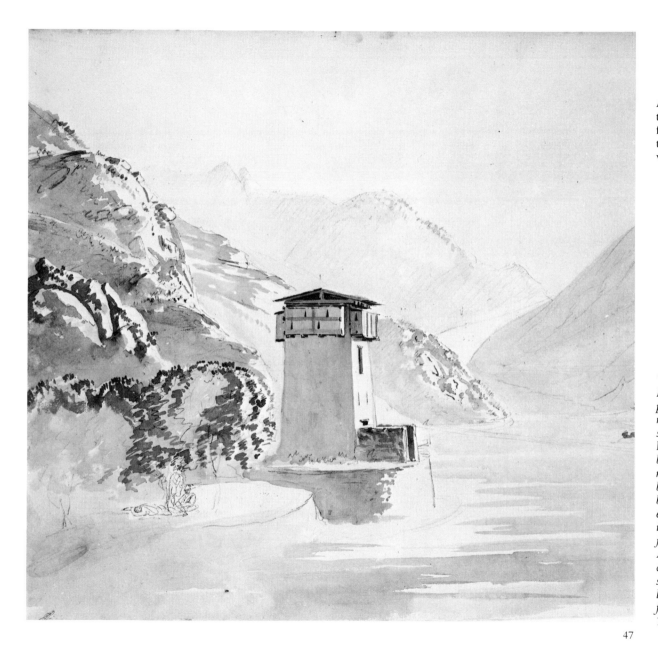

47. "View from the Bridge at Wandepore [Wangdü Phodrang]", 1783, wash-drawing, 13⁵/₈ × 19¹/₈ in. Yale Center for British Art, Paul Mellon Collection, B1977.14.251, formerly in the possession of the artist's family, purchased 1966.

A fortified bridge-house of a type not found in Bhutan today; since the bridge itself is clearly destroyed, only a few ropes still visibly in place, it may perhaps be surmised that the main bridge at Wangdü Phodrang (Plates 45–6,) was built to replace this one.

48. "Wandepore [Wangdü Phodrang]", 1783, water-colour, 13⁷/₁₆ × 19¹/₈ in. Yale Center for British Art, Paul Mellon Collection, B1977.14.247, formerly in the possession of the artist's descendants, purchased 1966.

This is considered as one of the consecrated habitations of Bootan; and the Daeb Raja makes it a point to reside here some part of every year. It stands upon the southern extremity of the narrow end of a rocky hill, which is shaped like a wedge: the sides of the hill are washed by the Matchieu-Patchieu [Pochu-Mochu] on the west, which runs in a swift smooth stream, and by the Taantchieu [Dangchu] on the east, which rushes with much noise and agitation over a rocky bed; they both join at the base of the point, below the castle. This is an irregular, lofty building of stone, covering all the breadth of the rock, as far as it extends. The walls are high and solid: there is but one entrance in front, before which, there lies a large space of level ground, joined by an easy slope on the north-west, to the Punukka road. About a hundred yards in front of the castle rises a round tower, on a high eminence, perforated all round with loop holes, and supporting several projecting balconies. It is a very roomy lodgement, has a commanding position, and prevents the castle from being seen even at a small distance: Turner, *Embassy*, pp. 131–2.

47

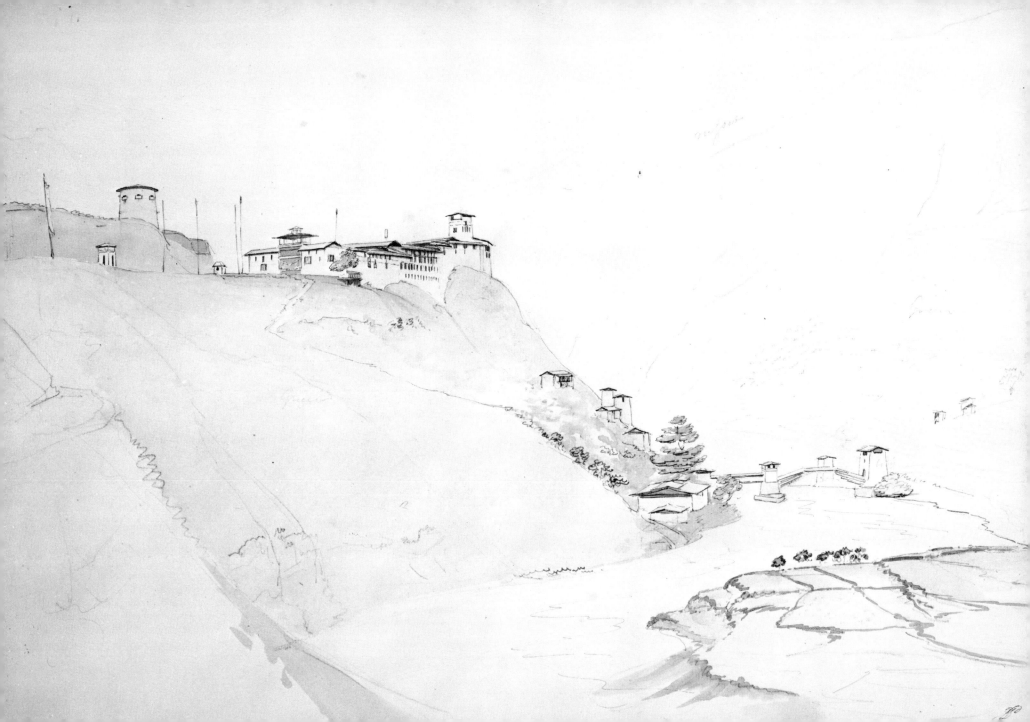

49. "View from Wandepore [Wangdü Phodrang] up the Valley towards Punokka with the snowy mountains seen on the frontier of Tibet", 1783, watercolour, 18⁷/₈ × 13 in. Victoria Memorial, Calcutta, R. 1248, formerly in the possession of Warren Hastings, deposited 1916.

It was about seven o'clock [8th July] when we descended the hill of Wandipore, passing by a sort of barn, where a tame elephant was kept, the only one I had met with in Bootan . . . We were fortunate in our day: the weather was serene, the atmosphere clear, and the sun shone full upon the distant mountains. In the rear of all, swelling high above the rest, the mountains of Ghassa were distinctly visible, clothed with perpetual snow . . . Our road lay near the river, at the foot of the mountains, winding through a verdant valley of unequal width. In general, the mountains terminated with an easy slope; but their sides were divided into small beds, for the growth of corn: and they were not incumbered with trees. The few which were upon them consisted of pine and fir, with some barberry bushes intermixed; and every breeze of wind, diffusing the fragrance of the jessamine, gratefully convinced us of its presence: Turner, Embassy, p. 138.

50. The fortress of Wangdü Phodrang Dzong, no title, 1783, watercolour, 18⁹/₁₀ × 13 in. Victoria Memorial, Calcutta, R. 1721, deposited by the Director-General of Archaeology in India, 1932.

This view was probably the model for William Daniell's oil painting of "Wandepore", which has left no trace since it was exhibited at the Royal Academy in 1811.

The castle of Wandipore [see Map] with its gilded canopy, is of equal antiquity with the bridge [see plate 45]; and both are said to have been erected by Lam' Sobroo [Shabdrung], about one hundred and forty years ago, when he first entered and possessed himself of Bootan. [As the fortress was built in 1638, it was one hundred and forty-five years old in 1783.] Nor did the conqueror of these regions, shew less judgment than good taste, in selecting Wandipore for the place of his principal residence: as it is a situation, both for strength and beauty, superior to every other that offered to his choice. Perhaps some objection might be made to the violent winds, which are drawn up the deep dells on every quarter, and urged furiously across the surface of the hill; but the strength of Wandipore is not lessened by the more lofty surrounding heights, which carry their high heads far distant, by gradual easy slopes, and contribute greatly to the majesty of the views: Turner, Embassy, p. 131.

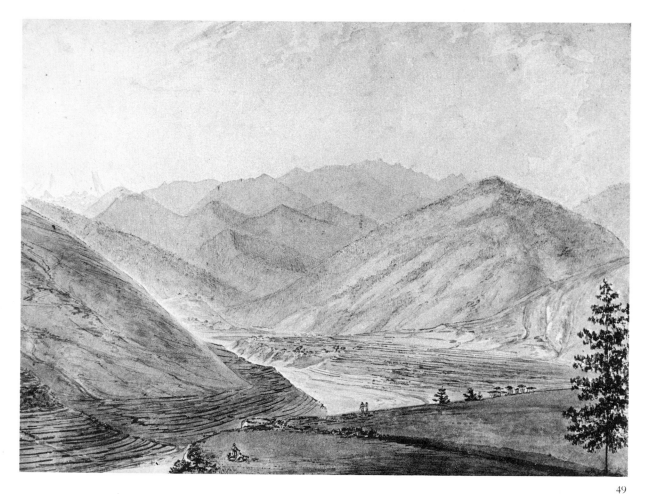

49

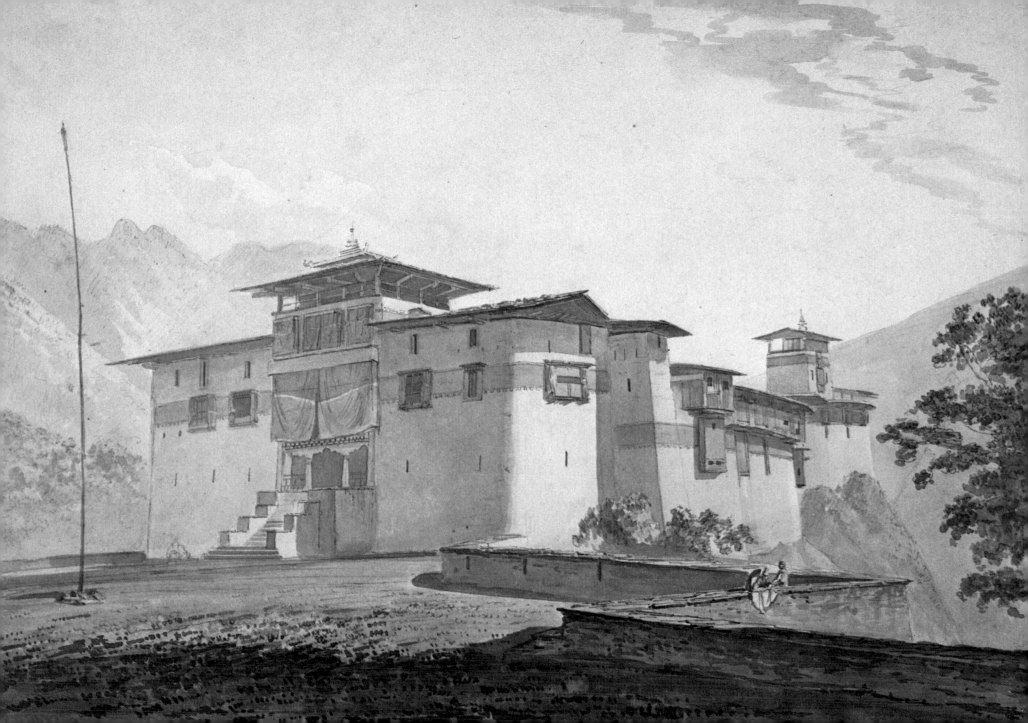

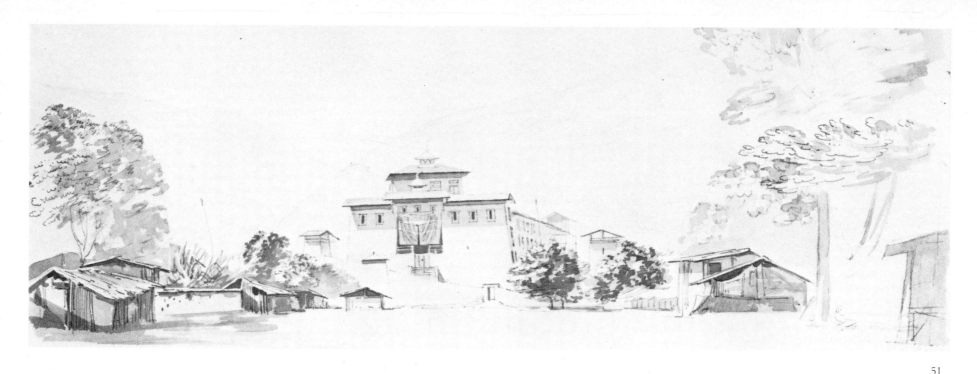

51. "Gateway of Poonaka", 1783, wash–drawing, 11 15/16 × 19 1/16 in. Yale Center for British Art, Paul Mellon Collection, B1977.14.239, formerly in the possession of the artist's descendants, purchased 1966.

The palace of Punakka, in its exterior form and appearance, very much resembles that of Tassisudon [Tashichö Dzong, see Plates 21–4], but is rather more spacious and extensive: it has, in the same manner, its citadel and gilded canopy. It is situated on the point of a peninsula, washed on both sides, immediately before their junction, by the Matchieu [Mochu] and the Patchieu [Pochu]. We crossed the Patchieu over a covered wooden bridge [visible in this plate], and, turning to the right, passed through a doorway in a wall, that serves to part the court-yard from the Raja's garden. We proceeded on, and took up our residence in a light airy pavilion, belonging to Zempi [Dzongpön, "fort governor"], erected on the bank of the Matchieu, under a large spreading tree. The valley, to a considerable distance, as far as it extended in a right line between the river and the garden wall, was as even as a bowling green, and with as fresh a verdure. The bank sustained a row of fine old trees, whose venerable branches spread their thick foliage, to the exclusion of the meridian sun, and cast upon the margin of the river, a constant but grateful shade . . .

Punukka is the winter residence of the Daeb Raja, and, as we were informed, his favourite seat: he has lavished large sums upon it; and I am told its decorations are much more costly, than those of any other of his palaces. I was greatly mortified and disappointed in not being permitted to see the inside of the palace; a stern porter kept the inner entrance; and, in consequence of an order given during the late tumults, obstinately refused me admittance: nor could I by any means prevail upon him to relent. We had not the same difficulty in gaining access to the gardens which were extensive, and well stocked; containing the orange, sweet and sour; lemon, lime, citron, pomegranate, peach, apple, pear, and walnut trees, loaded with unripe fruit . . . Punukka is esteemed the warmest part of Bootan, and, from its soil and situation, is chosen for the culture of exotics. Our English plants suffered by this injudicious care. The gardener brought me a handful of lettuces, weak and bitter, and also a few cabbage leaves, equally degenerate, with a small specimen of potatoes, not bigger than boys' marbles. Mr. Bogle had formed great hopes from the introduction of this vegetable, and they had been taught to call it by his name . . .: Turner, Embassy, pp. 138–40.

52. The former winter capital of Bhutan at Punakha Dzong, no title, 1783, watercolour, 17 1/2 × 27 5/16 in. (for detail, see Plate 25). Yale Center for British Art, Paul Mellon Collection, B1977.14.284, formerly in the possession of the artist's family, purchased 1966.

The great fortress of Punakha Dzong was founded by *Shabdrung* Ngawang Namgyel in 1667. It was intended to house six hundred state monks during the winter months, and does so to this day. It was the scene of several Tibetan attacks during the mid-seventeenth century, and numerous civil wars later. Three years before the mission which Davis took part in the building burnt down, and what we see here is the restoration of *c.* 1781.

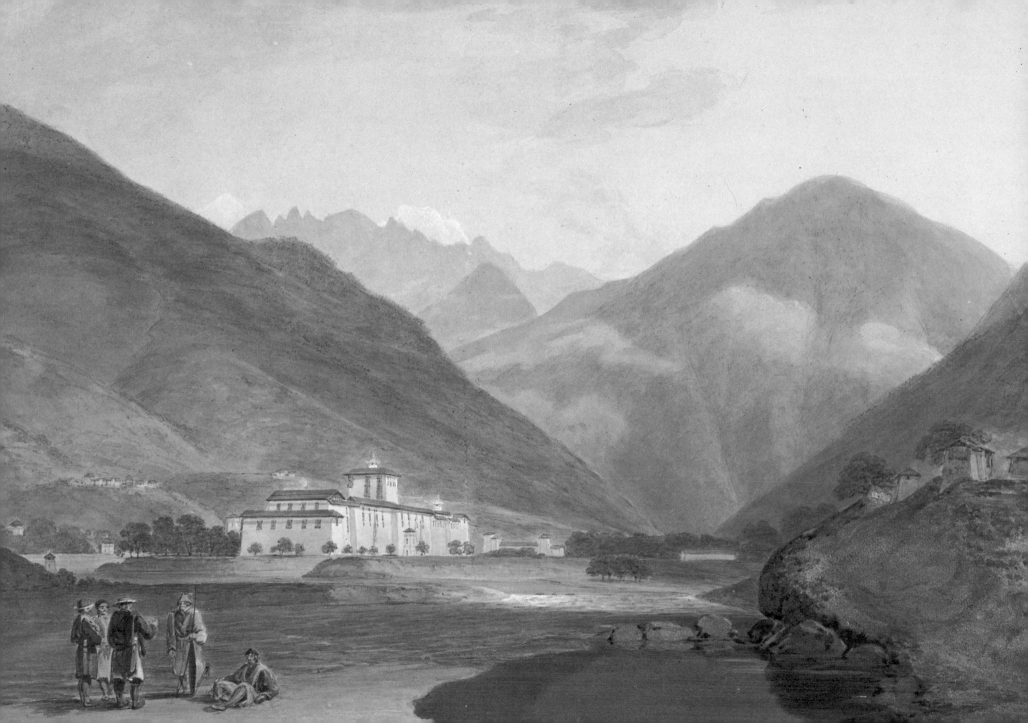

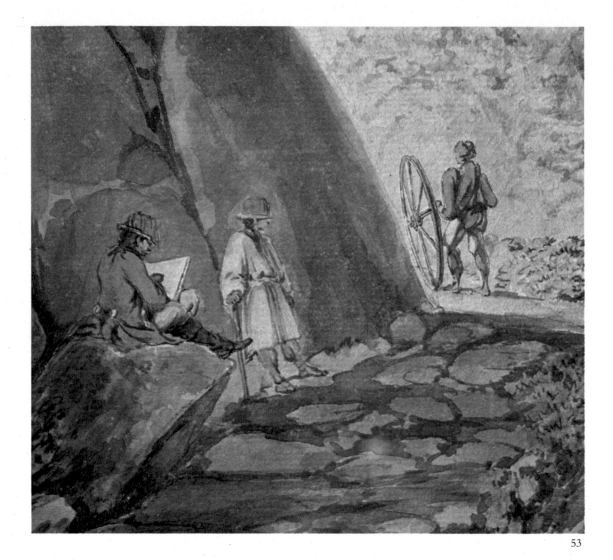

53. Detail of "The cascade Taanchoos [?] seen high across the channel of the Teenchoos on the road between Murichom and Choka in Bhootan", 1783, watercolour, Victoria Memorial, Calcutta, R. 1251, formerly in the possession of Warren Hastings, deposited 1916.

A more developed version of the watercolour in Plate 3, in which Davis has shown himself seated and sketching, with an Indian cooly wheeling along a waywiser for measuring the distance travelled, which would have been operated under Davis's own supervision as expedition surveyor. Between Davis and the cooly stands a Bhutanese attendant wearing the same (local?) headgear as Davis. The rock above is signed "Lieut. S. Davis 1783". For a steel engraving (based either on this version or on the one in Plate 3) by J. C. Armytage after William Daniell, see Hobart Caunter, *The Oriental Annual*, 7 vols. (London, 1834–40), vi, plate 8, "Mountain Scene in the North of India". However, the arrangement of the human figures is quite different.

53

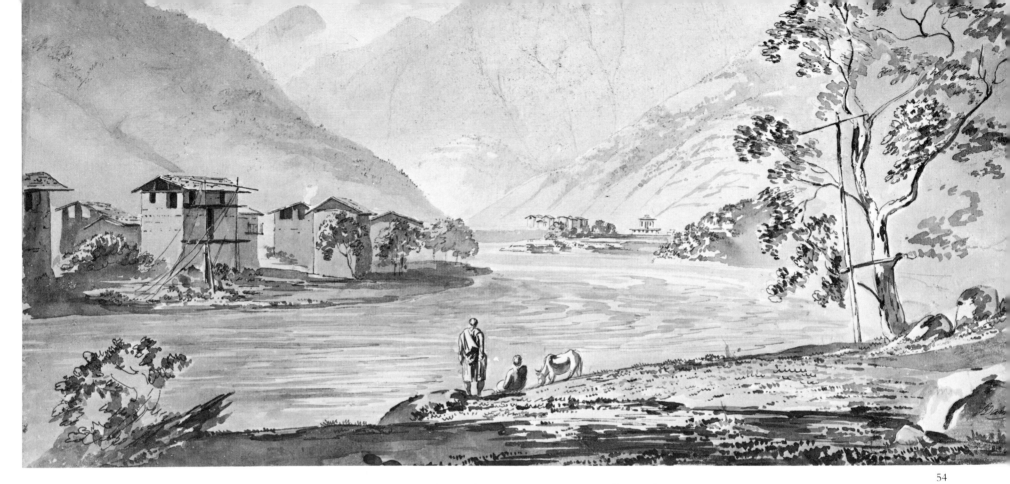

54

54. "View Near Poonaka", 1783, wash-drawing, 13¹³/₁₆ × 18¹¹/₁₆ in. Yale Center for British Art, Paul Mellon Collection, B1977.14.200, formerly in the possession of the artist's descendants, purchased 1966.

Turner's mission, which proceeded to Tibet without Davis, returned to India by way of Punakha, spending a week there in December 1783.

We passed the summit of Soomoonang, that lofty range of mountains which forms the boundary of Tibet on the south, and divides it from Bootan, and hastened with our utmost speed to reach a milder region.

This we found at Punukka, the winter residence of the Daeb Raja, who received us with every mark of hospitality and friendship. Compared with the land we had left, we now beheld this

garden of Lam' Rimbochay [the regent, see Appendix] in high beauty, adorned with groves, crowded with rich loads of the finest oranges, citrons, and pomegranates. The mango and the peach tree had parted with their produce, but hoards of apples and of walnuts were opened for our gratification; and this vast profusion of ripe fruit, added to the temperature of the air, most gratefully convinced us of the prodigious disparity of climate, within so short a distance.

My stay with the Daeb Raja, at his favourite palace of Punukka, was not of long duration. I hastened to make all the arrangements that appeared necessary, or expedient, with regard to the object of my mission. The Raja gave me frequent opportunities of meeting him, as well within doors, as by invitation to walk with him in the gardens. Indeed I was treated by him with

the greatest freedom and cordiality. He urged me strongly to pass a long time with him, extolling the beauty of the place, and the mild temperature of the weather; but I was obliged to decline the honour.

On the 30th of December I had my audience of leave, and received, at the Lama's hand, the valuable favour of a badge of thin crimson silk, over which various solemn incantations had been performed, and which was in future to secure for ever, my prosperity and success. Valuable as the present was, I fear I have unfortunately lost it. In the evening, I took a long farewell of all the officers of his court, and on the following day, departed for Bengal: Turner, *Embassy,* pp. 357–8.

Appendix: The Abbot's Rebuke

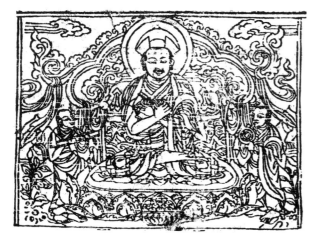

Yönten Thayé, 13th Head Abbot of Bhutan. Block-print from fo. 1b of his biography. By courtesy of Hugh Richardson.

Introduction

The only contemporary reference in the historical literature of Bhutan to the mission which Samuel Davis took part in is found in an undated letter in Tibetan sent by the retired head abbot Yönten Thayé (*r.* 1769–71, see opposite) to the titular head of state who was acting as a sort of supreme regent during the minority of the *Shabdrung,* incarnation of the state's great founder, Ngawang Namgyel (1594–?1651). The regent, Jigme Senge (1742–89), not to be confused with the reigning Deb Raja of the same name, was himself the incarnation of Tendzin Rabgye (1638–96), the first and most successful of the official "stand-ins" for the founding *Shabdrung* (see my *Bhutan: The Early History of a Himalayan Kingdom,* pp. 243, 250–3). Although the letter, reproduced in the abbot's biography, is undated, it comes in a passage dealing with events immediately following the abbot's return from a pilgrimage to Tibet in 1782–3, and so we can be sure that it was written in reaction to Hastings's mission of 1783 led by Samuel Turner.

The purpose of the letter is to rebuke the regent for his insatiable curiosity in English goods and gadgetry, but this only becomes apparent near the end after a long catalogue of historical woes. The abbot attributes all these to the breaking of a fundamental tantric rule: the initiate must never have relations of any sort with those who oppose the teachings, particularly not with the victims of his magical rites. It is unusual to find in the literature such a frank admission of the reciprocal danger in the use, or rather misuse, of destructive magic (Sanskrit *abhicara*); tantric sorcery is usually held up as the cause of the state's victories, not its imperfections and failures. In the abbot's view the worst of these tribulations were clearly the repeated difficulties faced by the Bhutanese in agreeing on the recognition of the reincarnations of all those religious figures who were pushed forward to fill the place of the state's founder after the failure of his line. Much of the complexity of Bhutanese politics in this period stems directly from the problem of convincing everyone that one's own candidate was the true embodiment of his predecessor and not merely the tool of political self-interest.

It seems that the rebuke took effect: none of the members of the 1783 mission appear to have gained access to the regent. Indeed it seems likely that the letter sought to avert what had happened during the first mission sent by Hastings, led by George Bogle in 1774. Bogle had several meetings with the regent, a rather shadowy figure who wielded intermittent power

118

behind the main political scene. The following passage from Bogle's *Narratives* (ed. Markham, pp. 26–7, my italics) can serve as a fitting prelude to our abbot's letter:

> A tower, about five or six stories high, rises in the middle [of Tashichö Dzong], and is appropriated to Lama-Rimboché [the regent Jigme Senge]. He dwells near the top. His apartments are furnished in the style of the [Deb] Rajah's, but better. In [Deb Zhidar] the former chief's days nobody could see him, but times are altered. His reception was like the Rajah's, only no *khilat* [ceremonial gift of a robe, see Bogle wearing it, p. 19 above] or whisky. On our arrival he lived in a castle on a little mount behind the palace. His apartments were finished while we were there, and a large image of Sakya [the historical Buddha] was gilded and set up in his presence chamber. When he came down the Rajah went out to meet him. After the first visit he used to receive us without any ceremony, *and appeared to have more curiosity than any man I have seen in the country.* One day Mr. Hamilton was showing him a microscope, and went to catch a fly; the whole room was in confusion, and the Lama frightened out of his wits lest he should have killed it. We used to get dinners at the Lama's . . . He has got a little lap-dog and a mungoos, which he is very fond of. He is a thin sickly-looking man of about thirty-five years of age. [In fact he was thirty-two.]

The Text

The letter is found on folios 122b–123b of the blockprint of the undated biography of Yönten Thayé by Jamyang Gyetsen (short title: *Ye-shes 'od-stong 'phro-ba'i nyi-ma*, "The Sun which Sheds a Thousand Rays of Wisdom"). I am grateful to Hugh Richardson for an extended loan of this work, and to Samten Karmay who kindly helped to shed light on several obscurities. The letter remains a very difficult example of the epistolary style in Bhutan, and some passages in the translation remain tentative. This version is based on a draft prepared by my wife Suu which we worked on together.

Translation

At that time I [Yönten Thayé] wrote a letter to the Precious Exalted One as follows:

I beseech the blessings of the lamas, the tutelary deities and the Triple Gem [Buddha, Dharma, Sangha] on this epistle, the good deed resulting from a good intention.

Now the protector of religion Mahākāla[1] bestowed the Southern Land [Bhutan] upon Ngawang Namgyel[2] so that the teachings of the Drukpa hierarchs[3] might exist in a pure state in the South. He looked to the benefit of an inconceivable number of sentient beings of the South and of Tibet. And so Ngawang Namgyel for his part cleverly contrived to come here to the South and established the teachings. Then because

1. Mahākāla ("The Great Black One", or "The Protector of Transcendental Wisdom" as he is known in Bhutan and Tibet) is the chief guardian deity of Bhutan.

2. Ngawang Namgyel (1594–?1651), hereditary prince-abbot of the Drukpa Kagyüpa school of Tibetan Buddhism, was the founder and unifier of the Bhutanese state.

3. The lineage of the Drukpa Kagyüpa school was passed down in a leading family of the Gya clan of Ralung in central Tibet, extending back to its founder Tsangpa Gyaré (1161–1211). After the consolidation of its hold on Bhutan in the seventeenth century, the school split into a northern (Tibetan) branch and a southern (Bhutanese) branch.

4. The family of the *Tsang Desi* ("Rulers of the Tsang Province") provided the effective "kings" of Tibet for part of the sixteenth and seventeenth centuries, until their defeat by the Qośot Mongols in 1642 which brought in the rule of the Dalai Lamas. In Bhutan the death of the *Tsang Desi* Phuntsok Namgyel is ascribed to the black magic of Ngawang Namgyel. The cave where the rites are said to have been performed is still indicated to one at the Tango monastery above the Thinphu valley.

5. Zhidar was the 16th Deb Raja of Bhutan, ruling from 1768 to 1773. After his defeat during the Anglo-Bhutan war of 1773–4 he fled to the protection of the Panchen Lama in Tibet, from where he continued to foment trouble in Bhutan. The minor insurrections witnessed in Bhutan during the British missions of 1774 and 1783 were said to have been instigated by him.

6. The *Gyesé Tulku* can probably be identified with Yeshé Gyeltsen (1781–1830), incarnation of the "verbal principle" of *Shabdrung* Ngawang Namgyel, and nephew of the ruling Deb Raja, Jigme Sengé (*r.* 1776–88). See Plates 32–3 for his residence in Thinphu.

7. On Tendzin Rabgye see the introduction above to this letter. The biography alluded to here is the *dPag-bsam-gyi snye-ma* (short title) written in 1720 by Ngawang Lhundrup (1670–1730).

8. See the quotation from Bogle's *Narrative* in the above introduction to this letter, where it is suggested that the regent, recipient of the letter, had been immured in the central tower of Tashichö Dzong during the reign of Zhidar.

9. *Phi-ling-pa* is derived from *Ferengi* ("Franks"), the term commonly applied to Europeans, especially the British, in India at this time.

10. The head abbot of Bhutan in 1783 was Kunzang Gyeltsen (*r.* 1781–4).

for a period armies would arrive again and again from Tibet, in former times this was a country where destructive magic was practised constantly in order to prevent them from drawing near. The "offerings" [of this magic] were directed against Tibet, and the Southerners then enjoyed material goods which came down to them from Tibet. According to the tantras, if between the practitioner of destructive magic and his victim there should come about material, let alone religious, connections, it is an offence displeasing to the protectors of religion. The arising of many things inauspicious to both the practitioner of destructive magic and his victim is the purport of the tantras, and this is known to all those in Tibet today who practise and are learned in the tantras of destructive magic.

Ngawang Namgyel himself also "liberated" [i.e., killed] the Tsang Desi[4] by means of this destructive magic and later confessed to it. Because he had established material connections [with his victim], the dominion of the Tsang Desi was seized by another and thrown into chaos, and to Ngawang Namgyel also there occurred many unworthy things such as the failure of his line, as is common knowledge. As [part of the] retribution for the Shabdrung Rinpoche [Ngawang Namgyel]'s offence, I also have suffered from malicious, meaningless gossip; since the time has not yet come to speak of the clear memories of the Shadrung Rinpoché's [present] rebirth, I wisely hold my peace, and so it came to be said that I had allied myself to Depa Zhidar.[5] As a result of this gossip all the people who disliked Depa Zhidar have lost faith, referring to me as "a learned divine who prophecies to be true incarnations the false incarnations recognized [only] by Depa Zhidar", and so all sorts of evil words are spoken. And even though the present Gyesé Tulku[6] has been ascertained to be the real Gyesé Tulku, and has been properly established as such, many peole have been compelled to amass sins without reason by saying things such as that [you?] Precious One have given a false recognition.

Even you, Precious One, at the time when you were previously born as Tendzin Rabgye,[7] you enjoyed the food and wealth of the victims of your destructive magic, so it is told in your biography. By the power of that offence even you, the true rebirth of the Precious One, have suffered meaningless, malicious gossip and heinous, evil acts perpetrated by Depa Zhidar.[8] As the present retribution for the [misuse of] destructive magic, the barbarian demons have disturbed your mind, holy being, to the extent that you are enamoured of the goods of the English (Phi-ling-pa).[9] Having been disturbed by that, you, a holy being who knows about karmic fruition, are without the power to feel shame in taking the wealth of others. In brief, you cannot perceive that this shamelessness in accumulating wealth through crafty means on the part of one who has received tantric initiations is due to your being under the sway of the English.

You and the head abbot[10] had better think over carefully today whether this is so or not, and please send me word at all cost whether what I have said is or is not true. Tomorrow I shall come there and must tell you a story which will always be of benefit to you.

Select Bibliography

ABBEY, J. R. *Travel in Aquatint and Lithography, 1770–1860, from the Library of J. R. Abbey*, 2 vols., London, 1956–7, no. 434.

ARCHER, MILDRED *Early Views of India: The Picturesque Journeys of Thomas and William Daniell, 1786–1794*, London, 1980.

—— *India and British Portraiture, 1770–1825*, London and New York, 1979.

ARIS, MICHAEL *Bhutan: The Early History of a Himalayan Kingdom*, Warminster, 1979.

Burke's Peerage and Baronetage, London, 1870 and later editions.

BYSACK, GAUR DAS "Notes on a Buddhist Monastery at Bhot Bagan (Howrah)", *Journal of the Asiatic Society of Bengal*, lix (1890).

CAMMANN, SCHUYLER *Trade Through the Himalayas: The Early British Attempts to Open Tibet*, Princeton, 1951.

Catalogue of Manuscripts in European Languages belonging to the Library of the India Office, ii pt. 2, *Minor Collections*.

CAUNTER, HOBART *The Oriental Annual*, 7 vols., with engravings after William Daniell, London, 1834–40.

DANIELL, WILLIAM (after Samuel Davis) *Views in Bootan*, 6 plates, London, 1813.

DAVIS, SIR JOHN FRANCIS *Vizier Ali Khan: or, The Massacre of Benares, a Chapter in British India*, London, 1844; 2nd edition 1871.

DAVIS, SAMUEL "On the Astronomical Computations of the Hindus", *Asiatick Researches*, ii (1790).

—— "On the Indian Cycle of Sixty Years", *Asiatick Researches*, iii (1792).

—— "Remarks on the Religious and Social Institutions of the Bouteas, or Inhabitants of Boutan, from the Unpublished Journal of the Late Samuel Davis, Esq. F.R.S., &c.", *Transactions of the Royal Asiatic Society*, ii (1830).

Dictionary of National Biography.

FARINGTON, JOSEPH Typescript of his diary: British Museum, Department of Prints and Drawings.

FERRARIO, GIULIO *Il costume antico e moderno*, 18 vols., Milan, 1816–34; 2nd edition Florence, 1826–8; French edition Milan, 1827 [for three engravings after Davis, based on those in the Italian edition of Turner's *Embassy*, see the 4 vols. within the *Costume* entitled *Dell' Asia*, iv, plates 6, 7].

HODSON, V. C. P. *List of the Officers of the Bengal Army*, 4 vols., London, 1927–47.

JONES, SIR WILLIAM "Letters of Sir William Jones to the Late Samuel Davis, Esq., F.R.S., &c. from 1785 to 1794, Chiefly Relating to the Literature and Science of India, and Elucidatory of the Early History of the Asiatic Society of Calcutta", *Transactions of the Royal Asiatic Society*, iii (1831).

—— *The Letters of Sir William Jones*, ed. Garland Cannon, 2 vols., Oxford, 1970.

LABH, KAPILESHWAR *India and Bhutan*, Delhi, 1974.

LAURIE, W. F. B. *Sketches of Some Distinguished Anglo-Indians*, 2nd series, London, 1888, ch. 1: "Samuel Davis, B.C.S., F.R.S.; and the Domestic Thermopylae at Benares" [based on a supplement to Davis, Sir John Francis, *q.v.*, by John Lockwood].

MACGREGOR, JOHN *Tibet: A Chronicle of Exploration*, London, 1970.

MARSHALL, P. J. "Warren Hastings as Scholar and Patron", in Anne Whiteman, J. S. Bromley and P. G. M. Dickson (eds.), *Statesmen, Scholars and Merchants: Essays in Eighteenth-Century History Presented to Dame Lucy Sutherland*, Oxford, 1973.

MOORE, THOMAS *Fables for the Holy Alliance*, London, 1823.

Narratives of the Mission of George Bogle to Tibet, and of the Journey of Thomas Manning to Lhasa, ed. Clements R. Markham, London, 1876; 2nd edition 1879; repr. New Delhi, 1971.

PENNANT, THOMAS *The View of Hindoostan*, 2 vols., London, 1978.

PETECH, LUCIANO "The Missions of Bogle and Turner according to the Tibetan Texts", *T'oung Pao*, xxxiv (1950), pp. 330–46.

PHILIPS, C. H. *The East India Company, 1784–1834*, Manchester, 1940.

Political Missions to Bootan, comprising the Reports of the Hon'ble Ashley Eden 1864, Capt. R. B. Pemberton 1837, 1838, with Dr. W. Griffiths's Journal and the Account by Baboo Kishen Kant Bose, Calcutta, Bengal Secretariat Office, 1865.

RAY, NISITH R. "Samuel Davis in the Victoria Memorial Collection", *Bulletin of the Victoria Memorial*, vi–vii (1972–3), pp. 36–42.

Register of East India Company Cadets: India Office Library, London, L/MIL/9/255.

RENNELL, JAMES *A Bengal Atlas*, London, 1780.

—— *Memoir of a Map of Hindoostan*, London, 1783.

RICHARDSON, H. E. *Tibet and its History*, London, 1962.

SARCAR, S. C. "Some Notes on the Intercourse of Bengal with the Northern Countries in the Second Half of the Eighteenth Century", *Bengal Past and Present*, xli (1931).

—— "A Note on Puran Gir Gosain", *Bengal Past and Present*, xliii (1932).

SAUNDERS, ROBERT "Some Account of the Vegetable and Mineral Productions of Bootan and Tibet", *Philosophical Transactions of the Royal Society*, lxxix (1789), repr. in Turner's *Embassy*, pt. 4, pp. 385–416.

SHELLIM, MAURICE *Indian and British Painters: Patchwork to the Great Pagoda*, Calcutta [1973].

—— *India and the Daniells: Oil Paintings of India and the East by Thomas Daniell R.A., 1749–1840, and William Daniell R.A., 1769–1837*, London, 1979.

SNELLGROVE, D. L. and RICHARDSON, H. E. *A Cultural History of Tibet*, London, 1968.

SUTTON, THOMAS *The Daniells: Artists and Travellers*, London, 1954.

TURNER, SAMUEL *An Account of an Embassy to the Court of the Teshoo Lama in Tibet; Containing a Narrative of a Journey through Bootan, and Part of Tibet*, London, 1800; 2nd edition 1806; repr. New Delhi, 1971 [among foreign editions see particularly *Ambasceria al Tibet e al Butan*, trans. Vincenzo Ferrario, 3 vols., Raccolta de' viaggi, xli–xliii, Milan, 1817].

—— "An Account of a Journey to Tibet", *Asiatick Researches*, i (1788), pp. 199–206.

—— "Description of the Yak of Tartary called Soora-Goy, or the Bushy-Tailed Bull of Tibet", *Asiatick Researches*, iv (1795), pp. 351–3, 1 plate.

YULE, HENRY and BURNELL, A. C. *Hobson-Jobson: Being a Glossary of Anglo-Indian Colloquial Words and Phrases, and of Kindred Terms*, London, 1886.

INDEX

Numerals in italics refer to plates and their captions. Some variant spellings have not been indexed.